Painting Rivers

FROM SOURCE TO SEA

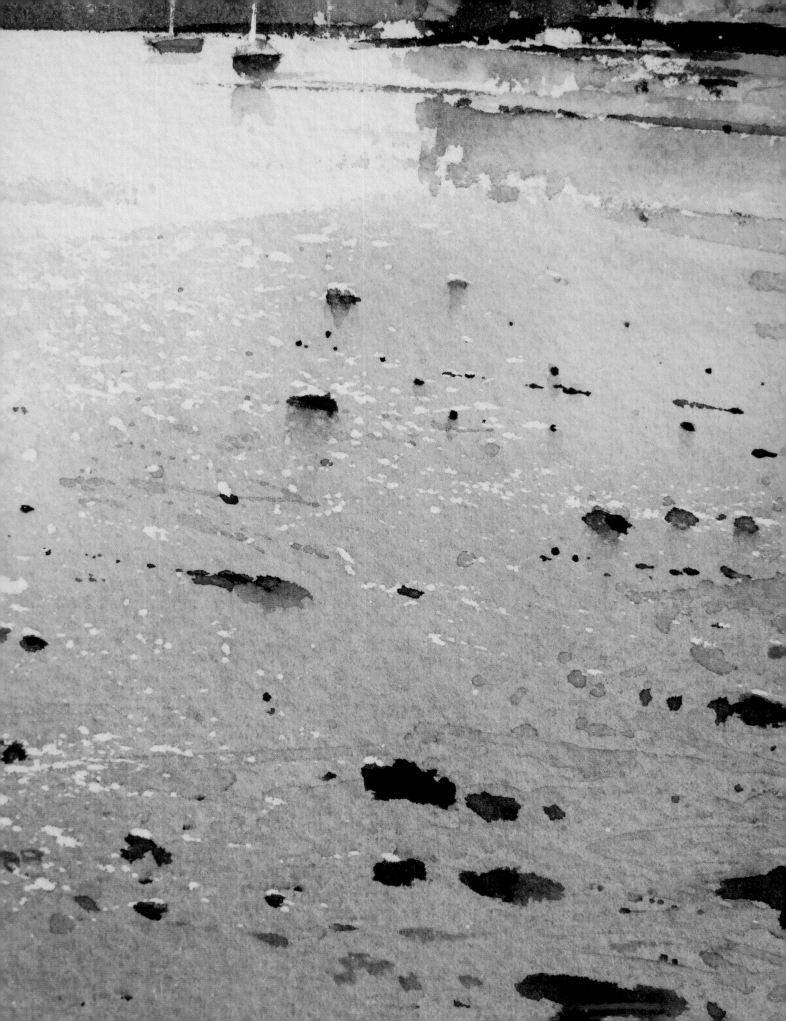

Painting Rivers

FROM SOURCE TO SEA

ROB DUDLEY

THE CROWOOD PRESS

First published in 2018 by
The Crowood Press Ltd
Ramsbury, Marlborough
Wiltshire SN8 2HR

www.crowood.com

British Library Cataloguing-in-Publication Data
A catalogue record for this book is available from the British Library.

ISBN 978 1 78500 359 2

Dedication
For RS and JG to whom I shall always be grateful, but especially with love to Siân.

Graphic design and layout by Peggy & Co. Design Inc.
Printed and bound in Malaysia by Times Offset (M) Sdn Bhd

Contents

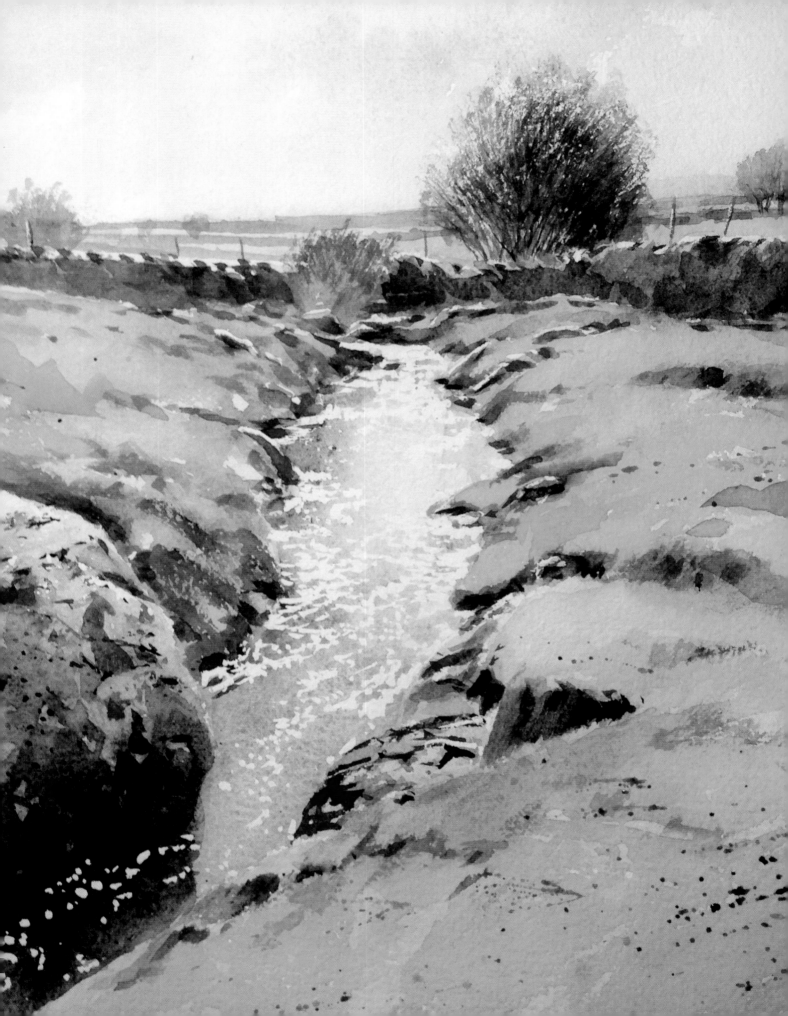

Introduction

I love painting. That might seem a rather bold statement, but I really do, I love it. A stretched sheet of watercolour paper sitting on an easel, with paints and brushes at the ready, thoroughly excites me and I can't wait to get painting. Some of my earliest memories are of the paintings that I produced as a small child. I can still remember drawing a face at my junior school with so much care and attention to detail that I sacrificed a break, or 'playtime' as we used to call it, just so that I could finish blending a red and yellow crayon to create a 'flesh' like colour. Both my parents must have been aware of how interested I was in 'art' because soon after that, better-quality paper and pencils were made available at home, and it wasn't even my birthday or Christmas. I was hooked and have been ever since.

Learning how to paint requires persistence and endeavour; it's not easy, it takes commitment and hard work. Like anything of worth, it requires effort. The nearest analogy that I can think of when it comes to learning how to paint is in learning how to drive a car. The first time sitting in the driving seat can make it all seem rather daunting: mirrors, manoeuvres, learning which pedal does what and when, lane positioning, signals, rules of the road, hill starts, requirements of the highway code – and all this whilst the car is moving at speed! So much to learn, so much to take in, but slowly, with guidance and practice the biting point of the clutch becomes second nature, dropping down a gear when going up a hill is almost seamless, reversing into a parking bay no longer such a challenge, over time the learner becomes a driver. It's similar when learning to paint: it also can appear to be rather daunting at the start when staring at a blank sheet of paper, with a handful of brushes and brand new tubes of watercolour paints unwrapped for the first time; what to do next? But with practice and effort, what in the beginning might have appeared to be almost impossible becomes more achievable. Washes become controllable, compositions balanced and techniques mastered. I believe that with the right instruction everyone can paint, and I hope this book points you in the right direction.

Why paint rivers? From the trickle of a stream at its source, slowly meandering through rich green water meadows, to wide expansive estuaries and then to the sea, rivers have so much to offer the artist. They are full of life, light, movement, colour and interest. I have painted riverscapes for many years, and I never tire of them; they sustain me and I feel comfortable beside them. Every visit seems to present a different set of painterly possibilities. The Thames, Wye, Severn or Dee might be considered 'Landscapes' with a capital 'L', attracting tourists from far and wide to visit and admire as I do. However, my interest also lies with the smaller, less well known, nameless rivers or streams, 'lower-case' landscapes if you will. These are nonetheless beautiful and inspiring and although, one might think, not as awe-inspiring as their grander cousins, they should not be overlooked.

Within the pages of this book, through paintings, explanations and step-by-steps, I have tried to share with you my approach to the painting of rivers in watercolour. I don't pretend that I will have all the answers to all the questions when it comes to watercolour, but I hope that by describing my methods, techniques and ideas you will be encouraged to pick up your brushes and have a go.

Getting Started

Watercolour is one of the simplest of media an artist can choose: it doesn't require the strong-smelling solvents common to oil painting; it is more stable when dry than a pastel painting; it is immediate, fluid and fun. With just a few tubes of colour, brushes, palette, paper and water you are ready to paint.

But where to start? It's no wonder that when confronted with racks of papers, dozens of colours and scores of brushes in various shapes and sizes, that many would be painters feel bewildered by the options available. So let's take a look at the essential requirements for the watercolour painter: namely paper, paint and brushes.

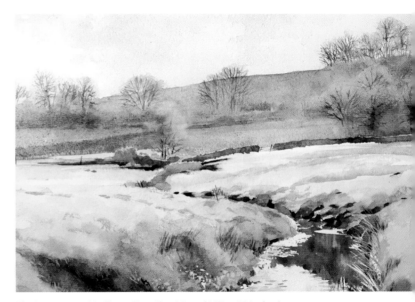

The Stream near Modbury. Size: 42 × 25 cm (16½ × 10 inches).

PAPER

The choice of paper is often overlooked by those new to watercolour painting. How often have I heard from students when asked what paper are they using, 'I don't know; it's just paper'? To the watercolour painter there is no such thing as 'just paper', its choice is crucial to the overall success or otherwise of a watercolour painting. Choose the right paper and certain effects are possible to achieve; choose the wrong paper and those desired effects might prove disappointing or even impossible. For instance, a paper with a smoother surface will tend to lend itself to a finer, more precise type of painting, whereas a rougher paper is often better suited to a looser style of watercolour.

The four qualities that artists consider when making their choice of paper on which to paint are: texture, weight, hardness, and whiteness or colour.

Texture

Watercolour paper is manufactured in three different types of surface texture. The types are known as Hot Pressed (HP), Cold Pressed (NOT) and Rough, the classification decided upon by the surface texture, the 'tooth' as it is sometimes called. You might like to think of them simply as smooth, medium and rough. A smoother paper will prove easier to work on when producing a tighter,

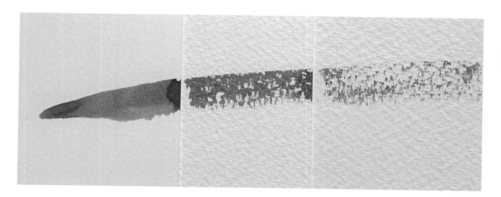

From left to right: Hot pressed, NOT and Rough papers. Note how the texture of the paper has a direct influence on the mark created.

more detailed painting, whereas a rougher surface allows for a looser, more expressive style of brush stroke.

A Cold Pressed (NOT) style of paper, which offers an acceptable amount of texture and allows for both the easy flow of washes and a degree of detail, is the preferred paper of many. Most of the paintings and exercises in this book are painted on Cold Pressed (NOT) papers.

Weight

Watercolour paper is available in a variety of different weights and thicknesses. The most common is 190gsm (90lb), a fairly thin one; 300gsm (140lb) is medium thickness; 638gsm (300lb) is much thicker. The lower the number, the lighter the paper.

Lighter papers are likely to wrinkle and distort when painted on, artists and papermakers refer to this as 'cockling'. Heavier papers cockle less than lighter ones, but even these will with the addition of enough water. Therefore, to reduce the chances of cockling it is advisable to stretch the paper before painting. This involves soaking the paper in water and sticking it to a stout wooden board with tape. As it dries the paper is pulled flat, and when painted upon will remain virtually cockle-free. Nobody enjoys painting on a bumpy surface and a flat, taut sheet of watercolour paper almost shouts out to be used!

Hardness

Watercolour paper comes in different degrees of absorbency and this is known as the paper's 'hardness'. The degree of hardness is arrived at during the manufacturing process with the addition of 'size'. This has nothing to do with the physical dimensions of the paper, but is the term given to the additive introduced during the manufacturing process that reduces the paper's capacity to absorb water. The more size used, the less absorbent the paper and the harder it is.

The level of a paper's hardness has a direct influence on the behaviour of watercolour washes and on the marks possible. A softer paper allows for the layering of delicate, subtle mixes of colour whereas with harder papers washes tend to float for longer on the surface, making the blending of colours easier. Each type of paper has its own characteristics and strengths and with experience the artist will learn which paper is best suited to their work.

Whiteness/Colour

Paper manufacturers produce a variety of 'white' papers, some of which are whiter than others. Other colours are also available – pale blues, cream and grey, for example – and the choice of paper colour is decided upon by the subject matter of the painting. For example, a snow-covered river scene might work better if a pale blue paper were used, rather than a creamy white.

Paper can be bought in sheets, pads or blocks. When painting in the landscape a spiral-bound A3 (297 × 420mm) watercolour pad will be large enough, particularly as the spiral binding allows for the pad to fold completely flat, making it much easier to work on. Anything larger than can prove difficult to carry. Watercolour blocks are sheets of watercolour paper glued on all four edges that are meant to do away with the need for stretching as the glued edges are designed to keep the sheets taut when painted on. I find that although the first couple of sheets remain flat, after being taken in and out of my painting bag a few times the remaining sheets begin to separate and any benefit the block might have had is quickly lost. In the studio A1 (594 × 841mm) sheets of paper are often the best choice as they can be cut to the required size and stretched accordingly.

Sample paper packs are available from manufacturers and some online stockists. These packs are particularly useful as they allow the artist to test out the various papers before purchasing larger quantities.

Stretching paper

Step 1: Soak the paper in cold water for a couple of minutes, longer if the paper is very heavy. If using the kitchen sink or bath make certain that it is clear of any soap or cleaning residue as this can affect the paper's performance when painting.

Step 2: Lay it carefully onto a wooden or plywood board no less than 13mm in thickness, and leave it for about a minute. Be careful not to catch the paper with anything sharp, as it is very soft and susceptible to damage when wet. With the four pieces of gum strip already cut to size, moisten with water, and stick them to the paper and board. Make certain that at least a third of the gum strip is stuck to the watercolour paper and the remainder to the board. Masking tape will not do as a substitute for gum strip.

Step 3: If puddles of water have gathered, remove carefully with kitchen roll.

Step 4: Leave to dry flat, avoiding direct heat, overnight if possible.

To check if the paper is completely dry, use the back of your fingers or hand to test it. If it feels colder than the ambient temperature of the room it is still damp and needs to be left longer. Some artists will test the surface of the paper by drawing with a 2B pencil. If it makes a mark easily then it is likely to be dry enough to use.

Papers can vary widely in price, with the beautiful handmade papers being among the most expensive and machine-made papers less so. Over the years I have tried many manufacturers' papers, finally settling on two makes that suit my style of painting. One is a beautifully textured handmade artisan paper made by the Two Rivers Paper Company in Somerset, England; the other is a more economically priced mould-made paper, Bockingford, again made in Somerset by St Cuthberts Mill Ltd. Both are excellent papers and a pleasure to work on.

PAINT AND PIGMENTS

Paintings are brought to life by the colour artists use. Colour can stir emotions, create moods, it can instil a sense of calm and stillness or dramatic excitement; it can create the illusion of space and distance, and although the tone often does all the hard work it's the colour that the viewer will notice first. Therefore the colours chosen are elemental to a painting's overall success and should be chosen wisely.

Watercolour paint comes in two grades: student quality and artist or professional quality, the student quality being cheaper than the artist quality and although student colours have improved over the years, artist colours tend to deliver better results. They often flow better, dry brighter and go further than those offered in the student range. Both are offered in tubes or pans. Tubes are preferable to pans when working in the studio as they allow for washes to be mixed more quickly and efficiently. However, when painting *en plein air* pans are useful as they are smaller and more portable compared to tubes. Whether tubes or pans are chosen ultimately comes down to personal preference, but if the budget allows, artist quality should always be first choice.

Paints, pigments and colour have particular characteristics and will be discussed later in the book.

Watercolour paints can be ordered not just by colour, but by several other qualities, including transparency/opacity, staining/non-staining, granulation, and lightfastness. Most manufacturers of artists' paints will give an indication on the tubes, pans, in colour charts or on their website as to the various characteristics of the individual colour.

Transparency and opacity

All watercolour paints will be transparent if enough water is included in the wash. However, some colours will produce a more opaque wash than others; they have a natural property towards opacity rather than to transparency, whilst others behave in the opposite manner. Drop some cobalt blue into a jam jar of clean water, and in a separate jar do the same with Winsor blue. You will notice how the cobalt blue clouds the water whereas the Winsor tints the water blue without it turning cloudy. The cobalt is more opaque than the Winsor blue.

Staining and non-staining

A staining colour is just that: it stains the paper often as a result of being a modern dye based colour and can be difficult to lift from the paper with damp brush or sponge. A non-staining colour can be lifted. An artist might choose to use a non-staining colour if they know that they want to soften the edge of a wash after it has dried with a wet brush or damp sponge. The wrong colour choice might make the lifting off almost impossible.

Granulation

Some colours when applied in a wash to watercolour paper will settle into the paper's valleys, producing a grainy texture. This effect is known as granulation. Ultramarine blue is a good granulating colour and I often use it when I want to add a texture to parts of the painting, for example when painting stonework in an old jetty.

Lightfastness

The paint's lightfastness gives an indication of how resistant the colour is to fading and change. Some colours will over time fade or even alter in colour. Alizarin crimson, if made from a particular pigment, is known to fade over time for example. Therefore, to know which colours might display this characteristic is useful to the artist, particularly so if they are exhibiting and selling their work.

Getting to know how colours behave individually, in mixes, whether they lift or if they granulate, whether they are opaque or transparent – all this information is vital to the artist's knowledge bank. For these colours and the way they react to one another on a physical level within the process of painting are often the reason behind success or failure within a watercolour.

Colour selection

Listed below is a selection of paints that I have used for the paintings in this book. All are artist quality from a number of suppliers.

Ultramarine blue: A rich granulating blue with hint of violet. When mixed with burnt sienna it produces rich, vibrant darks and useful greys. Transparent, non-staining.

Winsor blue (green shade): A wonderfully intense blue. Be careful as a little goes a long way. Transparent, staining.

NB: Winsor blue is available in two shades, green and red. Only the green shade has been used for the paintings within this book.

Cobalt blue: A chalky blue. Useful for skies and creating soft greys. Semi-transparent, non-staining.

Burnt sienna: A rich red brown. A useful colour on its own but also mixes well with ultramarine blue and cobalt in producing useful greys, particularly in distant land-scapes. Transparent, non-staining.

Raw sienna: Bright yellow brown. I often use it with cobalt blue for distant hills or moorland. Transparent, non-staining.

Winsor red: Bright, warm, intense red. Good for touching in details on boats to create interest. Semi-transparent, staining.

Quinacridone gold: Rich, dark yellow. Mixes well with certain blues producing vibrant greens. Dries quite pale in washes. Transparent, staining.

Cadmium red: Strong opaque red with a hint of orange, granulates well in washes. Opaque, staining.

Permanent rose: A soft blue red. One of my favourite colours, which when mixed with ultramarine blue gives a lovely purple. Transparent, staining.

Lemon yellow: Bright yellow, with a hint of green. I often use it as my under wash when painting trees. Transparent, staining.

Cadmium yellow: A strong warm yellow, with a hint of orange. Opaque, staining.

Viridian: Bright blue green. Often dulled slightly with the addition of a red or burnt sienna as it can be rather dominant. Transparent, staining.

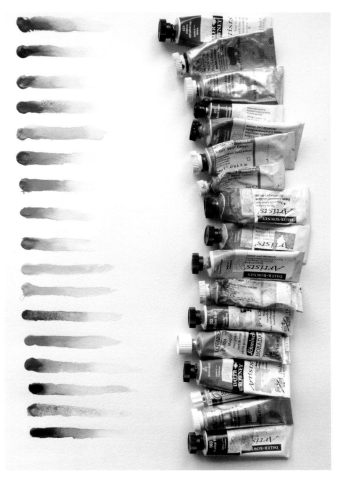

The majority of the paintings in this book have been painted from a selection of these colours. Although not an exhaustive list of colours that I have in my studio, these paints are the ones that I use the most often. I know how they work together, what mixes I can produce from them and the inherent characteristics of every individual colour.

May green: A bright yellow green. Semi-transparent, non-staining.

Green gold: Rich golden green. Mixes well with blues to produce an interesting range of greens. Transparent, non-staining.

Transparent oxide brown: A rich, warm lively brown. One of my favourites. Semi-transparent, non-staining.

Cobalt violet: A freely granulating violet. Works best in thin washes. Care should be taken if over painting as it has a tendency to lift. Semi-transparent, non-staining.

Neutral tint: A grey black that mixes well. Mixed with ultramarine or viridian it is a useful addition to the marine painter's palette. Semi-transparent, staining.

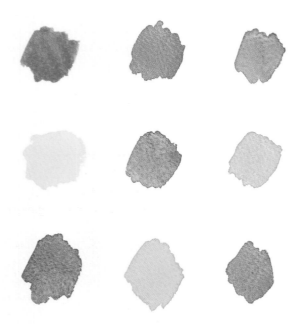

The first column shows permanent rose, lemon yellow and ultramarine blue as primary colours. The second column shows a mix of two primary colours, and the third column shows the colour created by mixing the colours in the row together. Varying the proportion of colours added to the mix will obviously affect the colour created; a bluer green will be created, for example, if more ultramarine blue is added to the lemon yellow rather than the other way around. Traditional landscape painters are more likely to work with tertiary colours in their palette.

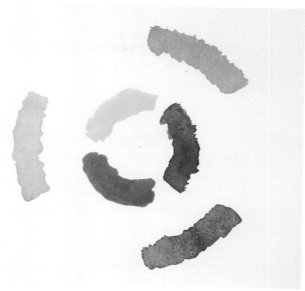

Colour circle.

It should be noted that the range of colours shown and their characteristics can vary between paint manufacturers and the watercolour paper used. Therefore it is advisable to spend some time getting to know how the colours you have within your palette behave and react.

In addition to the watercolours I will often use small amounts of gouache, acrylic ink and watercolour pencils when required. These are likely be some of the last touches to the painting, for example to restate a lost highlight or to add a lighter, brighter colour over a dark passage within the painting.

PAINT: SOME USEFUL MIXES

It is not necessary to have a scientific knowledge of colour, but a basic understanding of colour theory will prove invaluable when it comes to the planning of a painting and the mixing of washes.

Colours

Colour can be broken down into three groups: primaries, secondaries and tertiaries.

Primaries are colours that cannot be mixed by the combination of any other colours, secondary colours are created by the mixing of two primaries, and tertiaries are a mixture of a primary and a secondary colour.

Complementary colours

If the colours are set out in a circular pattern with the primaries at the centre and the secondaries arranged around the edge, notice that directly opposite the red lies the green, the yellow the purple and orange the blue. These combinations of colour are known as complementary pairs.

A working knowledge of how these complementary pairs can be used in a painting is extremely useful. For not only can complementary colours when juxtaposed enliven parts of a painting by their vibrant contrasts, they can also play a role in colour mixing by helping to create more useful colours for the artist to work with, in particular the landscape painter. If a colour appears a little too vibrant, try adding a small amount of its complementary to the mix to reduce the intensity of the colour. Painters often refer to this as 'knocking the colour back', producing a more workable, less energetic colour.

Useful Greens

Few colours, if any, seem to present so many problems to the watercolour painter as the mixing of greens – which, when painting landscapes, is very difficult to avoid.

The problem with green, I believe, is twofold: firstly, the mixing of the colour itself, and second, the overpowering effect that green can have over the rest of the painting.

Mixing greens

Being a secondary colour, a mix of the two primaries yellow and blue offers great scope to experiment by using various yellow/blue combinations. For example, a lemon yellow mixed with an ultramarine blue will produce a very different green from the same yellow mixed with Winsor blue.

Here I have mixed some greens from the different yellows and blues in my palette. Whichever combination you choose, it is best to start with the yellow and gradually add the blue. Note how the green alters as you gradually increase the blue proportion to the mix.

Look at the greens created; some will look brighter and less natural than others, and if these are used in a painting they are likely to overpower all other colours and unbalance the design of the painting.

Whereas some painters might be happy to work with these unnatural colours, the others will be considering how they can be altered to make them more believable, and this is where a knowledge of complementary colours proves useful. By adding a little touch of red, the complementary colour to green, notice what happens. The green begins to dull, become ever so slightly browner, resulting in a more nat-ural-looking green, which in turn is likely to prove of greater use to the landscape artist.

One area that seems to generate much debate amongst artists is whether to mix greens or to use ready mixed greens from tubes or pans. I have a foot in both camps, mixing my own greens and working from ready mixed colours. However, I never work with tube or pan greens without adding a little of another colour to modify it. Therefore I like to consider that all my greens are mixed to some extent.

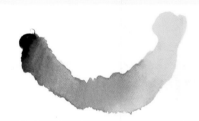

Winsor blue with lemon yellow.

Ultramarine blue with lemon yellow.

Cobalt blue with lemon yellow.

Winsor blue with cadmium yellow.

Ultramarine blue with cadmium yellow.

Cobalt blue with cadmium yellow.

Note how a touch of cadmium red introduced to a mix of Winsor blue and lemon yellow creates a more natural-looking green.

Introducing a little burnt sienna to a ready mixed green, in this case May green, produces a less vibrant, softer colour that is often more useful to the landscape painter.

A combination of ultramarine blue and burnt sienna produces a rich, useful dark. Notice the way that the colours have granulated out towards the middle of the mix.

Greys and useful darks

One the most useful mixes in watercolour, and one that I use over and over again is ultramarine blue and burnt sienna. It makes a lovely grey, a blue grey if more of the ultramarine is in the mix and a browner one if the proportion of burnt sienna is greater.

A useful dark can also be mixed from the two. Artists often find it difficult to mix a really good strong dark; a black straight from the tube is to be avoided as it can look flat and dries lifeless. Whereas a rich dark mixed from ultramarine and burnt sienna will have a depth to it that will be difficult to achieve from a tube colour.

To mix a good dark use plenty of pigment, but be careful not to add too much water as the mix will be weak and insipid. It might seem rather odd, but to mix a good dark I always use clean water; mixing with dirty water seems to reduce the dark's brightness.

BRUSHES

Brushes come in all manner of shapes and sizes, some with natural hairs, some synthetic, others a mixture of the two, and vary in cost from the very expensive to the not-so, and the somewhere-in-between. The choice can seem overwhelming, but it is perfectly possible to produce good paintings with just a small number of brushes; better to buy a few good brushes rather than many that are not so good! Although there are some good synthetic brushes available Kolinsky sable is still the choice and recommendation of many. A Kolinsky sable brush can be expensive, but it will hold a lot of colour, spring back into shape and point quickly. If cared for, it will be part of your painting kit for years to come; an investment worth making. If cost

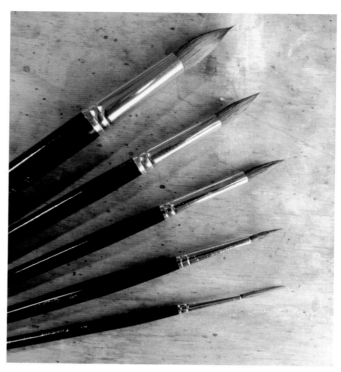

The majority of the paintings in this book have been carried out with the following selection of sable brushes: a No. 14 and 10 for covering large areas with a wash, a No. 8 for smaller wash work and some detail, a small pointed No. 4 for fine detail, and a rigger, useful for painting trees and grasses.

is an issue search out some of the sable synthetic mixes which offer good performance at a reasonable price.

Brush sizes are categorized by a numbering system, from 000 being a very, very small brush up to a whopping size 40.

Once you have a selection of brushes, play with them. Don't try to produce a painting – doodle with them, find out how they work. Get to know the varieties of marks that you can make with them, *all* of them; build a lexicon of marks that you become familiar with. For it is these marks that will bring life to your paintings. Find out what marks you can create if you hold the brush loosely and flick the tip across the paper's surface. What is the longest continuous mark that you can make without returning to the palette? By 'printing' with the side of the brush, what mark is created? How easy is it to spatter paint and what size of spatter is created? Does a pointed brush create a different mark to a flat one? Which brushes make a dry brush stroke most easily? Get to know what each brush is capable of. A brush can do so much more than simply fill in an area of the painting with a wash; it can and should be used as an expressive tool in its own right, capable of adding interest to the painting merely by the variations in marks created.

EQUIPMENT

Palette

Palettes vary in size and shape – square, round, rectangular and the traditional kidney shape. Some artists prefer a metal palette, others china or acrylic. But whatever your choice it should have sufficient space in which to squeeze out plenty of colour from tubes and deep wells to mix in.

Easel

Many artists produce excellent paintings without using an easel. A drawing board propped up with a couple of books on the kitchen table will do the job, but an easel gives the artist more flexibility. Certain effects, when painting in watercolour, are dependent on the angle that the board is tilted at. The steeper the angle, the more quickly a wash will run down the paper. To slow the movement of a wash, lower the angle of the board. Using an easel makes it much easier to control the angle that the board sits at.

In my own studio I'm fortunate to have an old, very heavy, engineer's adjustable drawing board that can take boards in excess of A1 in size. When painting on location I use a Herring Versatile easel, which is simple to erect, firm and takes an A2 board easily.

Sketch pads

A couple of sketch pads are essential in any painter's kit. They allow for quick drawings to be made on site and can be used in developing the painting back in the studio. A small one to be dropped into a pocket and a larger A4 will prove to be the most useful and both should be used at every opportunity. Get into the habit of drawing; not only will your drawing improve but so will your 'seeing', which will feed back into better paintings through better observation. Along with drawing pads suitable for pencil work I also have a few pads comprising heavy weight watercolour paper. These allow me to produce small, on-location watercolours without the paper cockling too much, which would be the case if I were to use the drawing pads.

Pencils

A good quality 2B pencil will be fine when sketching on location and indicating the initial drawing prior to painting. Anything harder than a 2B and it makes rubbing out difficult, and risks damaging the surface of the watercolour paper. When drawing, it is essential to have a sharpener to hand; use it frequently, as it is much easier to draw with a

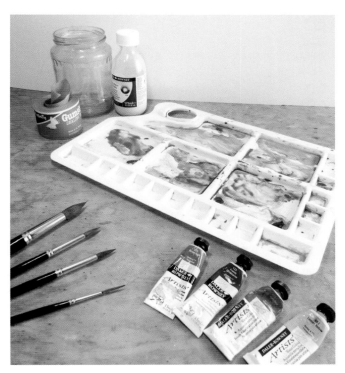

A selection of some of the most regularly used materials and pieces of equipment within my studio.

sharp pencil than a blunt one. A good quality mechanical pencil which offers a choice of leads is ideal as it does not require sharpening.

Masking fluid

The use of masking fluid in a painting often splits opinion, with some in favour of its use and some vehemently opposed. Masking fluid protects the paper surface from paint and by so doing it preserves the 'white' of the unpainted paper – a technique often used to create highlights and sparkles. If used sympathetically and with care it can have a positive impact on the final painting and I for one would not be without a jar of it in my studio. Application can be with dip pen, colour shaper, old brushes or even rolled up paper. Most of the paintings in this book have included the use of masking fluid during their production to a lesser or greater extent.

Painting boards

Strong painting boards are indispensable when it comes to stretching paper. Exterior grade plywood of no less than 13mm in thickness will suffice. Hardboard, thick cardboard or thinner plywood will not stand up to the pressure the paper exerts on the board when drying and will cause it to bow, rendering the paper useless to paint on.

Painting and Information – Gathering on Location

There is much to be gained in venturing down to the river-bank with paper, paint and pencils for a spot of sketching.

But be careful: don't take too much equipment with you. Not only will you have to carry it around all day, which can be both bothersome and tiring in equal measure, but you will be surprised how heavy a bag of unwanted equipment can become when you pick it up for the tenth time that day as you set off to look for other subjects to draw and paint. I'm sure in my early career I missed some inspiring locations as I ran out of energy and trudged wearily back to the car lugging a large bag of unused painting paraphernalia.

I try to take the minimum amount of art equipment when venturing out from the studio. Even if you are travelling to your painting location by car, at some stage you will have to pick up your painting kit and walk to your chosen spot. Over the years, therefore, I have reduced my outdoor painting equipment to the minimum: watercolour pad, two or three brushes, or even a single brush pen, a set of pan colours with built-in palette, collapsible water pot, pencil, sketch pad, eraser, kitchen roll, and water all neatly stored in a small ruck-sack that doubles up as a seat. All that's left to do is to pick up a camera or iPad, along with a lightweight easel if needed and I'm ready to go.

Clothing is particularly important when working on location. I don't like to get cold when painting; trying to hold brushes and paint with fingers numbed with cold, or shivering in the shadows when the temperature drops is not something I enjoy, nor is it conducive to good painting. By taking layers of clothing with me that can be taken off or put back on according to the weather conditions means that I can stay at a comfortable temperature, allowing me to get on with the painting. My wife knitted me some fingerless mittens years ago and these are always in my coat pocket when venturing out to paint, even in the summer months when a sudden change in the weather conditions can have me reaching for them gratefully.

In strong light, a hat with a wide brim is useful to shade the eyes and saves a lot of squinting. It might seem obvious but it is worth noting that sunglasses really won't help the painter! Decent shoes or walking boots are a must whatever the time of year but more so in the winter months when the ground becomes wet or icy and invariably slippery. I have also dis-covered that a stout piece of corrugated cardboard is useful to stand on during really cold weather, as it offers a degree of insulation from the coldness of the ground which otherwise seems to permeate from the feet upwards, particularly if you are standing in one spot for any length of time.

Don't forget to pack a few snacks as well as some cold or hot drinks, as these can add to the length of time you can spend out in the landscape painting or drawing.

Living and working on the edge of Dartmoor in south-west England, I am only too aware how quickly the weather changes from minute to minute. What starts out as a sunny, clear day can turn to a cold, rainswept wilderness in moments and many walkers and ramblers have been caught out by it, much to their regret. Therefore, if you are venturing out to places away from footpaths or to more isolated locations, it is wise to let family or friends know where you are proposing to paint and what time you hope to return. If you fail to return when expected then they can inform the relevant services.

Gum strip

Gum strip comes in a variety of lengths and widths and is widely available. Regardless of length choose the 46mm wide tape as it allows for adequate coverage of both paper and board when stretching.

Water pots

In the studio clear jam jars are the most suitable as they allow the artist to see how dirty the mixing water is becoming. Too often artists continue to paint with water that is so dirty it impacts on the colours in the painting – they become dull and lifeless – and this should be avoided. To keep the colours clean and bright, change the mixing water frequently: if you wouldn't put a goldfish in it, don't paint with it! Use at least two jars, one for mixing water and another for cleaning brushes, and change the water in both regularly when needed. Lightweight collapsible plas-tic pots are ideal when working *en plein air*, but remember to take a good supply of clean water with you and just as in the studio don't let the painting water get too dirty.

Cameras and tablets

Although the importance of drawing and sketching in gaining reference material can never be underestimated, more and more people are working with digital cameras and tablets. Both provide the technology to capture the

fleeting light effect in a landscape or a 'snapshot' of a particular scene that might otherwise prove impossible when sketching. Their benefit to the artist should not be underestimated and it is my own view that some of the greatest landscape masters of past centuries would have used them alongside their sketch pads if they had been available.

Tablets might have the advantage over digital cameras. It's not just that their screens are larger, making it easier to see what's on them, but they also offer the artist the invaluable facility of zooming in, on screen, to reveal more of the structure or detail in a particular part of the image – Something that is impossible to do with a printed photograph without going to a lot of time and expense. When trying to take photographs in bright sunlight their screens can be difficult to see, but I find that with practice, acceptable images are quite possible, even if at times it's a case of point and hope!

Working from sketches, photographs and tablets can lead to some successful watercolours and we will explore this later in the book.

Lighting

I much prefer painting in natural light and although not north facing, which is supposed to offer the most even of lighting conditions, my studio has a good-sized window that allows enough light to work by. However, this is not always the case – on dark winter afternoons or when working into the night, for example. Ordinary light bulbs will cast too warm a light onto the room, which makes the matching of colours difficult, particularly when moving from natural lighting to artificial lighting. At times like these I use my low voltage daylight lamps. These are colour balanced to offer similar lighting conditions to natural light, ensuring ease of colour matching throughout a painting session. They are easily adjustable, attach to both my engineer's drawing board and my studio easel without too much fuss, and although somewhat expensive are well worth the money.

Additional equipment

As you develop as an artist you are likely to gather various pieces of equipment and materials that you find useful when painting. This seems to grow over time and items are gleaned from some of the most unlikely sources; coffee shops often provide wooden stirrers and these make excellent tools for splattering masking fluid onto watercolour paper when painting crashing waves, the edge of old business cards can be used to print paint with and are ideal

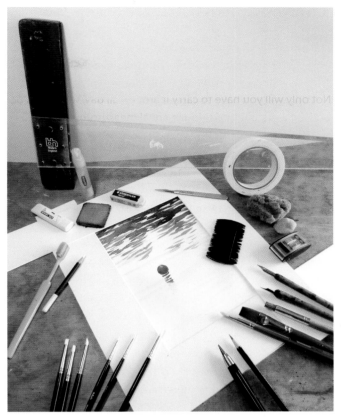

A collection of items that I have dotted around the studio that might not be used in every painting, but when necessary are vital and I would be lost without them.

when trying to depict mooring lines or the masts of boat seen in the distance.

A list of my 'extras' is always changing as I discover and try new things. However, looking around the studio today this is what comes readily to hand:

- Toothbrush for spattering paint or masking fluid.
- Colour shapers, although designed for blending pastel, are also ideal for applying masking fluid, especially as they are so easy to clean.
- Nylon masking brushes can be used either to create precise masked lines and areas within the painting or for flicking masking fluid onto watercolour paper.
- Dip or ruling pens used with masking fluid or paint can produce some very fine lines. Mooring ropes or the fine tracery of branches are both suitable subjects for pen work.
- A good quality rubber is essential. Choose one that is not too hard and removes pencil easily without leaving any marks itself.

- Scalpel, to scratch out highlights in paintings and to cut paper masks.
- Natural sponges, to lift colour or to apply paint. Try different sponges as they are all unique and painting with them will create different marks and textures.
- A 'nit comb', useful to comb out any dry masking fluid from masking brushes.
- Stencil brushes can offer some interesting foliage effects for trees and for spattering both paint and masking fluid. Old bristle brushes made for oil painting are also very useful.
- T square, for squaring up picture formats and horizontal horizons!
- Masking tape, low tack. It can be used to frame a picture prior to painting, which when the painting is finished can be removed revealing an instant 'mount' or for protecting areas of the painting without the use of masking fluid.
- Plenty of kitchen roll; I would be lost without this! It is useful not only for cleaning out palettes and mopping up spilt water, but also for lifting colour from the paper's surface, reducing the amount of watercolour held in a brush and for testing that the paint in masked areas is completely dry before removing the masking fluid.
- A spray bottle allows for water to be sprayed directly onto the paper's surface. If used to spray onto a drying wash it can create interesting textures and runs. It is useful to be able to add water to the painting's surface without using a brush.
- 'Ls': these are cut from old mounts, and are often available from your local framer. I find these useful to isolate parts of a photograph, drawing or painting to assess composition, design or progress when painting.

BASIC WATERCOLOUR TECHNIQUES

Washes

Watercolour is more often than not applied to the surface of the paper by way of the 'wash', a mix of paint and water introduced to the surface of the paper using a brush. The wash is one of the foundation stones of watercolour painting and is therefore one of the most important techniques to understand and master.

It takes time to comprehend the subtleties and unique effects it can offer the watercolour artist – for example, when to add water, when to add pigment, how to create strong washes – all, however, can be learnt through application and practice. Don't immediately rush to create your watercolour masterpiece; spend some time making friends with the wash. Work with it, watch how the colours move on the paper, how they dry, discover what happens to a wash painted on dry paper compared to one painted on damp. Play, watch and learn. The more you paint, the more you will be able to control the wash, not by bossing it around but by understanding it, working with it. You will become more attuned to its wants and needs. This knowledge and experience will make you a better painter.

Quantity of paint

There are few things more frustrating when painting in watercolour than running out of the wash mix mid-way through painting. It is worth mixing some puddles of colour in varying quantities in the palette and then painting these on scrap sheets of paper to discover the size of the area that can be covered with the different amounts. You might be surprised by how much paint you need.

Flat wash.

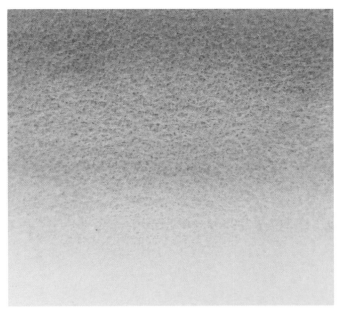

Graduated wash.

EXERCISES

As with any exercise, these are designed as learning opportunities. Even if they do not work out quite as expected they are still valuable, if you can analyse both why a particular effect has been successful, and conversely why it has not (the first in order to repeat it and the second to avoid it). The more you do, the more you will become aware of the conditions needed to create the chosen washes and desired effects.

The following exercises were all painted within 100 × 100mm (4 × 4 inches) drawn in pencil on stretched Bockingford 300gsm/140lb NOT with the board at an angle of approximately 20 degrees, using a size 10 pointed sable brush.

Wet on dry: flat wash

The flat wash should be exactly that: flat in colour with no streaks and a consistent colour and tone all over.

With a good puddle of colour in the palette, fully load your brush and stroke horizontally across the top of the square. Return the stroke in the opposite direction with the brush just touching the bottom of the first stroke. The strokes should flow into each other. Continue this down the square. If the brush begins to drag or the colour starts to run out, return to the palette and load the brush again. Avoid going back over a previously painted area as this might cause some streaking to the colour. This often occurs when the brush has lost its charge and instead of

laying colour down it begins to lift it off; this is a phenomenon often known as a 'thirsty brush' and is to be avoided.

Graduated wash

A graduated wash should change from dark to light evenly and with no stripes. Start with a puddle of colour, load the brush and sweep horizontally across the top of the square. Return to the palette and add a little clean water to dilute the wash slightly. Do this before each additional stroke as you move down the paper.

Wet into wet

The wet into wet wash is one of the most exciting and versatile of washes. It can create subtle blends of colour and tone with some interesting textures. When employing this wash technique it is not uncommon to work on damp paper. For this I use a large brush with plenty of clean water and paint it on the paper with the brush moving in all directions, the aim being to get an even coating of water over the paper's surface. I then leave it to allow the water to soak into the paper for a short while. The length of time that I leave it for depends on a number of factors – the type of paper, how 'damp' the studio is, whether it's a drying day with a light breeze and the studio window open – and it is therefore almost impossible for me to give a precise time. With practice you will soon be aware of when the paper is ready to accept colour and when it is not. Indeed watercolour painting can sometimes feel more about the water than the colour!

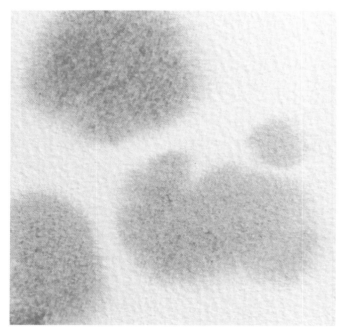

Mix two puddles of colour separately in the palette. With a fully loaded brush paint a few random shapes onto damp paper; leave a few areas of unpainted paper.

After cleaning the brush add the other colour. Notice how the colours mix and merge on the paper. Pick the board up and tip it, mixing the colours as you do so. Leave to dry flat.

Dry brush stroke

It seems rather strange at first to be writing about a watercolour brush stroke that's dry. But essentially that's what we are dealing with, a brush that holds just enough wash to make a mark. It is a really useful stroke for the artist to be able to use as it offers a variety of effects. The rougher the paper and the drier the brush the more pronounced the mark will be.

The easiest way to achieve it is to load the brush as if preparing for a wash and then blot off the excess paint using absorbent kitchen roll. Hold the brush at the end of the handle, keeping it as parallel to the paper as possible and scuff the side of the bristles over the paper. Try it first on some scrap paper; if the mark begins to fill in, then there is still too much liquid in the brush and you will need to blot some more away. Allow any dry brushed area to dry fully before adding any additional strokes; add these when still wet and the broken quality of the mark will be lost as the paint flows together, filling in the characteristic gaps left by the original stroke.

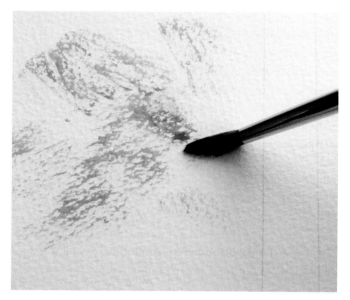

Dry brush stroke.

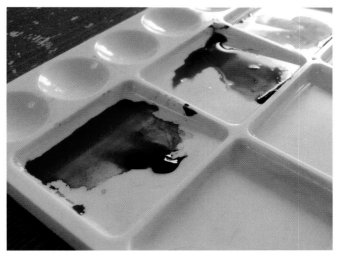

A deep welled palette makes it much easier to mix puddles of colours.

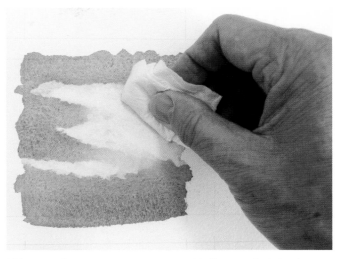

Lifting out when wet can create some useful effects particularly when painting skies to create cloud-like shapes.

Mixing colour

Whether using tubes or pans a good palette should have deep wells and plenty of space in which to mix the paints. Too small an area or too shallow a well makes it difficult to mix sufficient colour when painting a large area and can lead to colour matching problems if more paint has to be mixed mid-way through painting.

Lifting out when wet

A wet wash can be lifted or blotted out by using absorbent kitchen roll. This is a useful technique when creating cloud shapes. Paint the square with a graduated wash of ultramarine blue. Fold the paper towel into a chisel-like shape and lift the colour from the paper by blotting carefully. Keep folding the paper towel to present a clean edge or the kitchen towel will begin to print colour back onto the watercolour paper rather than lifting it off.

Natural sponges can be used instead of kitchen towel; they will give a slightly different result but are well worth experimenting with.

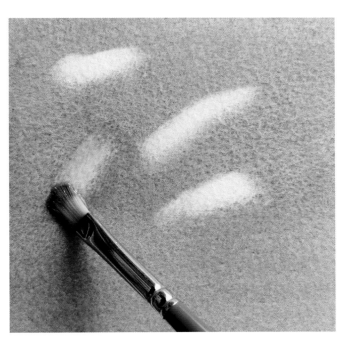

A stiffer brush makes the lifting of colour much easier than a softer one.

Lifting out when dry

The success of this technique relies very much on the type of paper and paints used. When completely dry the required area to be lifted is wetted with clean water and then gently rubbed with a suitable brush, lifting the colour from the paper. Any remaining colour can then be removed using kitchen towel. Note that if a soft, very absorbent paper and a staining colour have been used, it is likely that some colour will always remain.

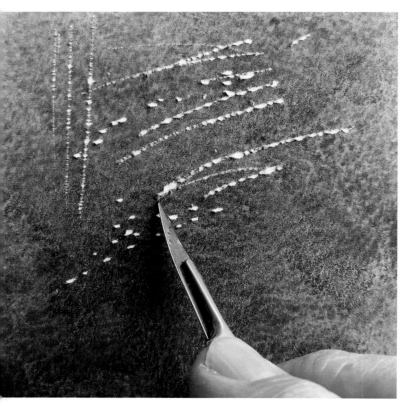

Scratching out: a really useful technique and one well worth practising.

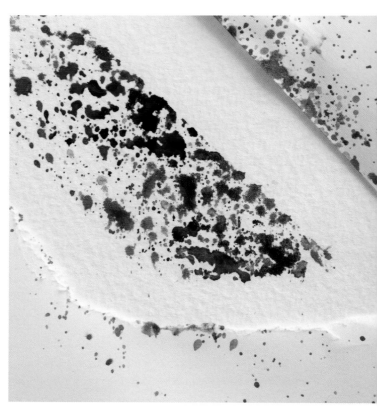

Torn or cut paper masks can protect areas of the painting from unwanted spatters.

Scratching out

With a sharp craft knife or scalpel it is possible to scratch back the colour to reveal the white of the paper. This technique tends to be employed towards the end of the painting as the surface of the paper will be damaged, making further applications of paint difficult. It is a useful technique for adding sparkles to rivers or streams and for indicating mooring lines from boats.

Spattering

The flicking and spattering of paint is an ideal way to create a variety of effects and textures, in foliage, moorland, beaches and stonework, for example. Its natural randomness is part of its charm and it is difficult to achieve this in any other way.

Mix plenty of paint and with a fully loaded brush tap it firmly against your hand. The paint should flick off and land in droplets on the paper. Leave to dry.

Textures can be built up with subsequent applications working from lighter colour mixes to progressively darker ones. Remember of course to let each layer dry before adding the next.

Spattering colour from the brush by flicking the bristles against your finger will create a different texture, as will using different types of brushes. When creating a texture over a larger area I use an old decorator's brush.

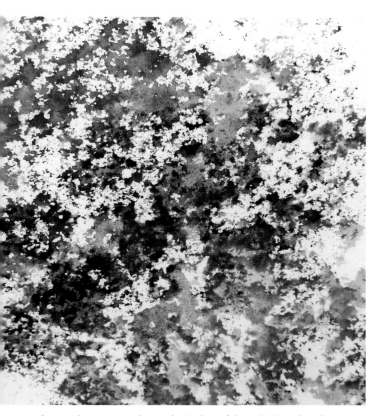

Sponged textures can be used to indicate foliage, brickwork and stone.

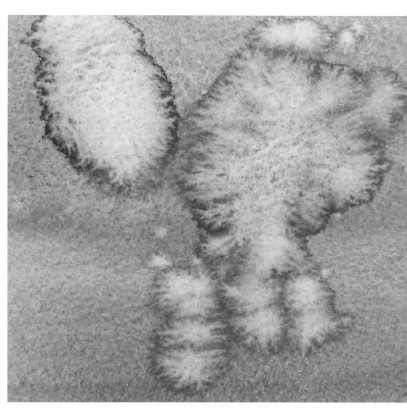

Cauliflowers are worth practising; by so doing the watercolour painter will know how to avoid them and how to create them when needed.

Sponge textures

As we have seen already it is not always necessary to use a brush when painting in watercolour. Using a sponge, natural or synthetic, to print or dab colour onto the paper's surface creates some useful textures and patterns. The different densities and characters of the more popular natural sponges create a variety of printed marks, whereas synthetic sponges have a more even, close-knit texture and this is reflected in the marks created.

A word about cauliflowers…

When more paint is added to a wash before it is completely dry the likelihood is that a back run will be formed: the new colour runs into the first wash creating blotchy, hard edges. This is often referred to as a 'cauliflower' as it resembles the vegetable. These tend to be accidental and are considered a mistake when they occur. The simplest way to avoid them is to allow the first wash to dry out completely before overlaying any further washes.

In my early days as a student of watercolour painting I was encouraged to avoid cauliflowers at all costs. But in recent years I have grown to enjoy them and now will often encourage them to develop in selected areas of my paintings to create a range of textures or effects, for example when painting cliff sides or rocks and boulders.

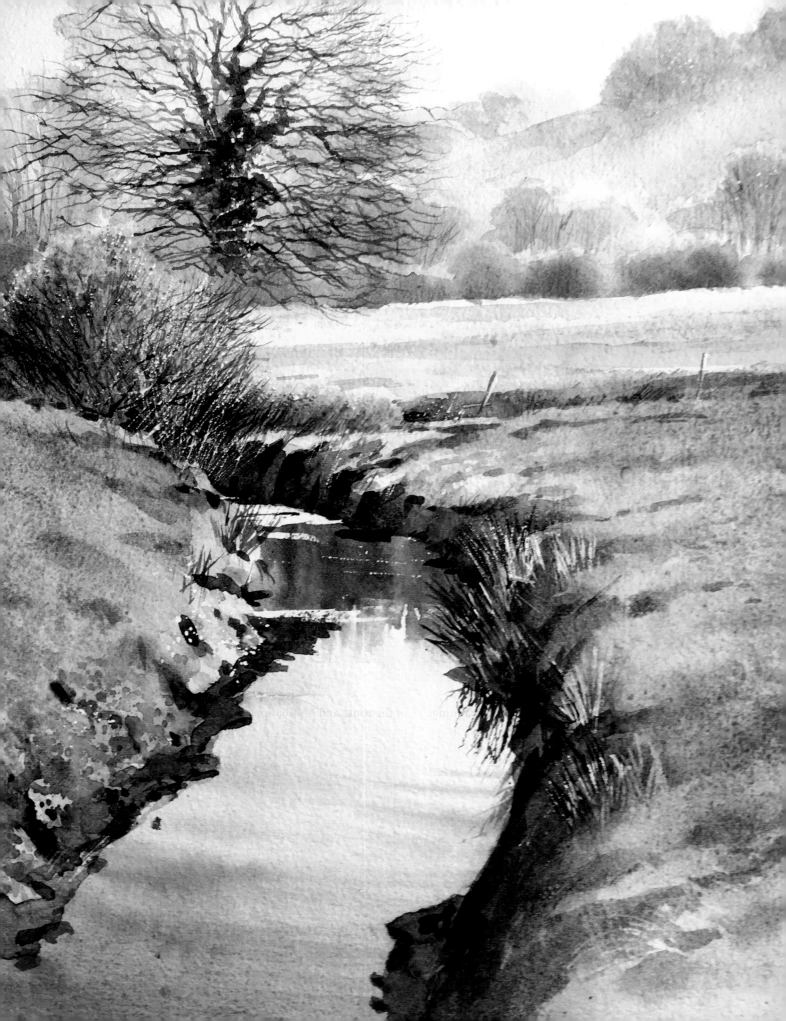

Objectives, Composition and Design – an Approach

When enjoying a slice of cake it might be possible to identify some of the ingredients and processes used, but is it possible to identify all of them? How many eggs have been used? Which flour has been used? How long was it baked for and at what temperature? These hidden ingredients and processes are vital to the cake's success. We might not be able to identify them easily, but if the baker had not included them or got the cooking period just right, the result would be a soggy mess. It's very similar when making a painting: although the viewer will see the colours, tones, shapes, textures, and so on, it's the hidden ingredients and techniques used that the artist must consider if the painting is to succeed. Forget to add or consider the hidden ingredients and the painting might end up like the cake – a soggy mess.

So what are the hidden ingredients in a painting? They are the parts of the painting that the viewer might not see or even be aware of when looking at the finished painting; however, they are real and identifiable. Just as a recipe has stages, so does the making of a painting. Note that I use the term 'making' a painting, not 'painting a picture'. It might seem a minor point, but one that can make all the difference in how an artist organizes their approach to the production of paintings. Paintings don't just happen – they have to be worked at; they are made.

Artists make paintings by carefully considering the various stages and processes that go together to create the finished artwork. Some stages are obvious, for example the choice of colours or placement of tones, but the hidden ingredients are of equal importance: paper choice, format, design and layout, variety of marks, amongst others. These hidden ingredients can have a dramatic effect towards the overall success of the painting. Fail to consider them adequately and their absence will stand out like a sore thumb.

When planning a painting I find it useful to break the process down into a series of carefully defined stages, from the initial idea to the finished painting, like the steps in a recipe. I'm sure many artists will want to go straight to the painting stage, which is entirely understandable; however, spending some time thinking and planning the initial stages before committing yourself in watercolour will result in a more focused, better painting in the long run. An analogy often used about painting is to compare it to a journey: these are often easier and more straightforward if the route and destination are planned in advance, rather than travelling aimlessly around hoping to find the destination as if by luck. In my experience this seldom happens.

Stages to consider are:
- Inspiration and focus
- Sketching and information gathering
- Planning
- Painting

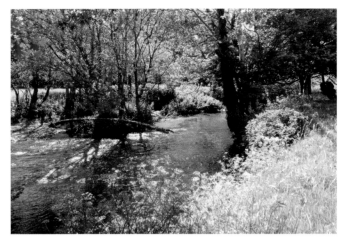

Reference photograph for the painting *Summer Shallows.*

Note in the photograph how a fallen tree arcs over the front of the islet. I chose to leave that feature out from the painting. I felt that it would dominate the composition by its inclusion, taking interest away from the focus of the painting. Photographs are useful to the artist, but they should be considered as a way of gathering information; as starting points rather than destinations.

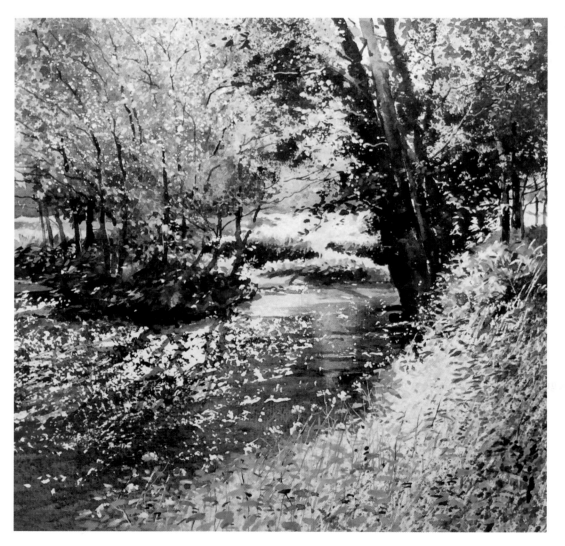

Summer Shallows.

INSPIRATION

Find your focus

Many people will have been struck by the beauty of a scene, or will have reached for a camera or phone and snapped the view; indeed, some will only see the view through a lens or as pixels on a screen and won't actually look at the scene in reality. As an artist it is hoped that you will both 'look' and 'see'. You will note the way that the colours of a tree reflect in the water, how the light shimmers in the shallows or note the way the bright orange of a buoy casts colours on the hull of a boat. All can offer inspiration to the artist. But it would be wrong to rely solely on inspiration when making a painting without considering *why* you have been inspired. What is it about the scene that interested you? What caused you to stop at that point?

For example, when out sketching in the meadows by the River Erme my attention was caught by the way that the shadows cast from the trees fell across the river shallows. This was my inspiration, and my subsequent design decisions when planning the painting supported my choice of focus. If I had simply painted the scene without any regard to what had attracted me to the view, then the result would more than likely have been a rather aimless, disappointing watercolour. Finding your focus is one of the most important stages when planning a painting.

When on location spend some time looking at the scene. Don't rush into drawing too quickly, but take a few minutes to look and see what's there. How does the light affect the view in front of you? What colours can you see? How does the scene make you feel? Listen to the sounds. Only then start to think about drawing. Get into the habit of carrying a small sketchbook and pencil or pen around with you, and take every opportunity to use it. You will be surprised how quickly your drawing and observation will improve if you use it regularly. The drawings do not have to be worthy of the old masters or so good that they could be hung in the National Gallery: they are for you, and don't have to be shown to anyone else. But their impact on your painting will be invaluable, for as you develop your drawing, so your seeing will also improve and this will feed back into your watercolours through better observation.

SKETCHING AND INFORMATION GATHERING

Once you have decided on your inspiration, and what the painting is going to be about, it's time to get all the information together ready for the planning. It is obvious that the sketchbook has an important role to play at this point. However, so might an iPad, smart phone or digital camera.

Artists have worked on location when painting for many years, *en plein air*, and many fine works have been created; look at the *Haystack* or *Rouen Cathedral* series of paintings executed by the leading French Impressionist Claude Monet (1840–1926). Others have worked in the landscape, drawing and producing field sketches to take back to the studio and from these have produced the finished paintings. Both methods have much to recommend them. My preferred method is to gather as much useful information as I can on location – sketches, colour notes, photographs, even written comments – and to bring these back to the studio where I can spend time working from them, using all the gathered information to produce more finished paintings. I find that this method of working back in the quiet of my studio allows me to concentrate fully on what I'm doing, particularly when producing larger more complex pieces. My materials and equipment are readily to hand and I don't have to keep one eye on the weather or inquisitive sheep!

Sketching

One of the phrases that I use constantly when tutoring or running workshops is, 'we draw to see, and photograph to record'. When we draw we are actively engaging and reacting to the scene in front of us. We notice things as we draw and, as we record and refine these in our sketchbooks our visual knowledge broadens and this will feed back into our finished paintings.

Sketching is the time to 'get it down'. Don't worry about producing a finished drawing, produce instead a useful drawing, a drawing (or drawings if the time allows) that is full of useful information. Information about the scale and proportions of objects, where the light is coming from, how shadows are falling, anything that will be of benefit when it comes to planning and making the painting back in the studio.

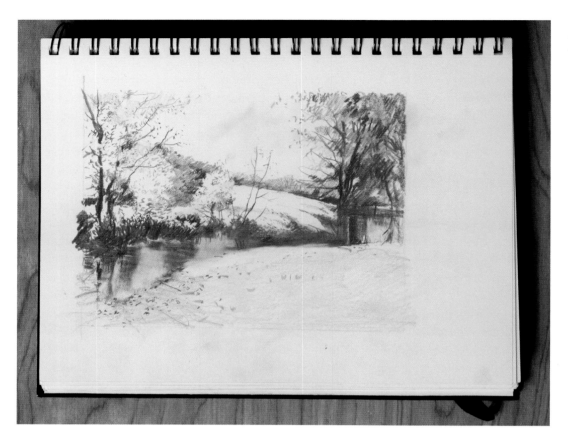

Quick 2B pencil sketch of the River Erme in one of the many sketchpads that I have and use regularly.

Have I done enough drawing? This is a question I'm often asked by students. Knowing if you have drawn enough is something that will come with experience. But one trick that I have used to good effect when working in the landscape is to turn my back on the view and look at my drawing as if back in the studio. By working around the drawing, I analyse all parts of it, trying to make sense of what's on the paper. Is it useful? What's going on in that corner? Have I got the proportions correct? If it's confusing or lacking in information, turn and draw some more until the drawing is useful.

Why turn in the first place? If you don't turn you are more likely to glance up at the scene before you, rather than assessing what's really going on in the drawing.

Annotated drawings

I recall drawing one November afternoon in an isolated corner of Dartmoor. It was quiet with very little wind and I was really engrossed in sketching a little stream that had caught my attention. Suddenly the silence was broken when from close by a fox called, giving me quite a shock. I recorded the occurrence by writing a brief note on the drawing, 'Fox barked', and continued to draw. When I used the sketch and other paintings made at the time some months later to produce a studio piece, I was surprised how those scribbled words brought back the emotions I had at the time and how useful these strong memories were in shaping my approach towards the painting. Since then I have included written notes in some of my sketches and drawings as it often adds an extra layer of feelings and memories to draw on when making the painting.

In this pen drawing I included some tonal and colour notes that would prove useful to me when working back in the studio. Don't forget that the sketches and notes are for your benefit; they don't have to be shared or shown to others.

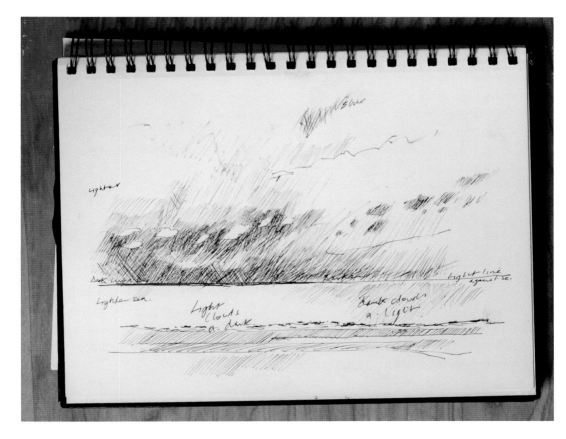

Cameras, iPads and smart phones

Many artists seem reluctant to admit that they use photographs in the production of their work, thinking that it is some form of cheating. But not to use them would seem to me to be missing a wonderful opportunity. I for one would not be without my photographs when making my paintings, using them alongside my drawings and sketches.

When taking photographs for a painting it is always better to think of taking useful photographs rather than snapshots. Snapshots might be all right on a family holiday but the images you take as an artist should be taken with a specific purpose in mind.

When drawing we can be selective in what we choose to include or what we choose to pay closer attention to. A camera takes what's in front of it, with little if any selection. Point the camera towards a bright section and detail can be lost in the rest of the image; point at a darker section and the lighter area will lack information as the camera tries to compensate for both light and dark areas. How often have we heard that the camera never lies? Well, it might not lie, but it will often distort the truth, quite literally with some lenses! Some lenses have a very wide angle and take a very broad view of the scene; some

seem to squeeze distance when zooming in. All lenses appear to distort to a lesser or greater extent, so it would be unwise to rely solely on photographs to work from. As long as we are aware of the camera's shortcomings, its use can still prove to be a valuable asset as the artist gathers information.

When working in the landscape I will often come across a scene that I feel has the makings of a good painting about it. Perhaps it is a cloud's reflection in the river, a boat just leaving its moorings, cows wading in the shallows, or any of a number of interesting things. The effect might be fleeting and within moments gone for ever. This is the time I reach for the camera. I am able to record the changing scene quickly, taking as many shots as I can in the time available; I zoom in and pick out specific details, or take a number of shots framing the main area of interest. As the moment passes and is lost, I reach for my sketchbook and begin to draw, safe in the knowledge that I already have some useful information stored in the camera's memory. The sketchbook/photograph combination is a good approach in gathering information and is invaluable at the planning stage of the painting.

Recently I have started to carry around an iPad in my sketching bag and have used it as much as my camera if not more. The screen is much larger than my camera's, and although in strong sunlight it can be difficult to see precisely what I am photographing, with practice it is possible to achieve some good results. It also has the added benefit of being able to zoom in and out from the image to see details more clearly without having to wait for the images to download to the computer to view them.

I have begun to use my iPad and smart phone back in the studio when painting, to help me check on how my watercolour is progressing tonally. By simply taking an image of the work in progress and converting it to grey scale I am easily able to assess how the tones are working within the painting, making it far easier to adjust as necessary.

A note on colour in photographs and screenshots

I'm often confronted with students on courses or workshops showing me photographs or screen shots and bemoaning the fact that they can't match the colours they can see; the colours in the paintings are wrong because they aren't exactly the same as those in the photographs. But why try to match the colours? If the same image was given to ten people and they were each asked to download and print them, the results would be ten photographs of the same images, but all ten would show different colours. Different printers, inks, papers and settings would contribute to the different colours. So which colours are correct? I would argue that none of the colours in a photograph are 'correct' and therefore there is no need to match them. The artist should use them as a guide; the only 'correct colours' are the ones that work in the painting.

PLANNING

In order to be certain to cover all the parts that make up the 'planning' stage, I have broken this down into smaller sub-stages:

* Content
* Format and design
* Style
* Paper
* Tone
* Colour

Content

What is the painting about? This question is likely to have been answered right at the start of the painting process. It is linked to the initial inspiration and is linked to what you are trying to communicate to the viewer in the painting. Be clear about what you are trying to say.

Format and design

The size and shape of the painting is known as its 'format', the most common being landscape, portrait, square and maritime format (sometimes known as 'letterbox' or 'panoramic'). Within the chosen space the artist must arrange the mix of the visual elements into a pleasing and balanced design. This is not simply about the placement of objects, but arriving at a satisfactory arrangement of tone, colour, texture, movement, scale and directing the viewer's eye around the painting where you, the artist, want it to go.

When producing a landscape it is generally considered wrong to divide the painting in half at the horizon, as this often leads to an unbalanced, unsatisfactory painting. Although it can be made to work I prefer to avoid this imbalance, dividing the painting into three equal rows and columns – the rule of thirds, as it is often called. This allows me to place one third sky and two thirds land, or vice versa, for a layout that sits proportionally better within the overall design. The four intersection points are also useful when placing areas of interest as they occur away from the edges of the painting and reduce the likelihood of them 'falling out' of the image.

Using the sketches and photographs as reference, now is the time to try out and experiment with different formats and layouts until you arrive at the composition that balances all the required elements and sits comfortably on the paper.

An increasing number of digital cameras use the same on screen 'thirds' grid and it is also widely available as an app for iPads and smart phones, the benefit to the artist being that even at the very early stage of information gathering through photography, some thought can be given to layout and design.

High and low viewpoints

When in the landscape notice how the view is altered when sitting compared to standing. From a higher vantage point you will see further, the horizon will drop and the sky will be more dominant, increasing the sense of space and openness. When sitting you won't see as far, the horizon drops and the foreground begins to take on more prominence with a greater emphasis on textures and detail. The scene becomes more contained and compact, presenting a more intimate feel. Take some time to consider how different viewpoints can alter your design and the sense of space and openness that they create.

Open and closed compositions

As you plan and design your painting, experiment with open and closed compositions. A closed composition tends to keep the viewer's eye within the painting. The eye moves around the painting but rarely, if at all, out of it. An open composition emphasizes the sense of space, the viewer moving around and often out of the design implying a space beyond the edge of the painting. Open compositions are useful when suggesting the expansiveness of a wide estuary, whereas the closed composition is likely to be better choice when in amongst the moored boats at a marina.

Horizontals, verticals, diagonals and curves

A painting can often be broken down into a series of simplified shapes or directional elements: horizontal, verticals, diagonals and curves. By skilfully arranging these shapes the artist can direct the viewer's eye around the composition. Horizontal elements tend to move the eye across the picture plane, verticals upwards; diagonal or curved lines take the viewer into or through the painting, creating a sense of distance.

Perspective

Perspective is a subject that seems to send some people's heads into a spin! Eye lines, vanishing points, two-point and three-point perspective – it seems full of complications. But it needn't be. Treat it as a guide, as a way of pointing a drawing or painting in the right direction. Having a working knowledge of perspective will be of use when it comes to the placement and setting out of manmade or natural features in the painting's design. Get it right and objects will 'sit' correctly, almost unnoticed by the viewer; get it wrong and the mistakes will be glaringly obvious.

However, as previously stated, perspective should be used as a guide. When drawing or sketching out prior to painting, my main concern is accurate observation. When drawing a building I am aiming to produce an accurate image, a drawing of a building that would stand up, not one that appears on the edge of collapse with the walls leaning precariously or the roof moments away from slipping off. An understanding of perspective helps me to check the accuracy of my observation, to make certain that my walls stand and my roof is attached. As one of my painting tutors at art college was keen on saying, 'Draw accurately, and the perspective will be there before you know it!' He was correct, but by using perspective as a guide, accuracy is more easily achieved.

Style

Which subject an artist chooses to paint, how it's painted, the colour, tone and detail all contribute to what might be called the artist's 'style'. It is something that an artist arrives at often after much work. Time spent looking at the work of other painters is always useful; it can offer different approaches to similar problems in, say, the depiction of foliage or reflections. This study of other paintings can often be a springboard in the development of the artist's own style. However, there can be no simpler way to develop a style of one's own other than just painting as often as possible.

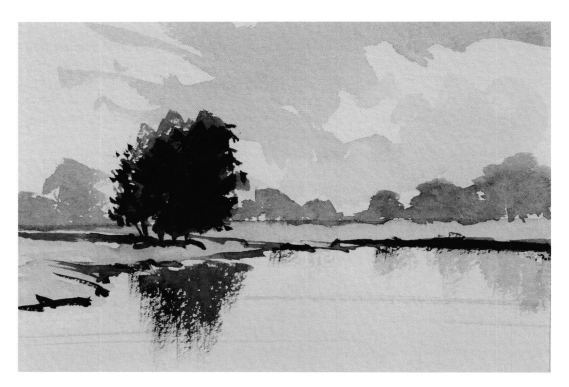

Tonal sketches of the River Stour near to Flatford Mill and the estuary at Pin Mill. These sketches do not have to be highly finished, but they make the planning of a painting much easier.

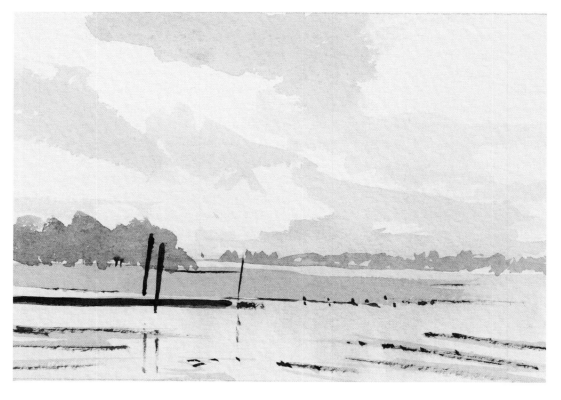

Paper

Which paper to choose to work on is down to a number of factors. A rough paper will make it difficult to produce a crisp, precise line as the paper is too bumpy, whereas a smooth paper will make such a mark easier to execute. Some papers allow for a wash to float on the surface longer than others, making certain effects much easier to produce. If masking fluid is to be used then selecting a paper compatible with its use is important. I would recommend trying a variety of papers until you find the one, or ones, that offer the most suitable characteristics for the paintings that you want to paint.

Most of the paintings in this book have been produced on Bockingford 300gsm (140lb) NOT or Rough, and Two Rivers NOT 300gsm (140lb).

Tone

The tonal arrangement, the lights, darks and greys in between, is one of the most important aspects of a painting's design. The placement and relationship between these tones can, if well placed, give a dynamic impact to any painting. I prefer to use a broad tonal range in my work, with some strong darks and bright lights, often juxtaposed for maximum effect. Using a limited range of tones with too many similar greys produces a limp, insipid painting and should be avoided.

Painting a simplified tonal map of the proposed painting using just one colour (a blue is good for this) is useful in seeing how the tones work together in the painting. An iPad or camera phone can be useful at this point: take a photograph of the image, convert it to black and white on screen, and assess the progress of the tonal arrangement at any given point.

A painting that works in black and white, tonally, is more likely to lead to a successful painting when carried out in colour.

Colour

There is an old saying in the art world: 'tone does all the hard work in a painting, but colour gets all the praise', and it would be right to say that colour is certainly one of the first elements that the viewer will notice, and therefore the choices made are critical and should be carefully considered. The artist needs to think about how the colours will interact, what mood or feeling they will convey, and whether to use a limited palette or a wider range of colours. They should also pay careful attention to the physical characteristics that the colours chosen can offer – another of the hidden ingredients that goes into the making of a painting. Some colours, even when dry, can be lifted from the paper with a damp brush, while for others this will be almost impossible to achieve; opaque colours will offer different effects compared to transparent colours; some paints will granulate, thereby adding texture to the painting, whereas others will stain and create little or no texture. The artist who understands how to control and use a paint's particular qualities will open up a wealth of possible techniques and effects that will lead to more interesting paintings.

PAINTING

The final act is to paint the picture. With all the decisions made during the planning stages, all that is left to do is to produce the watercolour. Some might think that this amount of planning takes the spontaneity away from the act of painting; I would argue the opposite, for by carefully planning we are able to enjoy the painting process knowing that much of the hard work has already been done in the preparation.

Developing a personal approach to planning

It might seem a lot to think about when planning a painting, but this 'planning checklist' has proved very useful over my years as a painter, with some of the stages becoming so familiar to me that I'm not always aware that I'm considering them. In the step-by-steps included in this book, I have tried to highlight some of my key planning decisions and offer an insight into the reasons for making them. However, with practice, most artists will develop their own checklist and order of elements to consider when planning and making paintings; mine are offered only as a guide.

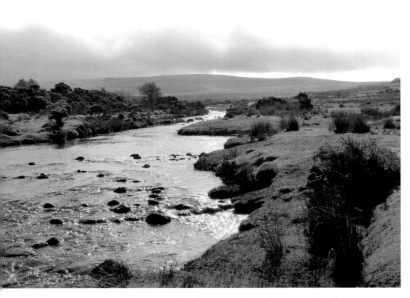

The light bouncing off the chattering River Plym was what first drew my attention and caused me to reach for camera and sketchpad. When the sun shone so did the river, but as can be seen from the photograph the clouds loomed large and would often obscure the sun from view. At times like this the sketchpad/camera combination can be the artist's best friend when gathering information.

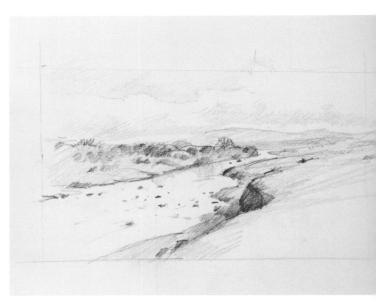

Location sketch for the painting *Just up from Cadover*.

JUST UP FROM CADOVER

This depicts what was a particularly chilly day in the upper Plym valley near to Cadover bridge on Dartmoor. The river at this location is quite shallow but flows swiftly and chatters loudly over the pebbles and stones. It is quite a wide, flat valley with large skies and, with an ice cream van parked near to the bridge just downstream, is often full of families enjoying the river and the stunning scenery. But not on this day: it was bright with spring sunshine but the wind reminded me that winter was still hanging on and still had a sting in its tail. For the best part of two hours I was the only person there, enjoying the day with a pair of mewing buzzards high above me my only company.

Although Dartmoor has a history of tin it was the silver river that drew me to that place. The effect that light has on the landscape or water is often the focus for paintings and this watercolour is no exception. The spring sunlight sparkling brightly on the river shallows and the bend in the mid-distance attracted my attention and became the key focus features of the painting.

Back in the studio, working with photographs and sketches, I developed the design of the painting with a slightly elongated landscape format. I felt this would help to emphasize both the expansive feel of the landscape and the width of the river valley at this location on Dartmoor.

The course and shape of the river leads the viewer's eye towards one of the focus features, the sunlit bend in the river. There is contrast between the dark of the bank and the light of the river, with a touch of burnt sienna adding to the strength of the focal point. Consider it as a kind of visual reward; if the eye is led somewhere, make sure that the journey is worth it!

Both areas of the focus features – shallows and river bend – were masked in order to preserve the lights. In order not to detract from the focus features the detail on both banks was kept to a minimum, the bank to the right painted with broad, loose sweeps with the direction of the brushwork describing the fall of land.

The central tree and its reflection is useful in bringing a little verticality to a design that is largely made up from horizontals and strong diagonals. A well balanced design should have a mixture of horizontal, diagonal and vertical elements. Care was taken to make certain that the position of the central tree's reflection accurately matched what was above it. Use a T square or ruler to check both object

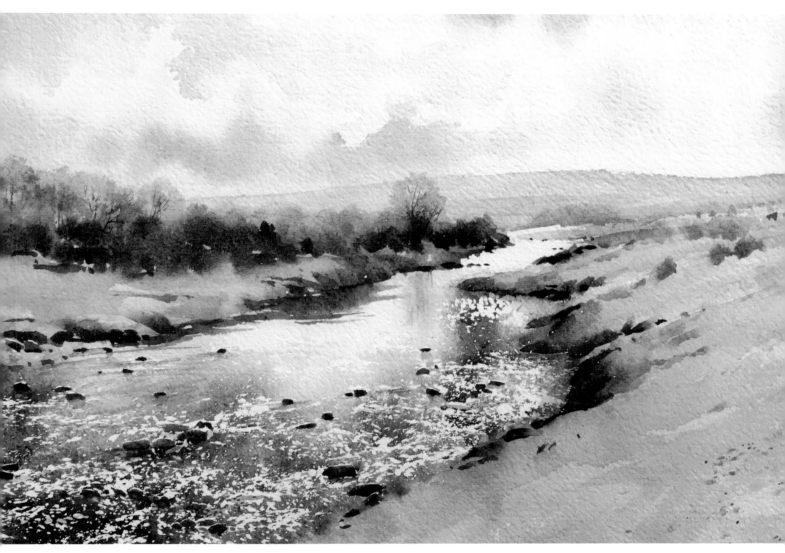

Just up from Cadover. Paper: Two Rivers 300gsm (140lb) NOT.
Size: 25 × 47 cm (10 × 18½ inches).

and reflection line up, as any discrepancy between the two will likely lead to a less-than-convincing portrayal of water, and the success or failure of a painting often hangs on these seemingly small considerations. On their own they might appear rather insignificant in the overall scheme of the whole painting, but get too many wrong and the accuracy and authority of the painting will be questioned in the viewer's mind and like a house of cards it can all come tumbling down.

Painting in harmony with the medium

Painting in watercolour for me is a real joy; watching colours mix and merge on a sheet of handmade watercolour paper still thrills me after over forty years of painting. I wouldn't like to count the number of paintings that I have produced over those four decades. The more I paint, the more I am convinced of and led by one guiding principle: to get the best from the medium it is essential to understand how and why watercolour behaves as it does.

This insight allows the artist to paint in harmony with the watercolour, creating if you will an air of cooperation between painter and paints. This empathetic approach will lead to greater control in all aspects of the watercolourist's art, and will in turn lead to better paintings. Trying to make the watercolour behave or perform in a way that it doesn't intrinsically respond to often leads to disappointing, muddy or insipid paintings.

For example, watercolour needs water. Trying to paint with too little water restricts the possibilities that the medium offers; colours will not blend and the painting seems forced. The potential of the medium is confined, lacking in life. However, by working with the correct amount of water the paint and all its possibilities seem to be freed. Colours flow more easily, the transparency of the medium is retained, and the paint looks livelier, resulting in more exciting paintings.

Getting to know which colours lift more readily than others can influence where and when you might use them in a watercolour. Use them too soon in the painting and any subsequent over washes can lift them, which in turn can muddy the new wash, resulting in a loss of the medium's delicate luminosity and transparency. When applied at the correct painting stage, with no further washes to come, these easily lifted colours can add texture and bring interest to the chosen passages of the painting.

This harmonious approach to panting does not rest solely on a thorough knowledge of watercolour paints and pigments, vital as that is. Clearly many other factors come together when painting: choice of paper, the angle that the easel is set at, even the warmth and drying conditions within the studio or out on location – all these will have an influence on how the watercolours react. These factors will make some effects possible whereas others not so; paint will dry slightly differently, brush strokes made moments before will now be almost impossible to achieve. The more you do, the more you will become aware of the watercolour's wants and needs.

This depth of understanding will make it much easier for the artist to control and work with the watercolour, which will make painting if not quite effortless then at least much easier for the artist.

Happy accidents

If you paint in watercolour it won't be long before you discover or hear of the 'happy accident'. This is when something occurs in a watercolour, something that wasn't planned but nonetheless works, at times even improving the painting. It might be the way that two colours react together, creating an unexpected mix, or the shape of a brush mark that describes the fall of a shadow across a stone perfectly. Stand back and enjoy the moment, then investigate how or what has happened to cause the 'accident'. Perhaps it was the water pigment ratio in the wash, the colours chosen or the level of dampness in the paper.

Analyse it; why was it so successful? Could it be used in other parts of the painting? Try to reproduce it.

Unless you can discover how and why the accident occurred there is nothing happy about it, and you might as well call them 'elusive accidents'. They are only 'happy' when you understand how they came about and are able to recreate them.

Mind the gap!

One of the questions I am often asked when tutoring or demonstrating is how much detail should a watercolourist put into a painting? This is not an easy question to answer, as it depends very much on what the painting is about. A loose, stormy seascape full of dark threatening clouds will likely call for a different level of detail from that of a tight, precise watercolour of flaking paintwork on an old door.

In my own paintings I strive for a balance between looser passages alongside passages that are slightly tighter, but without being overworked. Detail often equates to overwork, or over-emphasis, and is something that I try to avoid.

In an attempt to avoid overworking especially in the tighter parts of the painting I try to get the viewer to finish some of the painting for me. I don't mean that I am prepared to hand them paints and brushes and let then get on with it – far from it. I get them to finish the painting for me in their head.

Look at the shape on the following page. Some will declare it a circle, but is it? Look again, more carefully: it is not. It is a line, a line that doesn't meet; there is a gap, there is no circle. It doesn't exist.

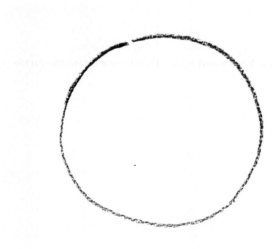

What do you see?

Figure exercise.

Sketching by the River Thames at Wallingford, and while my wife demonstrated to the local art group, I spotted a keen angler. Carefully, so as not to disturb him and the fish, who seemed to be avoiding him anyway, I took the opportunity to sketch him. These impromptu sketching opportunities are to be seized upon. I had and still have no plans to include an angler in any of my paintings, but if I decide to at any stage in the future then I already have some useful reference sketches.

However, with the gap as narrow as it is, our eye will likely fill in the missing section, the circle will appear complete, our eye will order and make sense of the information as best as it can. It will perceive a circle. The gap is as important as the line: what is not there is as important as what is there. Both need each other to complete the circle. It's rather like what happens when we look at an optical illusion, and the brain is tricked into perceiving a reality that doesn't exist.

Achieving the balance between what is there and what is implied is something that I constantly consider when I'm painting. By painting just enough to allow others to interpret and complete various passages within the watercolour, the possibility of over-working areas of the painting is lessened.

Look at the figures. They lack finer details – there are no fingers, feet or facial features, just the essential elements, simply presented. There is the right amount of visual information for the viewer to complete the studies. How do we assess how much information is enough to fill the gap and find the circle? There is, and you have probably guessed it by now, no better way than by drawing, in both paint and pencil.

If possible, work from life, being prepared to accept that you might not finish the drawing as the person walks away mid-session, the boat sails or, as happened to me on one occasion, the tree is felled whilst being drawn! Set a time limit, work no larger than A5 and use one colour. Fill a sketchbook or two with these studies; the more you do the easier it will become to pick out the essential elements that go together to make object, scene or figure understandable.

The Colour of Water

The painting of water is one of the most demanding and complex challenges that any watercolour artist can be presented with. It can be both exciting and frustrating trying to capture this constantly changing element, changed by light, weather, reflection and movement. Yet within this challenge lies the charm of the subject, for when a successful depiction is achieved the excitement of the reward is worth the effort.

Having painted waterscapes for many years, I am still captivated by how a colourless transparent liquid can seem to be so full of colour. Where does the colour come from? The most obvious way is through the effect of reflections from the sky or surrounding objects. But It can also appear to take colour from the ground it flows over, from the depth of water itself; even particles of impurities suspended in it will influence and contribute to the water's apparent 'colour'.

When trying to paint convincing-looking water the artist needs to consider all these factors; however, the single most important factor by far is in the artist's depiction and handling of reflections. The more accomplished and credible these are, the wetter the water will appear to be.

It is worth considering at this point what we are looking at when we see a reflection. Often we will view reflections from parts of objects that we don't see directly. When observing the arches of a bridge as it spans a river, for example, it is likely that we will see more of the underside of the arches as a reflection rather than through direct observation as this part of the structure will be hidden from us. The closer we look, the more we will realize that reflections have a visual complexity and beauty all of their own.

Notice how much more of the arch is visible in the reflection, rather than through direct observation.

A good reflection is not merely the copying of an object seen upside down in the water. The reflection should be treated as a separate element in its own right, with its own set of colours, shape and tone influenced by the reflected object.

This lovely little dinghy was being picked out in the strong morning sunlight and was just crying out to be painted. Within the reflection, note the difference in colour and tone compared to the object and the degree of fragmentation.

Reflections on still water

I have often been approached by students with a photograph showing a mirror-like reflection of a landscape or imposing country house, asking me how to paint it. The image is turned upside down and around several times to, I suppose, show how the reflection is exactly the same as the object. 'You can't tell which is which, can you?' Well, actually you can. The reflection is not a static mirror; there will always be some movement even on the calmest of days, ruffled water from a passing breeze or the ripples from a jumping fish. Look closely at the reflection itself, and analyse it carefully. Note that the colours will be slightly muted compared with those of the object, often with a green-grey cast to them; darker objects will appear to reflect slightly lighter, and lighter objects slightly darker. Reflections close to the object will appear sharper, almost perfect, but further away this effect will lessen as the reflection begins to fragment as a result of the water's movement. When examined closely the reflection becomes obvious.

Reflections on moving water

Water is a moving, reflective surface, full of angled facets that will have a distorting effect on any object's reflection, and the best way to learn how to depict reflections is to observe, study and record them. Drawing what we see will always add to our understanding and prove useful, although a series of photographs can be particularly valuable: not only do they allow the artist to study the reflective effects at their leisure but any movement will have been stopped by the camera's action. By breaking down the reflection's apparent movement into a sequence of still images it's much easier to assess the shapes and patterns they make and to include them in subsequent paintings.

Through observation you will notice that the reflections

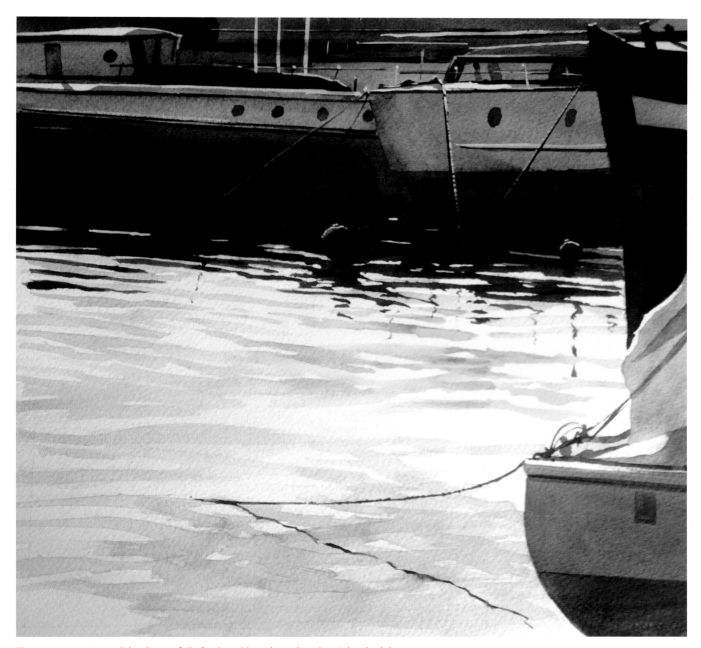

The sun was setting and the sky was full of reds, golds and purples when I sketched the beautiful River Deben one summer evening. The sky reflected the same colours into the water, their brilliance enhanced by the reflected darks from the moored boats.

closer to an object are more defined; further away from the object, and with the effect of the water's movement more pronounced, the reflection will appear to fragment and break up. A mooring post emerging from the water, for example, will reflect what appears to be quite a solid reflection at the point where the object enters the water; further away the post will appear to fracture into many pieces. The more movement in the water, the more the reflection fragments. Drop a stone into a reflection and watch the effect the ripples have on it. The reflection can appear to lengthen or shorten depending on the ripples' movement; areas of dark can be punctuated with light and light areas with dark. The stronger the ripple, the more pronounced these effects can appear.

River Stones and Ripples

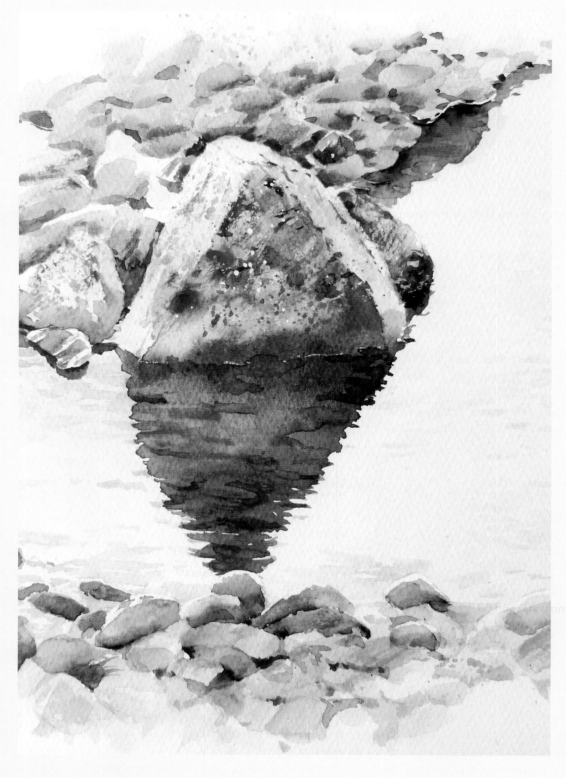

The depiction of water through paint can present the water-colourist with a series of seemingly unsolvable problems. How do you paint a life-giving element that in the same stretch of river can appear to be as transparent as glass yet as reflective as a mirror? As with so many things in painting, the successful depiction of water lies in careful observation.

Spend time looking at a stretch of river and you will appreciate the problems: clouds, overhanging trees, boats reflecting off the water's surface, yet within a short distance water turns from mirror to transparent glass, with the bed of the river clearly visible. The realistic depiction of water is a challenge but with practice and perseverance it is surprisingly achievable.

The painting *River Stones France* illustrates the problems and the opportunities presented to the artist in equal measure. On a rather overcast day in a little French town, I wandered down to the river's edge to see what was there. Noticing a triangular shaped stone I moved closer to have a better look.

When there I was struck by how, in the vicinity of the stone, I could clearly see through the shallow water to the bed of the river. It was almost as if the water didn't exist, so clearly did the stones and pebbles stand out. I found this intriguing, as either side of the main stone almost nothing could be seen of the river bed.

The reason was relatively simple: from the angle that I was looking at, directly below the stone where the reflection of the sky was blocked by the shade of the stone, the water appeared transparent, making the river bed plain to see. However, on either side where the stone was not blocking the reflection, the sky prevails, this reflection effectively preventing the view through the water to the river bed.

It is a useful effect to be able to paint when trying to depict convincing-looking water and the first step in trying to achieve this is by observation. The artist must spend time looking at the subject; it is something that cannot be rushed. Make notes and sketches, take photographs, and gather information.

Pay particular attention to the tones, the level of detail both above and below the water, the strength of colours and the level of reflectiveness. All need careful assessment. It is only through this investigation that the artist will learn to paint what is there, rather than what they believe to be there.

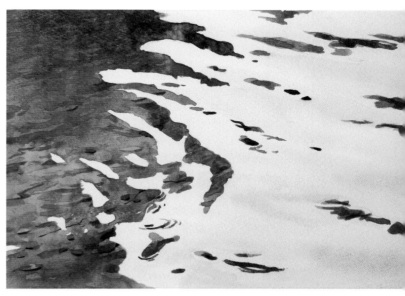

Somerset Ripples.

Notice that if the water is cloudy or muddy, its reflective qualities lessen. Strong shadows can also reduce the amount of reflective information to be seen. This is most evident in shallow water, where in the shadowed areas more of the river bed and less of the reflections will be visible.

Ripple patterns and reflections

The reflective quality of water is a constant source of wonder and inspiration to me: how a transparent liquid can at times seem completely impenetrable and as solid as hammered metal.

On a bright summer's day I sat by a tree-lined river in Somerset and watched how the ripples moving across the water's surface affected its transparent quality. One moment the ripples' passage revealed the river bed; the next moment the river bed was hidden when the sky was reflected – a case of 'now you see it, now you don't'. It's not that the ripples are turning the water from transparent to opaque, it is that their movement is having an effect on what can be seen.

Ripples are really just shallow troughs moving across the water's surface. The observer sees only the reflective face of those troughs turned towards them. This in turn results in the sky being reflected in some of the ripples and the overhanging trees in others. From the angle at which I was looking at the river, where the ripples reflected the trees, blocking out the sky, I could see to the bottom of the river bed, but across the rest of the water, in the ripples

and calmer stretches the sky was clearly reflected, reducing the water's transparent quality to practically nil and making it appear almost impossibly solid.

On closer observation of ripples it will be seen that verticals are more easily made out across the water's movement, where horizontal elements are less so. Think of how masts or mooring posts stand out as reflections whereas horizontal details are often lost in the water's rippled movement. Including this phenomenon in paintings can create a more convincing-looking representation of reflections, and in turn, the water.

No two minutes – or even two seconds – are alike when painting moving water, although recurring patterns are not uncommon. At this point on the river, the ripples were moving slowly away from a small waterfall, following a distinct pattern, and as their energy dissipated this gave way to calmer, slower moving water; the water's movement had a rhythm and shape to it. Getting to know the river's rhythm greatly assists when trying to capture it in paint. Placing a mark or shape that is different from the water's rhythm can make it stand out discordantly from the others and create the wrong type of attention.

Light on water: masking fluid

When people ask me what I paint I have a simple answer: light, and the depiction of light on water in particular. The sparkle of sunlight in the shallows or the shining light on wet estuary mud fills me with excitement and never fails to inspire me. Sit me by a little known creek on a dropping tide in full sun with paints and paper and I'm in my element. But how to capture the effect of the dazzling white of the light in watercolour has always been a challenge, and is one to which I constantly return.

The placement and consideration of colour, the strength of tone, and contrast between lights and darks, are of utmost importance when attempting to produce light-filled watercolours. Having too narrow a tonal range will make a painting look insipid, lacking any impact. A good range of darks and bright lights is essential, and to keep the white of the paper free from any unwanted colour I protect it with masking fluid.

I like to paint quite loosely in the initial stages of a painting, adding structure and detail towards the end. The first washes can be quite free with lots of water and colours mixing and merging on the paper. Sometimes the whole sheet can be dripping with paint and I don't want to have to reserve the white of the paper by carefully painting around small, intricate shapes; can you imagine how difficult it would be to capture the myriads of sparkles on a river scene if employing that method of watercolour painting? Therefore I use masking fluid to protect the unpainted paper. This allows me to paint freely over the masked area knowing that the white of the paper is safe; when dry I remove the masking fluid to reveal the white of the unpainted paper, which creates the sparkles, the light.

Planning with masking

As is so often the case in watercolour painting, planning is the key to success and the use of masking fluid is no exception. Too often, less experienced painters will approach the use of masking fluid as if it were fairy dust, randomly sprinkling it onto the paper with little thought of placement or outcome, hoping that something magical will happen; it won't, it needs careful planning.

The tonal arrangement of the painting, the lights and darks, will already have been decided at the planning stage. The lightest parts are often where the masking fluid is applied, thereby protecting the white of the paper from any washes and maintaining the lights. In most cases the masking fluid is applied before any washes are painted, so it is essential that the artist is clear from the start where the lights are and what needs to be protected.

The use of masking fluid, when used with care and consideration, can produce some wonderful effects in the finished painting. Bear in mind that the marks created initially when applying it are likely to be the marks that you end up with on its removal. Badly applied masking fluid will stand out like the proverbial sore thumb; if its use is blatantly obvious then this is likely to lessen the success of the finished painting. The aim is to use it, but not be seen to have done so! Try to make it part of the art work, not apart from the art work. To achieve this I consider the masking fluid as a paint in its own right and use it in the same way that I would when applying any other wash or painted mark, affording it as much consideration. This approach leads to a more homogeneous set of marks and effects, which results in a cohesive painting where the use of masking fluid doesn't scream out but sits comfortably within the artwork.

Consideration must also be given to the stage in the painting when the masking fluid needs to be both applied and removed, as both actions can have drastic implications on the overall success (or otherwise) of the painting. Masking fluid should only be applied to dry paper.

Paper

Masking fluid should dry on the surface of the paper, not soak in and dry. Therefore the 'hardness' of the paper needs to be taken into consideration. Too soft a paper and the masking fluid will dry 'in' the paper, making the removal of it difficult and more likely to tear the paper's surface. It is wise to test the paper that you propose to work on in order to assess its suitability before using masking fluid.

Viscosity

I always decant the masking fluid that I'm going to use into a small glass jar or saucer to discover how runny it is. If it's too thick or lumpy it can prove very difficult to use effectively; fine lines and small marks would be almost impossible to create. If this is the case add a few drops of water and mix it until it is the same consistency as single cream. Masking fluid with this viscosity is the most useful and much easier to work with. Add the water carefully: too much water and the masking fluid will be of little use. Add a drop at a time and mix between drops.

Application

Masking fluid can be applied with a variety of items and instruments. In the studio I have collected many sticks, pens, old brushes and the like that I use for applying the masking to the paper. The means of application should be dictated by the required mark on the painting once the masking fluid has been removed. I would at this point like to offer a word of caution when applying masking fluid with a brush. I would avoid using a good synthetic mix or quality sable to apply masking fluid. I was once told that any brush could be used to apply masking fluid; the person telling me waved a sable brush before my eyes insisting that although the brush had cost many pounds, masking fluid hadn't affected it, as long as it was washed thoroughly. He was wrong: the brush had lost its point, was stiff with dried masking fluid near to the ferrule, it was a mess and would make painting almost impossible – the phrase 'bad hair day' came to mind. Better to use a brush specifically designed for the purpose. These are normally made with nylon bristles and even then, before

Colour shapers, originally designed for the blending of pastel, are ideal for applying masking. The rubber tip can be cleaned easily, and they come in a variety of sizes with a variety of tip shapes; fine lines and interesting marks are possible across the range. Dip and ruling pens all offer the possibility of very fine lines and can be used when painting mooring lines or lit boat parts.

use I dip them into soapy water to make the masking fluid flow more easily and to reduce the risk of it drying on the brush.

I also have made numerous 'sparkle brushes' over the years. These consist of round bristle type brushes, normally associated with oil or acrylic painting. These are forced into the bottom of a small jar so that the bristles fan out from the ferrule in a circle and just enough masking fluid is added to keep that shape when dry. I leave this brush to dry overnight and with fresh masking fluid I 'roll' the brush onto scrap paper several times, letting the masking fluid dry on the brush each time. Slowly a series of 'petals' from the brush develop until it resembles a rubber daisy. I then use this to apply masking fluid where required with a rolling action which mimics the light catching a wave top, or the light catching the directional flow of water as it cascades down river. Never cleaning the brush allows the petals to develop and it evolves its own personality over time. I find the marks created seem more natural and random. Remember each time you use the brush, however, to check the marks that it will make on some scrap paper.

How to Make a Sparkle Brush

I have been making these sparkle brushes for many years now and find them invaluable in my painting.

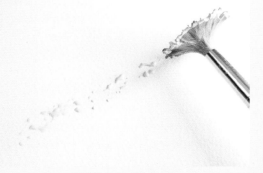

Step 1: Use a round bristle brush suitable for oil or acrylic paint. Any size works but I find the No. 10 the most useful. You will need a small glass jar or saucer and some masking fluid. Force the bristles firmly down into the jar or saucer so that they spread out evenly from the ferrule.

Step 2: Pour a small amount of the masking fluid on to the bristles until they are just covered, paying particular attention to the edge of the bristles. Leave to dry. This can take a few minutes (I often twist and stick a piece of masking tape to the brush and jar to hold them in place). If, when removing the brush from the jar the bristles begin to close up, push it back down and wait a little longer.

Step 3: When completely dry, dip the edge of the brush into fresh masking fluid and roll it across some scrap paper. You can do this several times. It's important not to clean any of the masking fluid from the brush; let it dry.

As the masking fluid builds up from use, it begins to resemble a daisy flower with groups or individual 'petals' being created from the masking fluid. When rolled onto watercolour paper the petals deposit the masking fluid in a series of small marks. For the best effects roll the sparkle brush quickly over the surface of the paper; it will bounce slightly. If you use too slow a roll, the 'petals' can drag the masking fluid, leaving a series of short, unwelcome lines.

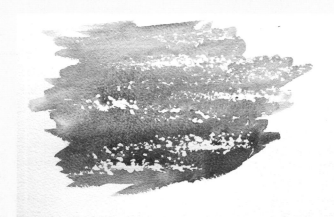

As with all brushes, spend some time playing and practising with the sparkle brush, finding out what marks you can create. Remember: as it's never cleaned the brush will grow and develop, and as a consequence the marks created every time it is used will be different from the time before. Therefore it would be worth trying out some test marks on scrap paper.

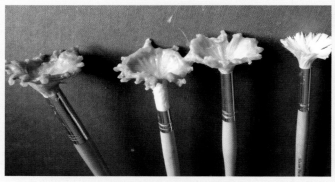

I have created a range of sparkle brushes that vary greatly in size depending on the amount of use they have had. As the brushes grow, so the size of marks created by them also increases and their scale in relation to the painting needs to be carefully assessed (the larger marks working more proportionately with larger images). As they evolve with use I find it necessary to produce newer ones on a regular basis, which enables me to produce marks that are better suited to smaller works.

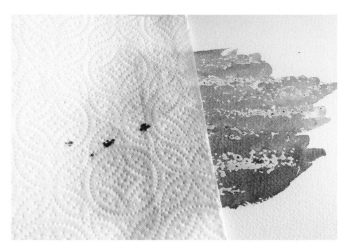

Don't be in a hurry to remove the masking fluid before checking that it's safe to do so.

Removal

The removal of masking fluid should be treated as carefully as its application. The first thing that should be checked is that the paint is bone dry and that there is no risk of smearing paint over the unpainted surface you have worked so hard to protect. I often rest a piece of kitchen roll over the area to check its dryness; any areas still wet will bleed onto the roll and I will have to wait a little longer before removal.

It is perfectly possible to remove the masking with nothing more than a little rubbing with a clean finger. But there is also a slight danger that the oil from our skin can transfer to the paper and over time affect it. To prevent this I use a masking fluid removal block to gently rub the masking away.

AUTUMN ON THE YEALM

Autumn can be a spectacular season for colour. Ask people to name the colours of autumn and they are likely to come up with a list of reds, oranges, yellows and golds. Many would argue that it's the most colourful of all the seasons; as an artist I might challenge that, but it certainly has a very different palette from that of the other three seasons. The rivers can appear to be full of all the colours of autumn – to witness the reflection of a blue sky and a hillside full of golden trees is a painting waiting to happen.

I like the bright colours, strong light and rich purple blue shadows, and I tend to search them out when drawing and painting. One might think therefore that I would be in my element, but I find autumn one of the most challenging seasons in which to paint and the reason behind it is all the colour. Don't get me wrong: I really enjoy them, but they can control the painting if the painter doesn't control them. The dramatic colours of the season seem to vie with each other for attention, almost shouting to be heard, and that can make the balancing of the composition and design within the painting something of a challenge.

My approach is to play down the strength of the colours slightly, knocking them back with a little of their near complementary colour within the mix, and to look for the overall shapes rather than the individual detail.

In *Autumn on the Yealm*, the stand of trees running down the hillside to the river's edge has been considered primarily as one overall shape rather than a series of individual trees. These were painted wet into wet with mixes of green gold, quinacridone gold, burnt sienna and ultramarine blue, the burnt sienna acting as the complementary within the mixes. As these washes began to dry, further defining details were picked out with additional washes and more structural marks: trunks, shadows, and smaller groups of trees. These autumnal colours were taken down into the river reflections, which themselves were complemented by the purple shadows on the riverbank and the range of blues in the river.

The focal point is the small fishing boat, again using the strong complementary pairing of blues and oranges, with the strong diagonal leading the eye towards it.

Note how the white sail towards the right-hand side of the watercolour gives both a vertical element to the design and acts as a stopper, keeping the viewer's eye within the border of the painting.

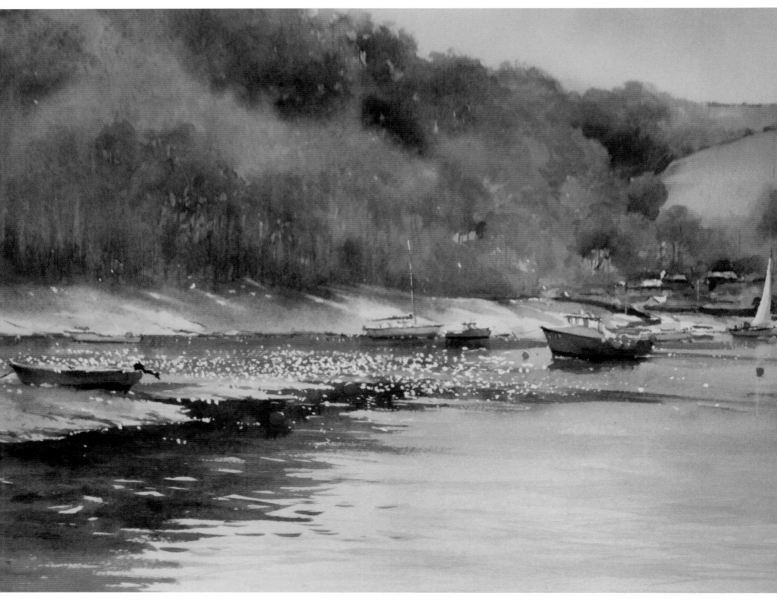

Autumn on the Yealm. Paper: Bockingford 300gsm (140lb), Rough.
Size: 68 × 50 cm (27 × 20 inches).

TOWARDS NOSS

Some of the of the joys of autumn are the bright reds, yellow golds and rich purple blue shadows. Here at Bridge End in south Devon where a small stream flows into the river Yealm the dramatic colours bring an intensity to the scene, the yellowness of the morning sun emphasizing the yellows and browns of the autumn and bringing a sense of energy and life to the river.

Faced with such a view it didn't take me long to start sketching and taking photographs. The decision about inspiration and focus was quickly arrived at: the painting had to be about the light and the colour. I made a note of the colours, not in the traditional way of working up some coloured sketches, but by painting some patches of colour in my sketchbook, more like the paint swatches one can get from a decorating shop or interior design company. With the light and the colours changing so quickly, this

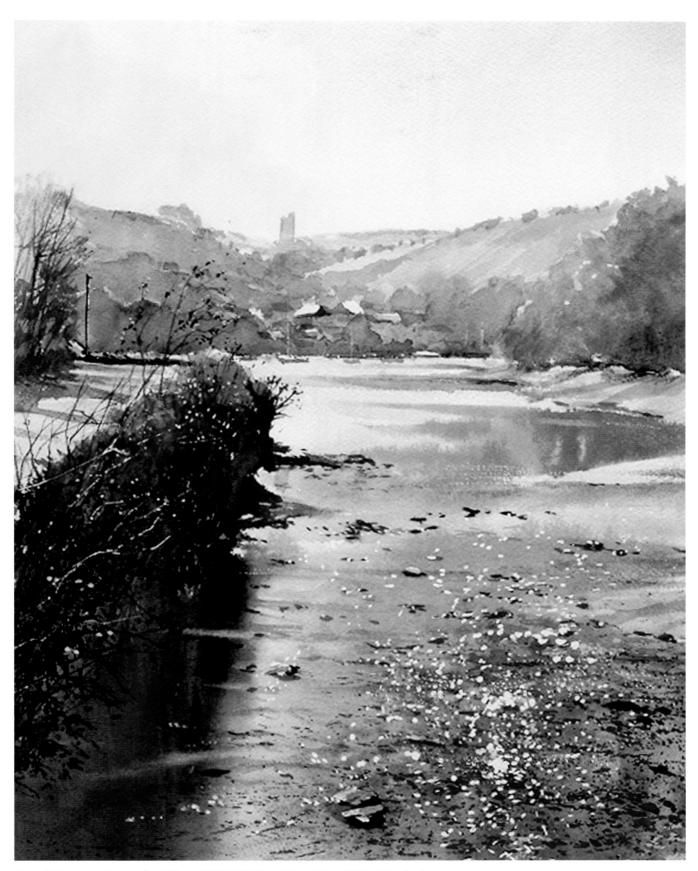

Towards Noss. Paper: Bockingford 300gsm (140lb) NOT. Size: 31.5 × 43.5 cm (12½ × 17 inches).

swatch approach allowed me to work at speed, recording what I saw without having to make a sketch, which would have taken too long to complete before the colours changed completely.

After some quick thumbnail sketches I settled on the painting's portrait format and use of diagonals within the design to force the viewer's eye to move up and through the painting, coming to rest on the focal point – the distant church.

The village in the distance below the church tower would have to be painted with a series of simple shapes, with little if any detail. This was an important decision and contributed much to the success of the painting. If I had painted the houses with so much detail that the viewer's eye was drawn to them, inspecting every tile or window frame, then they would be likely to see the painting as about the riverside village rather than a painting about a river and the brilliance of autumn colours. This might seem a case of pure semantics but it can change the whole feel and emphasis of the painting.

The balance between detail and focus within a painting should always be carefully considered at the planning stage.

Don't think that the painting of the 'simple shapes' I refer to when painting the village are just random, irregular shapes; they are most definitely not. For the shapes to be believable and interpreted by the viewer as houses or roof tops they have to have an authority gained through accuracy; this accuracy can only be achieved by two things – observation and drawing. Carry a sketchbook and use it regularly. The more you look, the more you see; the more you draw, the better you'll be.

The same applies to the boats, again simply painted with little more than a short horizontal mark and a slightly longer upright. It takes confidence gained through observation and practice to paint simply, knowing when to rely on one well-placed mark to do the work of ten, or appreciating when a few more might be needed.

The context in which the marks are used are almost as important as the marks themselves in describing the object being painted. Consider the position and the context that the boats have been painted in: they are clearly on a river, so what else could a short horizontal mark and a thin vertical be in that context, other than a boat? Give the viewer the right amount of information and the right place and they will complete the painting for you.

Tonally the background is much paler compared to the foreground; this contrast in tone helps to pull the foreground forward and push the hills and church tower back into the distance. The darker foreground in the river and on the bank also allowed me to create some contrasting lights; both by scratching out and protecting the paper with the use of masking fluid. This gives a real kick to the painting and is especially useful to describe the intensity of the autumn sunlight.

THE ERME IN MARCH

For a very brief period in the early spring until the trees burst into leaf, the overall colour palette within the landscape can resemble that more commonly found in autumn, as was the case when I ventured down to the banks of my local river to make some drawings one chilly March morning. I was expecting the bright vivid greens of spring to be all around me but the greens were more muted, much subtler in colour. I had expected, or assumed, that certain colours would be present, but on closer observation I discovered a completely different palette. Add to this the shallowness of the water, revealing the golden brown of the river bed, and the colours that I had expected to encounter on this bracing spring morning were very much absent. The only areas where the greens were more spring-like were the bank and the field in the middle distance. Once again the importance of direct observation had proved its worth and would feed into the planned painting giving the work a more authoritative feel to it.

To paint based on a series of pre-conceived ideas will always lead to poorer paintings. It is always better to observe and paint rather than to paint what you believe to be there; observation leads to better, more convincing paintings. These unexpected colours of both the trees and the river became the inspiration and focus for the watercolour *The Erme in March*.

The painting relies on a balance of geometric shapes and strong tonal contrasts. The diagonal shape of the river leads the viewer's eye from foreground to mid-ground, towards the focal point of the barns glimpsed through the trees; the trees provide the strong verticals within the design. Note how the size of the trees reduces as they recede further into the painting. This is important as it helps to create the illusion of space and distance within the painting (larger means close; smaller means further away). The strong darks in the trees and their reflections juxtaposed with the lighter passages give reference to the brightness of the day. The colours chosen are worked primarily around mixes of green gold, transparent oxide brown and quinacridone gold, reflecting the observed colours that I had noted when on location.

I chose to work on a heavier weighted paper than I normally work on, in this case a Two Rivers 630gsm (300lb) handmade paper. The surface had a lovely rough texture that would complement perfectly the techniques that I wanted to employ, especially for the reflections in the river. The paper was so heavy and hard sized that, rarely for me, I decided not to stretch it. My chosen techniques for this particular painting would use less wet wash work than my normal method and having used the paper before I felt that it would perform extremely well with the demands that I would place upon it with little if any cockling. Therefore I deemed stretching was unnecessary. Even so I held it securely in place on the painting board with masking tape around all four sides.

One of the key points to focus on when painting a watercolour such as this is the level of finish. There should be a degree of rough, untidiness about it, particularly in the trees and depiction of the river and its reflections. Too neat and tidy, and it would look out of place – this is the countryside, not a well-kept formal garden. The marks need to be made quickly, with conviction and vitality; too slow and the work will lack energy. Aim to convey an impression of the scene, a painterly response rather than a leaf-by-leaf copy.

STEP BY STEP DEMONSTRATION

The Erme in March

Paper

- Two Rivers 630gsm (300lb) handmade paper
- Size: 37 × 32 cm (14½ × 12½ inches)

Materials and equipment

- 2B pencil
- Masking fluid
- Nylon masking brush
- Colour shaper
- Pointed sable brushes, size 10, 8 and 4
- Fine rigger
- Flat ¾-inch brush
- Palette
- Kitchen roll
- Masking tape
- Scrap paper

Artist quality watercolours

- Lemon yellow
- Burnt sienna
- Ultramarine blue
- Winsor blue
- Green gold
- May green
- Transparent oxide brown
- Quinacridone gold
- Neutral tint

Drawing and masking.

Step 1: With a sharp 2B pencil, loosely indicate the shapes and forms of the key elements, paying particular attention to size and scale. With the nylon masking brush mask out the barn roof tops, pick out some branches and trunks, and flick some masking fluid into the trees to create both sky holes and light hitting some of the leaves. Using the masking fluid and a colour shaper, define some larger leaf shapes on the bank in the foreground, reducing these in size as you move further along the bank; at the far end flick a few spattered marks. Mask out a few vertical shapes in the river and flick in a few short horizontal marks, taking care not to make them too regular and neat. Allow to dry.

Initial field washes.

Step 2: With a mix of green gold and a touch of May green, paint in the mid-ground field, varying the strength of the wash as you paint (don't allow it to become too strong, however, as it is in the mid-ground). Allow to dry flat.

Distant trees.

Step 3: Taking a slightly stronger version of the field mix used in the previous step, paint in the distant tree line, using a dry brush stroke towards the top of the trees. With the board at a slight angle, touch in a little ultramarine blue and burnt sienna at their base and allow it to bloom upwards.

Spattering the foliage.

Step 4: With the board flat, and using a piece of scrap paper (tear the paper for a more natural-looking edge), mask the river, trees and sky area. Spatter some clean water onto the unmasked area. Spatter a mix of green gold and May green using a size 8 brush into the same area, pulling some of the paint droplets together towards the base of the trees, and allow to dry.

Use the same technique for the other, smaller, trees but this time mix lemon yellow to the green gold and use a smaller sized brush, which will create smaller spatters, following the rules of perspective and adding to the sense of recession. Allow to dry.

Building up foliage texture.

Step 5: Using the same splatter technique as in the previous step, continue to build up the trees' foliage, reserving the lemon yellow mix for the smaller trees on the left-hand side of the riverbank. Allow to dry.

Initial riverbank washes.

Step 6: With a size 10 brush loosely brush on mixes of May green with green gold, concentrating the larger shapes in the foreground. When dry, add further layers using the same mixes, brushed loosely on to develop the riverbank's texture of leaves and grasses.

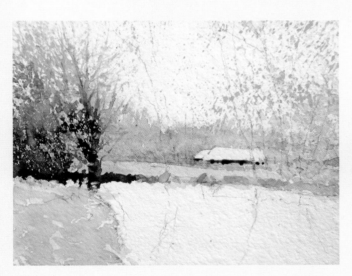

Riverbank trees.

Step 7: Carefully remove the masking fluid from the barn roofs, nowhere else. With the painting flat begin to develop the trees with mixtures of green gold with burnt sienna and green gold with neutral tint. Protect the sky, bank and river with scrap paper and spatter the foliage with the first mix using a size 4 brush. As this begins to dry, drop in the darker mix towards the bottom of the trees, pulling some along the riverbank and pulling some marks upwards with a fine rigger indicating branches. Using a slightly paler version of the previous mix add some dark accents to the barn walls. When dry repeat the same process for the other trees. Allow to dry.

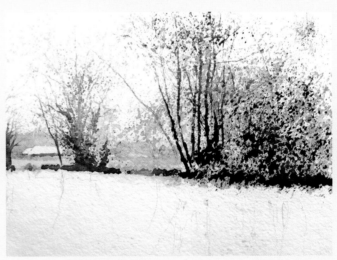

Adding darks to the large trees.

Step 8: After protecting the rest of the painting with scrap paper, use a strong mix of green gold and neutral tint (make up plenty) to build up the darks of the main trees by spattering. Concentrate the spatter towards the bottom of the tree and along the bank, pulling some of the droplets of colour together. With the board still flat allow the painting to dry completely. Don't be tempted to use a hair dryer; let it dry naturally.

Initial river wash.

Step 9: With the board at a slight angle, wash clean water over the river area. Mix Winsor blue and a little neutral tint and lay in a graduated wash working from the bottom of the river upwards. Allow to dry fully before moving on to the next step.

Tree reflections.

Step 10: With a fairly dry brush working from the side rather than from its tip, scuff on some vertical reflection marks. Use fairly stiff mixes of quinacridone gold, transparent oxide brown and green gold. As this is drying, paint in the main reflections from the trees, concentrating on the larger branches and trunks. The further the reflections are from the object the less defined and the more wobbly they become.

Developing the reflections.

Step 11: Have fairly strong puddles of transparent oxide brown, quinacridone gold and a mix of transparent oxide brown and neutral tint ready to paint. Develop the reflections by adding vertical marks, some of which define the trunks and larger branches. As before, scuff the brush across the paper's surface producing a broken mark, particularly at points furthest away from the trees. Use the darker mixes nearest to the bank and the quinacridone gold towards the bottom of the reflections. Allow to dry.

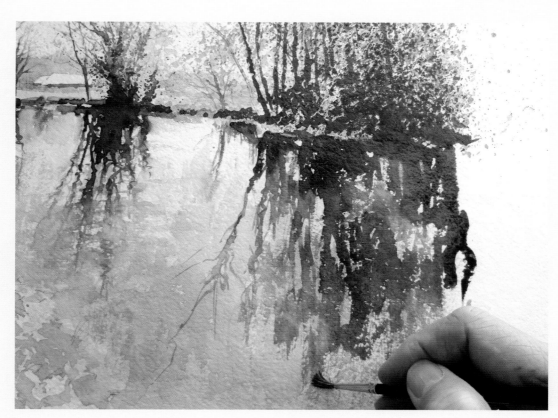

Furthest reflections.

Step 12: As the river disappears from view around the bend, dampen the area with clean water and using a No. 4 brush add some vertical marks of green gold. Allow to dry.

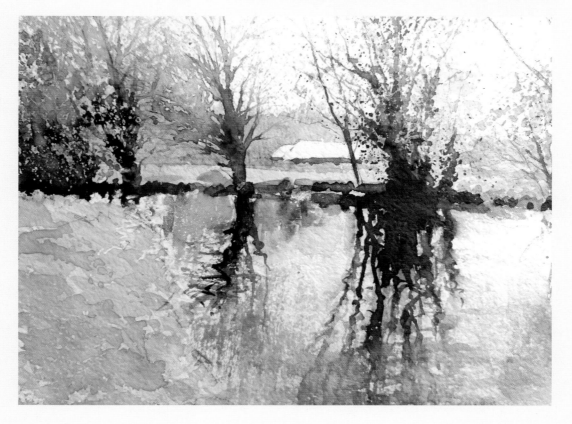

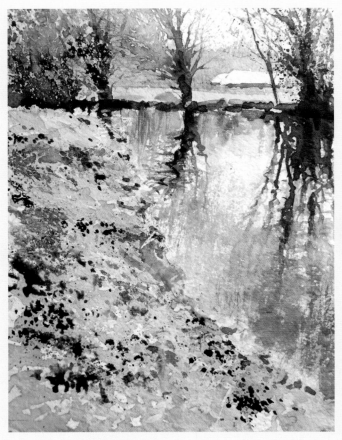

Developing the riverbank.

Step 13: Using mixes of May green and ultramarine blue develop the riverbank. Spatter and paint over the previous washes to build up the texture. Work wet on wet and wet on dry to add variation and interest to the bank. Add some vertical marks to the distant river reflections with the same washes used for the trees.

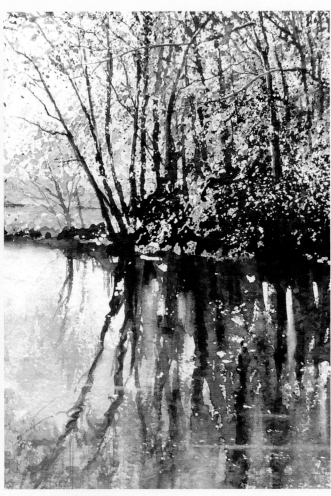

Remove all the masking fluid.

Step 14: Check that the painting is completely dry and when certain use the Maskaway eraser or clean fingers to carefully remove all the masking fluid. With a well pointed No. 4 brush or fine rigger, paint in the trunks and branches that the removal of the masking fluid has revealed. Leave the top edges free from paint to indicate sunlight hitting some of the branches. With a damp flat brush and some kitchen roll, lift out some horizontal marks from the river to suggest wind-ruffled water and lift some verticals at the bend in the river to add to the reflective appearance. Be careful not to overdo the lifting out: the results should be subtle within the painting rather than intrusive and clamouring for the viewer's attention. With a fine brush and some burnt sienna add a few strokes to the barn roofs, hinting at rusty corrugated tin sheeting.

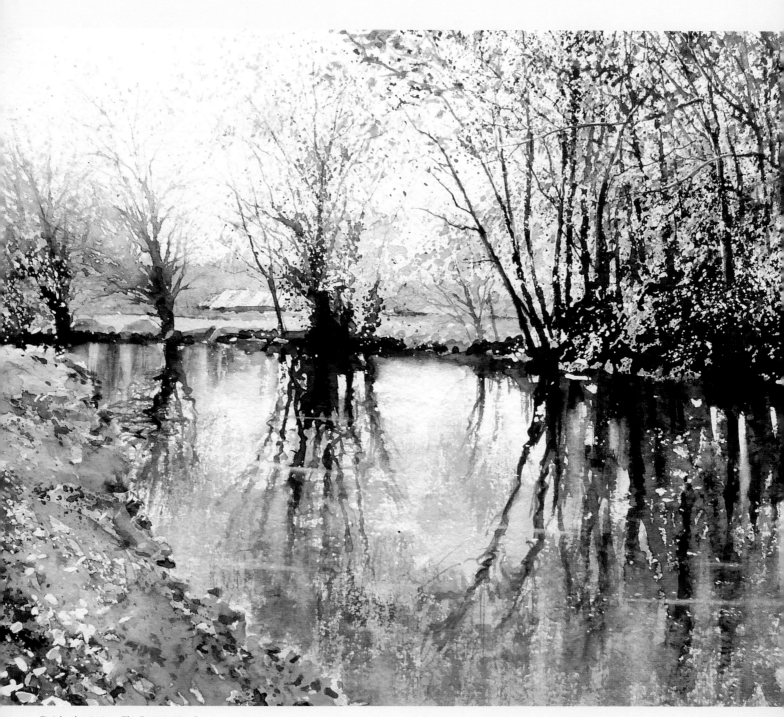

Finished painting: *The Erme in March*.

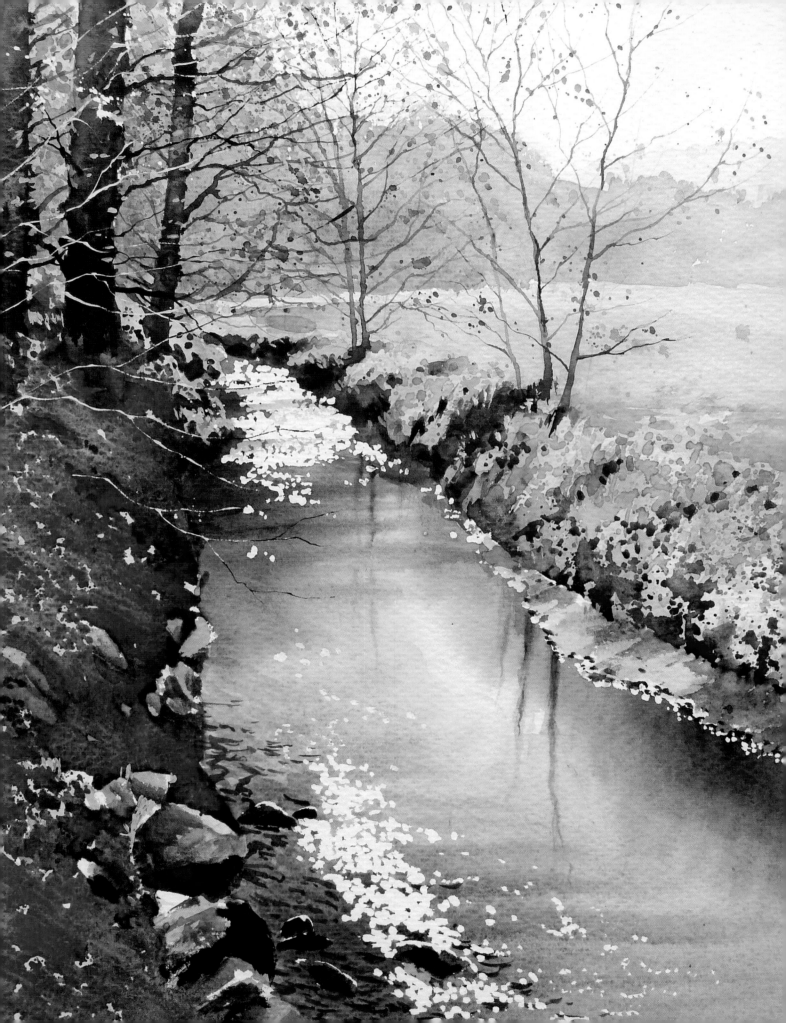

The Young River

Young rivers are quite often no more than streams, easily straddled by a single stride. Here, on the edge of Dartmoor, I am fortunate to have a lively narrow stream, the Butterbrook, flowing nearby; after many twists and turns it joins the River Erme. It has many of the characteristics that I enjoy when drawing and painting a young river: cascades, small waterfalls and fast-moving shallows. Dartmoor ponies drink from it, dippers walk in its water and the occasional trout can be seen darting from cover if disturbed. It's typical of the streams and young rivers found up and down the country, and it is a joy to paint and sketch.

Cascades

Cascades are some of the most interesting sections of a young river; you will often hear them before you see them as the water tumbles and splashes over stones and rocks, the noise telling all who listen that the young river is born, full of energy and eager to make its way in the world. Cascades are wonderful to paint and draw, and the key to depicting them successfully is to focus on this energy and movement.

Spend time sitting and looking at the tumbling water and it soon becomes apparent that, although there is likely to be a loose pattern and rhythm to the movement, every fleeting second is different – unique and unrepeatable. So, how to paint something that is so transient? As with all painting, careful observation is essential before committing paint to paper. Try to assess the underlying pattern and shape of the water's movement. In which direction does it flow? How does it move around the rocks and

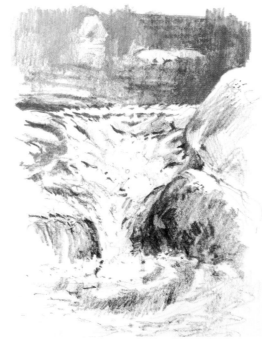

Location sketch in pencil of a small cascade on the Butterbrook, Dartmoor.

stones; where are the recurring lights and darks? Note how a slow moving pool of water often precedes the first cascade, full of reflections and offering an interesting contrast to the fast-flowing water slightly downstream.

Having spent some time information gathering and taking some photographs, I returned to the studio to make the painting, my area of interest being the abrupt change to the stream from the calmness of the slow-moving pool to the frenetic fast-flowing water down through the cascade; from calm to chaos.

STEP BY STEP DEMONSTRATION
Butterbrook Cascade

Paper
- Bockingford 300gsm (140lb) NOT, stretched
- Size: 19 × 25 cm (7½ × 10 inches)

Materials and equipment
- 2B pencil
- Masking fluid
- White pencil crayon
- Nylon masking brush
- Pointed sable brushes, size 10 and 8
- Small filbert brush suitable for oil or acrylic painting
- Palette
- Kitchen roll

Artist quality watercolours
- Raw sienna
- Burnt sienna
- Ultramarine blue
- Green gold
- Winsor blue (green shade)
- Neutral tint
- Quinacridone gold

Drawing.

Step 1: Referring to both sketches and photographs, draw up the design of the painting using the 2B pencil onto the stretched watercolour paper. Indicate the large stones and add a few pencil lines to show the direction of the flowing water within the stream.

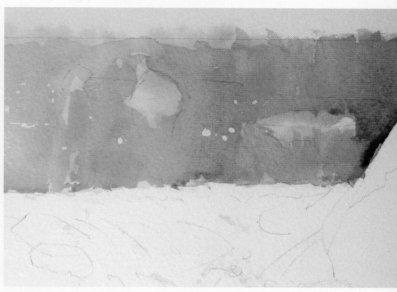

Masking.

Step 2: Using a nylon masking brush and with a quick action apply masking fluid to selected areas of the painting, the strokes of the brush corresponding to the fall and movement of the rushing water. Pick out a few bubbles in the slow-moving pool and indicate ripples and eddies in the foreground with the masking fluid and allow to dry thoroughly.

Initial washes.

Step 3: With clean water dampen the top pool, taking care not to get any water onto the large stone on the right. Allow the water to soak into the paper. Using a No. 10 sable brush and with the board at a slight angle, paint vertical strokes of raw sienna, quinacridone gold and green gold. Let the pure colours mix on the paper; wet into wet, notice how the colours blend softly together. Allow the paint to dry throughly.

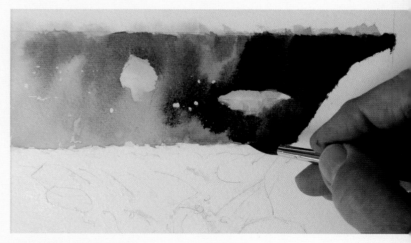

Building the reflections.

Step 4: Add clean water to the previously painted area, leaving the stones dry. Add a few vertical strokes of a green gold, ultramarine blue and burnt sienna mix to the right-hand side of the pool. These will create the soft reflections from some overhanging trees just out of the design.

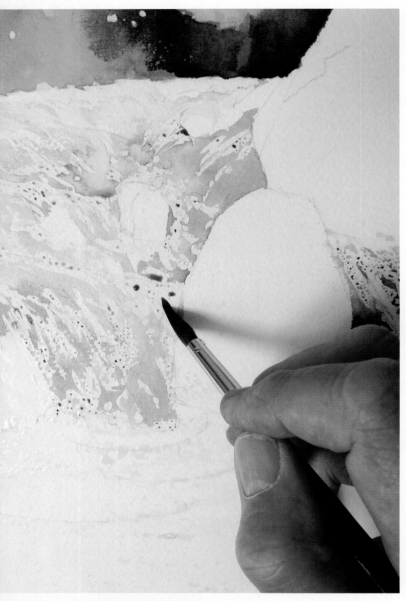

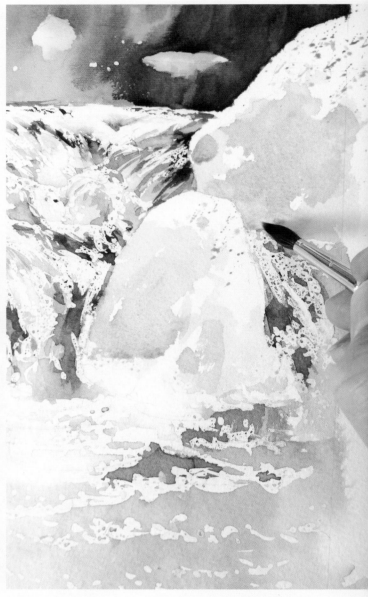

Developing the cascade.

Step 5: Taking mixes of ultramarine blue and neutral tint in varying strengths (some with more ultramarine, others with less), begin to paint in the rushing water using the pointed No. 10 sable. Keep the brush strokes loose and lively, following the direction of the stream's movement within the selected part of the painting.

Stone textures.

Step 6: Dampen the area of the large stones on the right and some of the smaller submerged rocks within the cascade itself. With the No. 10 sable drop in mixes of burnt sienna to the wet areas. Keep the top left-hand side and the top of the two larger stones free from any colour as the unpainted sections will give the impression of bright light in the final painting, particularly when seen against the darker background. When dry use some scraps of paper to protect the rest of the painting and flick some burnt sienna onto the stones to build up further texture.

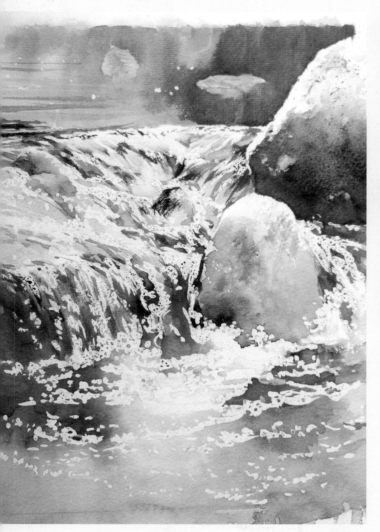

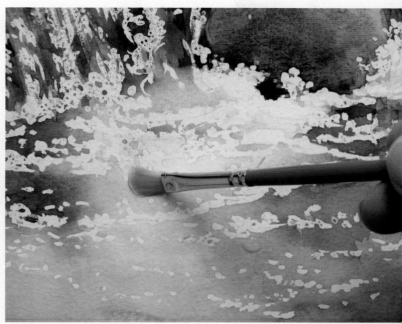

Lifting out.

Step 8: Gently soften a few of the edges within the bottom pool by using the small filbert brush and plenty of clean water to remove some of the colour. Pay particular attention to the agitated water to the left of the foreground rock. Softening some of the edges in this passage of the painting gives a far more natural-looking result.

Adding more structure to stones and water.

Step 7: After checking that the previous stage is completely dry, continue to build up the tones in the falling water with mixtures of ultramarine blue and neutral tint. Wet the large stones again and drop in mixes of burnt sienna and ultramarine blue. Vary the strength of this mix across the stone as this will add to its shape and texture. While this is still damp, add some touches of green gold and allow to dry fully. A paler version of the burnt sienna and ultramarine blue mix can be used to add some structure and detail to the rocks in the top pool. Be careful not to add too much information to these stones as this might cause them to appear to come too far forward in the overall design and unbalance the final painting. Add touches of Winsor blue to the mid-section of the cascade; be aware that too much could lead to losing the light areas. Allow to dry completely.

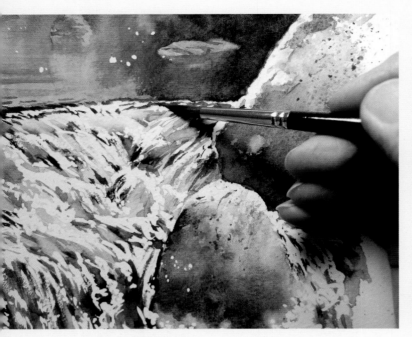 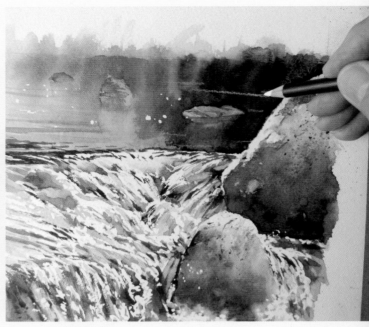

Remove the masking fluid.

Step 9: Carefully remove the masking fluid and with a strong, dark mixture of quinacridone gold and neutral tint paint in the reflections running across the top edge of the first cascade. Using a No. 8 sable, paint these in carefully and precisely, paying particular attention to their shape and structure, their gentle curve giving shape and form to the water's edge. Continue adding adjusting tones with mixes of neutral tint and ultramarine blue.

Pencil work and sparkles.

Step 10: On the left-hand side of the top pool add a couple of lines with a white pencil crayon. These depict the wind ruffling the water's surface. Paint in a few ripples in the top pool with a pale mix of green gold and neutral tint. With a sharp scalpel or knife, scratch in any tiny sparkles as needed. Be careful not to overdo this stage.

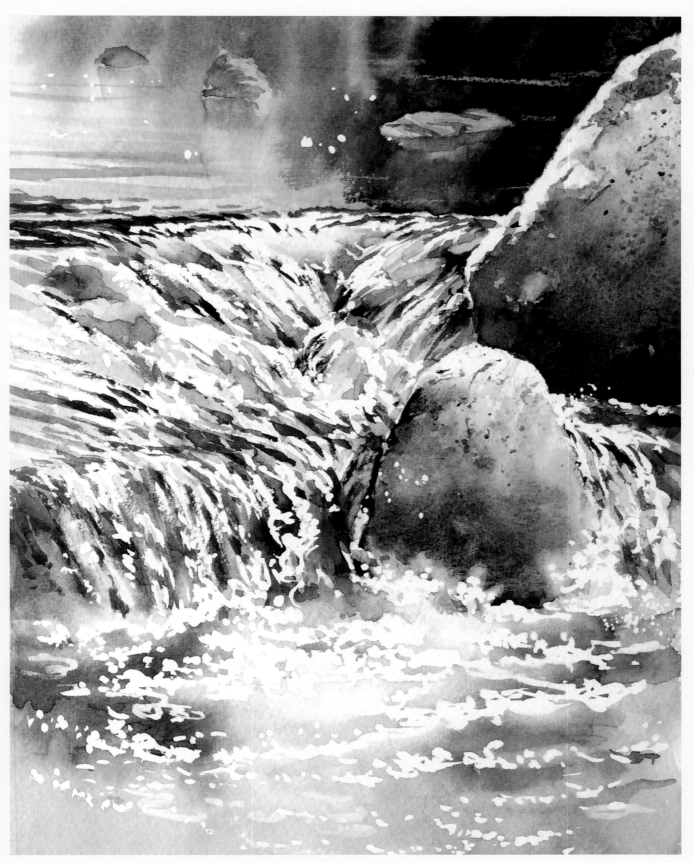

Finished painting: *Butterbrook Cascade*.

STEP BY STEP DEMONSTRATION
Spring Stream

Paper
- Bockingford 300gsm (140lb) NOT, stretched
- Size 44 × 28 cm (17 × 11 inches)

Materials and equipment
- 2B pencil
- Masking fluid
- Nylon masking brush
- Brush soap
- Colour shaper
- Dip pen
- Pointed sable brushes, size 14, 10 and 8
- Rigger
- Palette
- Kitchen roll

Artist quality watercolours
- Cobalt blue
- May green
- Green gold
- Ultramarine blue
- Winsor blue
- Burnt sienna
- Quinacridone gold
- Raw sienna
- Cobalt green
- Transparent oxide brown
- Permanent rose

SPRING STREAM

Between the moor and the sea lies the small town of Modbury. In nearby fields a small un-named stream flows through them. In the autumn and winter rains it can burst its banks and spill into the surrounding meadows – flooding that can often stay for several weeks. In the summer, however, it can shrink to a mere trickle.

For me the most interesting time of the year is the spring, bringing it with it both sunshine and showers. The sunshine often lacks the warmth of summer days but the delicate tracery of shadows cast from trees not yet in full leaf fully compensates for the cooler temperatures and is ample reward for venturing out with sketchbook and camera. I have chosen to paint the stream field on one of these days, my focus of interest being the bright stream, dark shadows in the banks and the patterns that the tree shadows make on the bright spring grass. After gathering information with drawings, colour notes and photographs I return to the studio to make the painting.

Seasons often seemed to be defined by colours, the most obvious being the reds, oranges and golds of autumn. In the winter it might be greys and blues; in the summer deep, rich greens. Springtime is often a curious mixture of colours, and early spring can be almost autumnal in colour with leaves still tight in bud, flushed with delicate yellows and soft warm browns. However, when spring has well and truly sprung it shouts its presence with bright, almost unnatural greens, vivid and full of life. In the meadow where this painting is set the green was certainly the star of the show and the colour would be a large part of the painting, but the light on the stream and the blue of the sky's reflection would become the focal points.

A landscape format was chosen to give width to the design. I planned to use the stream running through the valley to move the viewer's eye from one side of the painting towards the area of attention, the focal point, with the angle of the main tree giving a nudge to start that horizontal movement in the right direction. The dominating colour of the painting would be the vivid spring green, with softer grey greens in the background conveying the appearance of distance. The green might have become overpowering; in order to prevent this I decided to add touches of a near complementary, burnt sienna, both on its own and within some of the mixes to knock back the starkness of the green in parts. The lightest part of the painting, even lighter than the sky, is the focal point: the stream. Juxtaposed with this is the darkest part, the rich dark of the bank. These two contrasting tones give a kick to the painting and attract the viewer's attention.

Drawing and masking.

Step 1: After deciding on the design, draw the main elements onto the stretched watercolour paper using a 2B pencil. Then with a medium-sized nylon masking brush dipped into some soapy water to help the flow of the masking fluid, mask out the stream, the brush marks following the direction that the stream flows in. The trees are also masked out and a dip pen used to pick out some of the finer branches and a few sunlit blades of grass. Be careful to get the dip pen flowing freely on some scrap paper before using it on the painting, as it can often 'blob' annoyingly until working properly. Allow to dry completely.

Initial washes.

Step 2: With the stretched paper tilted at a slight angle of about 20 degrees, use a No. 14 brush to wet the sky, distant hills and mid-ground areas with some clean water and allow it to soak into the paper slightly. Have some mixes of raw sienna, cobalt blue, cobalt green and a very pale wash of May green made up. When working onto wet or damp paper it is worth remembering to make the colours a little stronger than you ultimately need them to be as they will weaken when taking up the additional water from the damp paper. Paint in the sky with the raw sienna, the distant hills with both cobalt blue and green, and the mid-ground hill in the pale May green. Note how the colours mix and fuse on the paper with no hard edges. These soft edges and pale colours help to create the illusion of space and distance in this painting. Keeping the board tilted at the same angle, allow the colours to dry fully. If the angle of the board is altered at this stage it can cause wet paint to creep back into drier areas and might cause back runs, more commonly known as 'cauliflowers'. Although these can create some interesting effects in certain paintings they would look out of place here.

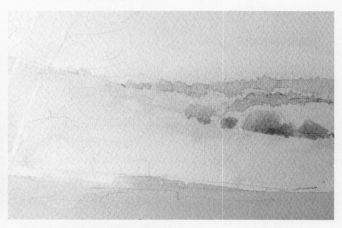

Sky and distant hills.

Step 3: Check that the previous stage is completely dry, paying particular attention to the masked areas where the rubber solution can cause the watercolour to take longer to dry and therefore be easily smudged with a careless sleeve. Use a No. 8 sable and add a weak wash of cobalt blue over the sky. With the sky dry, mix cobalt blue with a little of the May green and strengthen the distant hills. For the main hill behind the trees use a mix of May green with a touch of cobalt blue. With the brush strokes following the fall of the hill, strengthen the mix to the right. Allow to dry.

Developing the distant hills and trees.

Step 4: To complete the distant hills and trees mix cobalt blue, cobalt green and a little quinacridone gold and with a No. 8 brush, paint in the field boundaries and trees, varying the strength of the washes as you go to provide interest. For the trees running down the hillside on the skyline and those in front of the hills use a slightly stronger version of the same mix and combine both dry brush strokes with washed areas to create variation in tone, colour and mark. With a stronger wash of May green work up the hill and the foreground fields. Leave to dry.

Mid-ground hedge and trees.

Step 5: Indicate the trees on the crest of the hill with a weak mix of Winsor blue and ultramarine blue, with the colour fading to the left indicating the direction of light. Apply the colour from a relatively dry No. 8 sable, using the side of the brush to 'scuff' the paint onto the surface of the paper to create texture and interest.

Note: Although to be true to the landscape there were no further trees on the crest of the hill I indicated a few as their inclusion would make the position of the hill and its shape more understandable to the viewer. This is a good example of where we, as artists, can move, leave out or invent elements within the design that can lead to a better painting.

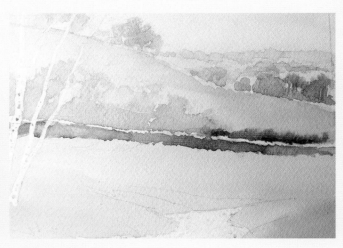

Defining the hill.

Step 6: Separating the main stream field and the hill runs a Devon hedge with a copse behind. Using mixes of green gold, quinacridone gold and ultramarine blue, paint in the copse. Vary both mix and brush direction to create a variegated passage within the painting. The hedge is painted with green gold and, when still wet, neat burnt sienna and ultramarine blue are dropped in at various intervals and allowed to dry. It is important to leave a gap between the top of the hedge and the copse indicating some soft spring sunlight.

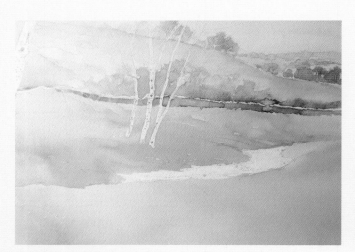

Initial field washes.

Step 7: With clean water dampen the foreground fields and with a variety of green mixes in varying strengths – green gold and May green, Winsor green and May green – drop these randomly into the fields using a No. 10 brush. These marks will begin to add texture and shape; without adding these details there might be a danger of the fields resembling a well manicured bowling green rather than some rough pasture more usually the home of sheep or cattle. Allow to dry.

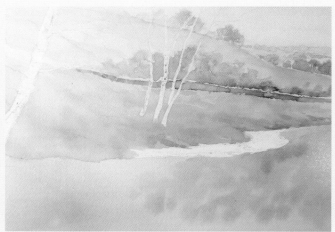

Adding texture to the field.

Step 8: With a No. 8 sable, flick some clean water onto the field, with the greater concentration landing in the nearer field. Allow this to soak into the paper slightly and in order to build up the texture of the field flick on some stronger green mixes, May green and ultramarine blue, Winsor green, joining some of the spattered paint together to create larger marks, ensuring that they follow in direction the fall of the land. Careful spattering creates a more natural, random effect, an effect almost impossible to achieve through painting alone, which can often appear mechanical and contrived in comparison.

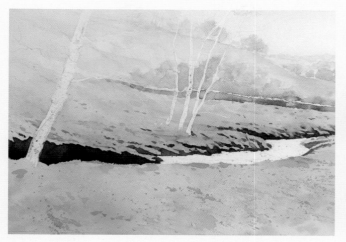

Painting the banks.

Step 9: Once the previous stage is completely dry, make a strong mix of burnt sienna and ultramarine blue and begin to paint in the heavily shadowed bank. The burnt sienna is within the mix for two reasons: not only does it combine with the blue to make a lively dark – much more interesting than a plain black, but it also 'warms' the dark up. As warm colours appear to come forward whilst cooler colours recede, it plays its part in bringing the bank further forward in the painting's design.

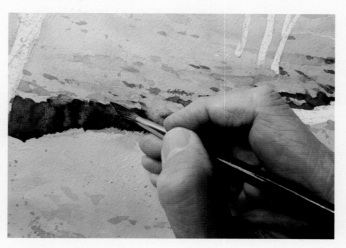

Softening some edges.

Step 10: Check that the previous stage is completely dry. If the bank appears too defined, particularly in the middle distance, wet a brush with clean water and gently soften some of the hard edges. The bank should be seen as a series of lost and found edges.

LOST AND FOUND, HARD AND SOFT EDGES

You might not be familiar with 'lost and found' or 'hard and soft' edges in relation to painting, but you are likely to have seen them already. I believe them to be an essential part in the making of a successful painting.

In the world we see examples of lost and found, and hard and soft edges on a daily basis. Consider a group of trees: we can identify where they stop and the sky appears to start. This would be considered to be a 'found' edge. As our eye travels back into the trees, however, we have trouble making out where one tree stops and another starts; they appear to blend together. This is known as a 'lost' edge. A good painting will have a balance of both lost and found edges; I sometimes liken it to being 'in focus' and 'out of focus'. If a whole painting was painted in sharp, high-definition focus with no blurred edges, it would look not only very unnatural, but it would also be difficult on the eye.

Watercolour is an ideal medium in which to achieve both types of edges. For lost or soft edges, simply apply paint to wet or damp paper and let the colour run. Working wet on dry will result in hard or found edges. Softening the edge of a dry wash with a damp brush and lifting it off will also produce a softening of the edge and is something that I do towards the end of the painting process.

The use of masking fluid in a watercolour can often result in the paint leaving a distinctive hard edge around the previously masked area – great if you want it but not so good if you don't, as it can look rather intrusive. Softening the hard edge with a damp brush will be all that is needed to reduce its intrusion.

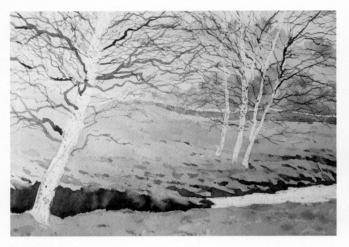

Initial tree washes.

Step 11: Time to tackle the trees. With various mixes of transparent oxide brown, ultramarine blue and green gold use a rigger and paint in the branches of the trees. Don't make the mixes too strong and dark. These slightly paler brush strokes are a good way to get some form and depth into the trees; the paler toned branches will appear to recede when, at a later stage, branches of a stronger tone are painted over them, the darker branches seemingly coming forward to the viewer. Allow to dry.

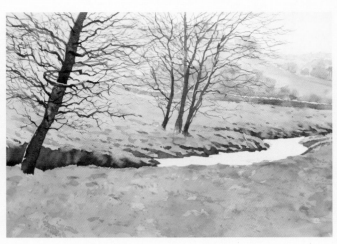

Remove the masking fluid and paint the main trunks.

Step 12: After checking that the branches are completely dry, carefully remove all the masking fluid. The trunk of the tree to the left is painted next. An under wash of green gold is painted first and while still damp mixes of transparent oxide brown and ultramarine blue are dropped in. Allow the colours to merge on the paper, wet into wet. Leave a thin unpainted edge to the left-hand side of the trunk, to represent the sharp sunlight catching the tree. With the paint still damp touch a darker mix of the transparent oxide brown and ultramarine for the shadow on the right-hand side of the trunk. With a rigger, add the larger branches with the same trunk mix, and using a slightly paler tone of the same colour mixes, paint in the main branches and trunks of the smaller stand of trees to the right.

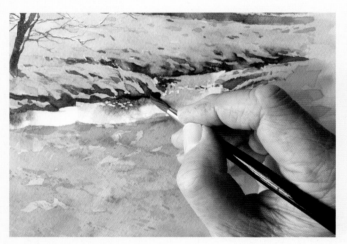

Sparkles and reflections.

Step 13: Using a pointed colour shaper, mask out a few sparkles and rocks in the stream. Allow this to dry fully. With clean water and the board at a slight angle, wash over the stream area and drop in Winsor blue allowing it to flow down the paper. With this area still damp, paint in mixes of ultramarine blue with a little permanent rose, some green gold and ultramarine blue, using vertical brush strokes. Leave to dry, keeping the board at the same angle.

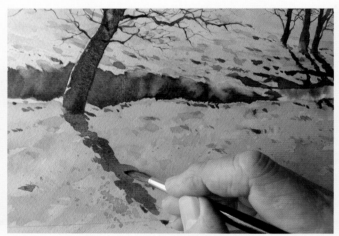

Tree shadows.

Step 14: With a No. 8 pointed sable and a strong wash of May green and Winsor blue, paint in the shadows cast from the trees. Make certain that these lie in the same plain as the field. The unevenness of the field is described by the way that the shadows fall across the field.

Scraping and lifting out.

Step 15: With the previous step completely dry remove all the masking fluid. Carefully scratch in a few small sparkles using a sharp craft knife or scalpel. Using a damp brush lift off a little of the colour from the trunk of the main tree to portray shadows, the shape of these helping to describe the trunk's shape and form.

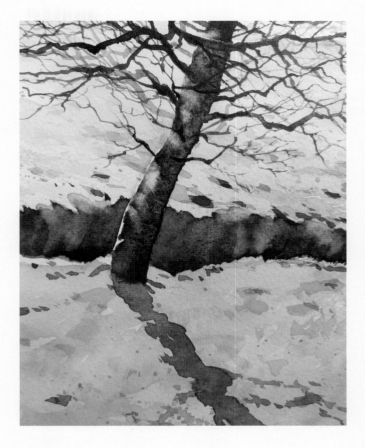

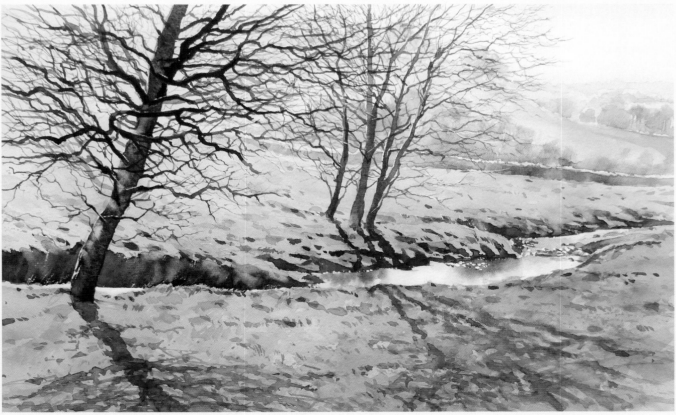

Finished painting: *Spring Stream.*

SHALLOW WATER

The young river, fresh into its journey towards the sea, is often quite shallow with the river bed easily visible. Small fish, tiddlers, dart for cover, shadows falling through the water across the varnished stones.

Shallow water was an interesting watercolour to paint for not only did I have great delight in depicting the submerged stones, but I was particularly interested in the river on the left of the design, showing as it does the bright sky reflected in its clear waters. It seems quirky to have no 'sky' at the top of the image but to have it at the bottom and this made for an unusual yet interesting painting.

The design of the painting is really in four parts – the riverbanks, shallow water, deeper water and the river to the left reflecting the sky above – and the challenge was to bring these parts together into one whole. The design is based on a triangle, the diagonals pointing the viewer's eye towards the cascade at the top of the painting. The horizontal elements of the design are created by the stones and rocks that link both sides of the painting together and the important balancing verticals are provided by the tree trunks and the reflections just below the cascade.

The painting also breaks down into three main colour areas: the blue of the sky reflected in the water, the greens on both banks and within the reflections, and the peaty brown of the river bed in the foreground. Somewhat unusually, the divisions between all three are quite marked, but by introducing touches of the other colours within all three areas I can integrate them into one, linking all the parts together to create a more unified painting.

Shallow Water

Paper
* Bockingford 300gsm (140lb) NOT, stretched
* Size: 44 × 28 cm (17 × 11 inches)

Materials and equipment
* 2B pencil
* Masking fluid
* Nylon masking brush
* Brush soap
* Dip pen
* Pointed sable brushes, size 14, 10, 8, and 4
* Soft filbert brush
* Palette
* Kitchen roll
* Maskaway eraser
* Scrap paper

Artist quality watercolours
* May green
* Ultramarine blue
* Green gold
* Winsor blue
* Transparent oxide brown
* Burnt sienna
* White gouache

Initial washes for the bank.

Step 2: With the board at a slight angle of about 20 degrees, and working on dry paper, use a well loaded No. 10 brush to paint washes of pure May green and green gold for the distant bank, keeping the main stones clear from any colour. Allow the washes to mix together on the paper. Let the painting dry completely.

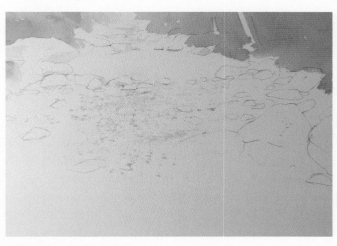

Masking the cascade and sparkles.

Step 1: With a fine nylon masking brush, mask out the cascade in the background, each stroke following the water's flow over the cascade. Use the sparkle brush to mask out the sparkling water in the mid-ground by rolling the masking fluid quickly onto the surface of the paper. Allow all the masked areas to dry completely before moving onto the next step.

Building up the riverbanks.

Step 3: With stronger versions of the same mixes, begin to add some shape and form to the bank sides, the No. 10 brush stroke indicating the direction and fall of the bank. While this is still wet drop in some ultramarine blue at the bottom edge and watch how it creeps upwards adding more indication of shape to the bank through shadow. With a No. 8 sable add a few more marks on both banks, painted and spattered, to add some texture.

Deep water reflections.

Step 4: Dampen the river with clean water and allow it to soak into the paper slightly. (Adding paint before the water has soaked in often results in it floating uncontrollably on the wet surface, but if you let the water soak in slightly it is easier to control the colour.) With washes of pure green gold, May green and transparent oxide brown, paint in vertical marks with a well pointed No. 8 for the tree reflections. With a wash made up from transparent oxide brown and ultramarine blue, drop some colour into the mid-ground and some Winsor blue where shown.

Masking ripples.

Step 5: Check that the previous stage is fully dry and with a fine nylon masking brush pick out some of the bright blue reflections with masking fluid. Paint these masked marks following the flow and ripples of the stream; this will ensure that they become part of the painting and don't appear to stand alone from it.

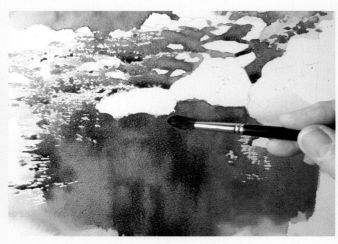

Initial river bed washes.

Step 6: Prepare some large puddles of strong colours in the palette ready for use (this is not the time to be constantly revisiting the palette to mix up more colours!). Prepare some burnt sienna, transparent oxide brown, and mixes of transparent oxide brown with ultramarine blue and green gold with ultramarine blue. With clean water wet the foreground pool and some of the stream flowing amongst the mid-ground rocks and stones. Allow the water to soak in a little and using a No. 14 brush, paint with vertical strokes the burnt sienna, transparent oxide brown and brown and blue mix in the foreground. Work quickly, letting the colours mix and flow vertically. It is important to keep the mix strong and dark. With the same mixes and the addition of the green gold and ultramarine blue mix, paint in the water in the middle pool, avoiding the rocks and stones, letting the colour do the mixing for you. As soon as areas begin to lose their shine they are drying; stop at this point. By continuing to paint, not only might you create cauliflowers, by the action of the brush you might begin to lift some of the colour off. Leave these washes to dry completely.

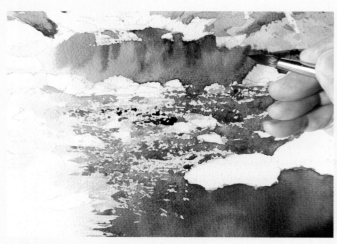

Developing the reflections in the middle pool.

Step 7: Working on damp paper with May green and a mix of green gold and ultramarine blue, add some vertical marks to the middle pool. Allow to dry.

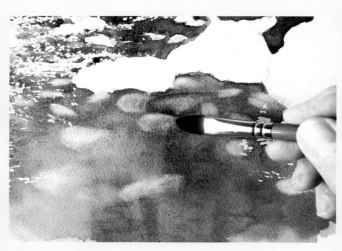

Lifting the foreground rocks.

Step 8: With plenty of clean water and using a soft filbert style brush, wet some of the paint in the foreground pool; for the shapes of the submerged rocks, lift out with kitchen roll. Don't scrub too vigorously with the filbert: the aim is to dislodge some of the colour, not all of it. When complete, use a mix of transparent oxide brown and ultramarine blue to paint in the shadows and dark hollows that define the shape of the rocks and stones on the river bed. Leave to dry.

Adding ripples.

Step 9: With a dilute wash of Winsor blue, using a No. 8 brush paint in some of the ripples on the left side of the foreground pool. Mix the Winsor blue with green gold and continue developing the ripples, particularly where the light side of the pool meets the darker edge.

Developing the larger rocks.

Step 10: With clean water dampen the large stones above the water line with a No. 10 brush and drop in mixes of burnt sienna and ultramarine blue, concentrating the darks on the shadow side of the rocks. As this dries, touch in some green gold. Continue to build up the texture and form of the stones by repeating the above step. Protecting the rest of the painting with scrap paper, spatter some of the same wash onto the rocks to increase the texture. Vary the strength and size of the spatter marks to create interest.

Defining the mid-ground rocks.

Step 11: Carefully remove all the masking fluid using the Maskaway eraser, but only after checking that the painting is completely dry. With a No. 8 sable and using mixtures of burnt sienna with ultramarine blue, transparent oxide brown and ultramarine blue, develop the stones in the mid-ground. Make sure that the shadows on the stones are consistent with the direction that the light is coming from. Allow to dry fully.

Adding small sparkles.

Step 12: In a separate palette or on an old saucer add a little water to some white gouache – just enough water to be able to paint with (too much water will thin the mix and reduce the paint's opacity). Using a No. 4 pointed sable paint in a few small sparkles and ripples below the cascade. Add a little Winsor blue to the white gouache and paint in a few ripples in the foreground pool.

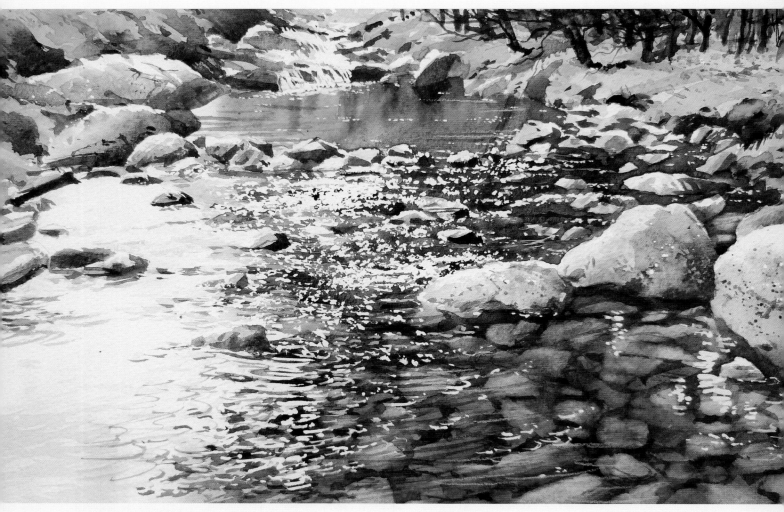

Finished painting: *Shallow Water.*

When I stood back to look at what I thought was the finished painting I decided that it was rather empty towards the top of the right-hand bank. I had painted a couple of trees within the space, but felt that increasing the number would add further visual weight and keep the viewer's eye from drifting out towards the top of the painting.

MOORLAND STREAM

The bright blues and purples in the fast-moving stream first caught my attention when sketching on Dartmoor and became the focus for this small watercolour. After making some sketches and photographs, and before a very heavy hail storm hit, I returned to the studio to develop the painting.

I chose a portrait format for the painting, wanting to concentrate the design on the stream and not the banks on either side as I felt this would be a distraction. The watercolour is divided into simple thirds, one third sky and two thirds moorland, with the stream, a strong diagonal, leading the eye into the painting from the bottom left foreground to the top third centre.

Masking fluid was used to create the sparkles, the sunlit top of the wall and the bright areas on the large stones. When masking out highlights on water in a painting such as this, it is important that the marks follow the flow of the stream and sit on the same plane as the water's surface. If the marks are misplaced parts of the stream could appear to be flowing up hill or at the wrong angle to the rest of the water and would look odd and out of place, and would certainly be noticed by the viewer. At times the viewer might not know precisely what is wrong with or about the painting, but they are aware that something is and this can have an influence on how they perceive the rest of the painting. If the artist can get the little things right within the painting it is easier to produce a more satisfactory whole.

With a limited palette of green gold, ultramarine blue, Winsor blue, permanent rose and burnt sienna it was painted quickly and loosely with the minimum of alterations or additional washes. When the watercolour was completely dry I carefully scratched in some branches on the tree using a sharp scalpel.

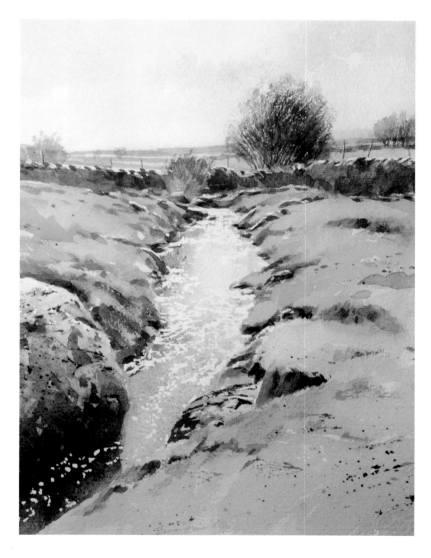

Moorland Stream. Paper: Two Rivers 300gsm (140lb) NOT. Size: 23 × 29 cm (9 × 11.5 inches).

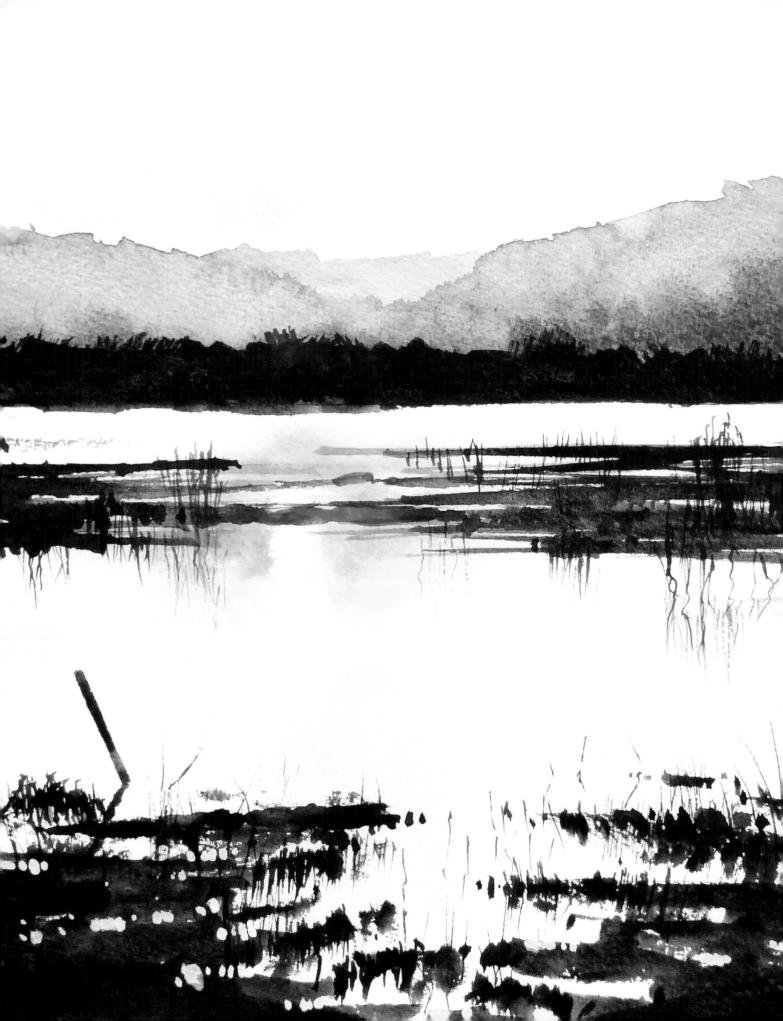

River Moods

When painting on location or back at the studio in watercolour, I am not trying to duplicate everything before me as if it were a photograph – picking out every tree, boat, line or post in pixel-clear detail. Instead I'm trying to capture something of the way that it looks and the feeling that it evokes in me; the *genius loci*. As one of the greatest English landscape painters, John Constable, stated when writing to a friend in 1821, 'painting is but another word for feeling'. I couldn't agree more.

A successful landscape painting should not only look good, but you should also be able to 'feel' it, the truly great paintings provoking a response that at times can be almost overwhelming.

Mood and atmosphere

A river will take on many moods during its journey from source to sea. These are created by a variety of factors: location, the seasons, time of day, weather conditions, activity on the water – even the height and speed of the water's flow can have an influencing effect on the mood and atmosphere created.

To appreciate the atmosphere and moods that can affect the river, get to know it. Visit it as often as you can, if possible at different times of the day, throughout different seasons and in a variety of different weather conditions. The more you visit, the more you are likely to note how the mood of the river changes and what the factors are that influence that change. Take a sketch pad with you,

make a few drawings, jot a few notes down, use a camera to record the fleeting changes of light, or if time is limited, just go and look.

Analyse what factors contribute to the changing moods and atmosphere: a busy river full of yachts, billowing sails, with plenty of colour and movement, will feel very different to the same stretch of river later in the day as the setting sun dips over the now deserted water. The mood now will appear calmer, tranquil, more restful.

We can bring a very different feeling to a scene simply through the number of people that we populate the painting with. Place a single figure on a beach and we portray solitude; paint that very same beach with dozens of figures and the mood created this time is one of a bank holiday.

The weather brings its own set of influences to the river: a spring day with barely a breeze to ruffle the water's surface will present a very different mood when compared to a winter storm as it rages and whips up the river into a frenzy of spray and movement.

Consider how a location can be transformed by bright sunlight, the colours often appearing stronger, the shadows sharper in contrast. If a scene can be compared to sound, then when the sun is out so the volume seems to have been turned up – it appears noisier. An overcast sky leads to duller colours with less contrast in the shadows. The tones are closer together, giving a 'flatter', quieter scene.

Once we begin to understand which elements evoke which moods within the landscape, we can use similar factors in our own paintings to illicit the desired mood or atmosphere that we want to create.

Skies

Do not underestimate the usefulness of a sky to the artist. John Constable knew its worth to the landscape painter and considered it the 'key note' of the painting; it sets the mood for the rest of the painting. A bright blue sky full of fluffy white clouds will create a different mood within a painting when compared to a storm-filled one. This might seem to be a rather banal statement but the painter who does not see its worth and importance will miss the benefits that a good sky can offer. Too many students seem to dismiss it as just a bit of blue at the top, as I overheard a student telling another on one occasion. A good sky is essential; a poor sky will detract from the overall image no matter how good the rest of the painting is.

The sky should be given just as much consideration and thought as any other part of the painting, both in design and execution, particularly when one considers that the sky is the light source for the landscape below and has a large role in setting the mood and atmosphere. Although a knowledge of cloud structure and formation will prove useful, nothing can replace direct observation through sketching in both pencil and watercolour. If possible, select some big skies with far-reaching views to work from. The combination of the two will allow you to observe the effects of perspective and tonal recession on both sky and land and how this contributes to the sense of space and distance within the scene.

Pick a day when there are some interesting cloud formations. Before committing pencil or brush to paper, take some time to look closely at them and how they are moving and changing. Select a part of the sky that interests you. You don't have to capture the expanse of the whole sky; this can often present the student with too daunting a challenge and leads to poor observation and disappointing results.

Choose a soft pencil to work with. A 4B is ideal as it allows for a good tonal range to be easily achieved without too much over-drawing. When working rapidly in watercolour it is a good idea not to try to paint on too large a sheet of paper. The larger the washes the longer they will take to dry and the less easy they are to control, especially when working against the clock. My own choice is nothing larger than A4, and even then I don't often paint to its full size, preferring to work from the middle of the paper out, with the painting ending well inside so as not to appear cramped.

Time is of the essence when trying to capture rapidly changing skies in pencil or paint and a certain degree of urgency is required. Search for the larger shapes and masses

A watercolour study of a rapidly changing sky, painted in fifteen minutes with some notes added at the time. Sketches like these can not only prove useful in gathering information for future paintings, but working on small watercolours such as these helps the watercolour artist to hone their colour mixing and brush skills alike.

within cloud formations and get these down first. Note how the guiding principles of perspective apply just as much to skies as to the landscape below. Clouds in the distance, nearer to the horizon, appear smaller and closer together than those overhead. Aim to capture the character and mood of the sky rather than photographic realism.

Look for the shadows in the clouds; these will indicate the direction in which the light is coming from. Make careful notes of the colours and tones within the clouds and the subtly different blues within the sky. The sky will appear to be a paler blue towards the horizon, getting stronger above your head. Nearer to the sun the blue will appear bleached almost to a white, as if the strong light is sapping the colour.

Note how the edges within certain clouds seem softer, more blurred, whereas other edges stand out from the blue of the sky more crisply. Artists refer to this effect as lost and found edges, the lost edges being the less defined and the found edges the sharper. A balance of both of these edge effects will give the sky a more natural look.

Cloud shadows falling across the landscape can offer the artist many compositional possibilities. Shadows can be used to lead the viewer's eye to key points, and a stark contrast between light and dark adds interest and focus to the painting, for example a sunlit white sail of a yacht set against the dark grey of a storm cloud low to the horizon.

Notice how in *Coastal Clouds* the clouds appear to diminish in size and get closer together as they recede towards the horizon. Perspective applies just as much to the sky as to the landscape below and is a useful device that the artist can use to give the impression of distance.

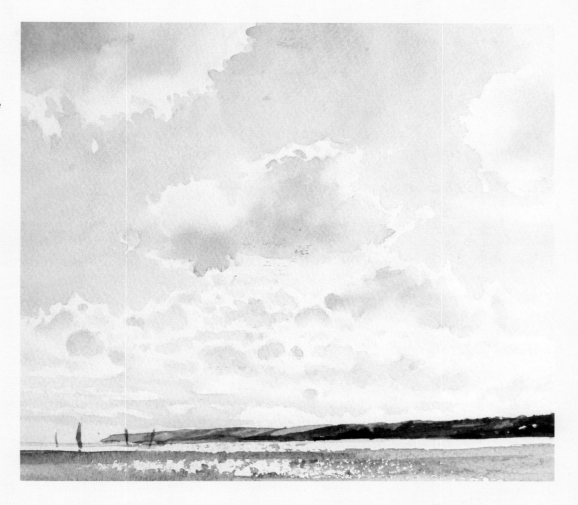

A simple study of clouds and their shadows, approximately 18 × 25 cm (7 × 9¾ inches).

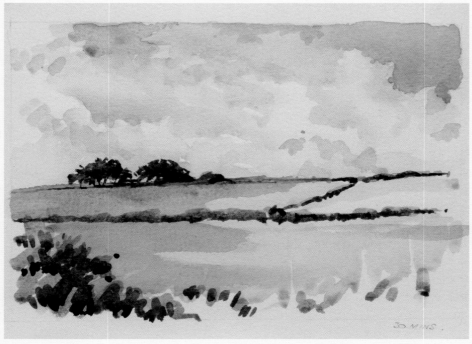

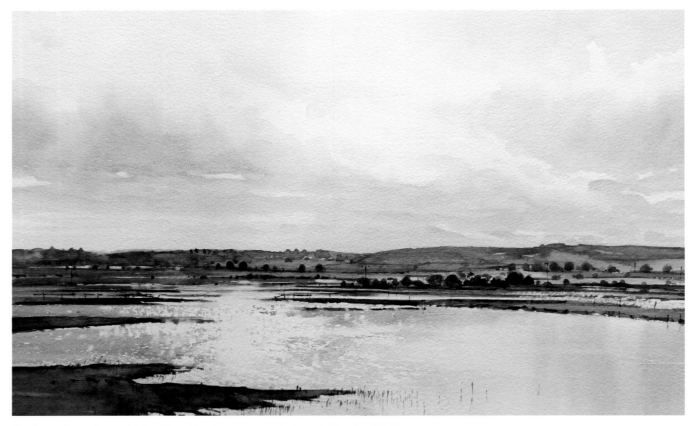

Floods near Exeter. A completely different landscape was created near to the city of Exeter after the the river flooded and formed an unexpected lake in what was normally farm land. I was interested in capturing the strong sunlight shining off the floodwater and the thin horizontal slivers of light receding towards the dark distant hills. Such a contrast to the normal pastoral scene was unexpected and a delight to paint.

FLOODS NEAR EXETER

How different a meadow or field can look after a period of heavy rain has caused the river to burst its bank and to flood the surrounding land. It can offer the artist a whole new view to the landscape, one that they might know well, but now totally transformed by the flooded river. The floodwater presents unexpected reflections, surprising light effects and often curious wildlife eager to explore this newly formed wetland.

SUNSET AT AVETON GIFFORD

Who cannot be inspired by a sunset over a river or wide open estuary, lasting only a few moments and then, tantalizingly, gone for ever? Colours change before one's eyes, the light drops and time is very limited. When working *en plein air* the artist must work quickly in order to capture the essence of the scene. There is no time to waste, no opportunity for fine tuning, there are no second chances. It might seem an almost impossible task to capture the scene in paint, but the rewards are well worth the concentrated effort.

It would be useful as artists if we were able to control time; by slowing the sunset down we would have more

time to capture the colours and light effects on paper. We might not be able to do this, but we can give ourselves more time by working back in the studio where time is not so constrained. Working from information gathered on location, or even from a west-facing window, we can work from sketches and photographs back in the studio to make the painting. Not only will we have more time to paint but in the studio other materials or media are readily to hand.

A word of caution: although photographs are an ideal way to record fleeting changes, do not rely on them to record sunset colours accurately. Often the camera will add a red cast to the sky which is rarely correct. They can only ever be used as an approximation to the true colours seen in the sunset sky; the colours selected by the artist in their notes should be considered more favourably.

Sunsets use a different colour palette than those for when the sun is higher in the sky. Reds, oranges and purples abound. Detail is lessened as boats, trees, people and even buildings are reduced to simple shapes. An accurate assessment and depiction of the tonal range is important to the overall success of the painting as this can create the 'glow' of the lowering sun.

The challenge when painting a bright sunset is to keep the colours just that: bright. Wherever possible, try to work with transparent colours and even then try to have no more than three colours in a mix, preferably two. Too many colours in the mix, particularly opaque colours, can result in muddy, dull, sludge-like mess, lessening the brightness of the wash. Keep the mixing water clean and test your colours on a piece of scrap paper, making certain that you let the colours dry to get a true view of their colour and tone and that you are working on the same type of paper that you will painting the finished watercolour on. (It is not necessary to stretch paper for this type of testing.)

Attention needs to be given not just to the colours chosen, but also to the order of painting and how the paint is used. Too much over-painting of washes will reduce the luminosity and brilliance of watercolour, which ultimately will have a detrimental impact on the sunset's portrayal. I try to keep my washes light and bright, wherever possible letting pure colours mix on the paper, with as few alterations and fiddling to the painting as possible. The fewer the alterations, the less likelihood of the appearance of the much feared 'cauliflower' or back run! Better to let things dry and re-assess at that point, rather than to keep going

back in with colour and risk creating a muddy mess. Time spent thinking about the process and application of paint before committing the first washes to paper will be time well spent and will result in a better painting.

Aveton Gifford is a small village not far from where I live in south Devon with the River Avon running close by. It's a particularly interesting place to draw and paint. At this point the river is tidal, which makes the road that runs alongside it impassable at high tide, but this all adds to the special quality that seems to pervade the area. A sense of calm and timelessness, the river is in control and will not be hurried. The plaintive cry of a curlew emphasizes nature's authority.

At low tide vast areas of glorious mud are revealed, which attracts waders and sea birds alike, sometimes in groups or in ones or twos, busily searching for food amongst the beached boats and full of colour and life. But whatever the state of the tide it never fails to offer something of interest.

This painting is based on a trip late in the year just as the sun was setting, with the incoming tide on the turn. The evening air had a lightness about it, whereas the landscape in the gathering dusk seemed more solid, hills, trees and marsh merging into one as the light began to drop. I wanted to try to bring these two distinct qualities to the painting: a lightness to the air and water and a heavier, more velvety quality to the landscape. This was my inspiration for the painting.

I decided on quite a wide, elongated format to complement the breadth of the landscape at this point of the river. The river leads the eye from bottom left through and into the painting with the reflection of the setting sun almost in the middle of the composition. Placing such a strong focal point in the centre of the design tends to break the rules as far as composition is concerned, yet I feel that the balance is restored by the placement of the contrastingly dark hills and foreground.

Tonally the design had the lightest part framed by some of the intense darks, the positioning of which help to give the painting what I like to refer to as a 'tonal kick' –vital if we want to describe the intensity of the bright sunlight in watercolour.

The design lacked verticals consisting as it did mainly of horizontals and diagonals; fortunately, a well-placed telegraph pole saved the day and restored some balance to the design.

Sunset at Aveton Gifford

Paper
- Two Rivers 300gsm (140lb) NOT, stretched
- Size: 46 × 23 cm (18 × 9 inches)

Materials and equipment
- 2B pencil
- Masking fluid
- Nylon masking brush
- Brush soap
- Sable brushes, size 14, 10, 8 and 4
- Rigger
- Scalpel
- Palette
- Kitchen roll
- Maskaway eraser
- Painting board

Artist quality watercolours
- Ultramarine blue
- Quinacridone gold
- Green gold
- Cadmium yellow
- Permanent rose
- Burnt sienna
- Lemon yellow
- Cobalt blue
- Neutral tint

Drawing and masking out.

Step 1: Draw out the main elements of the scene loosely using a 2B pencil. (Using a pencil harder than a 2B might leave grooves or indentations in the paper, which in turn during the painting stage will cause washes of colour to gather in these grooves producing unwanted lines in the watercolour, which are impossible to remove.)

Using masking fluid, mask out the sun, the path of the sun's reflection and the course of the river as it appears to narrow to the right. Pick out the tops of the boats, the upturned dinghy on the right and the narrow inlet in the foreground. Use a fine nylon brush and wash it with soapy water at regular intervals. This will help to keep the brush point clean from the masking fluid, making accurate application much easier. Leave to dry.

Initial washes.

Step 2: With a large No. 14 sable, wet the painting all over with clean water and allow it to soak in a little. The paper's surface must be damp rather than flowing with water. If it is too wet, any paint applied will barely leave any colour behind when dry. With the board at an angle of about 20 degrees, freely apply washes of lemon yellow and permanent rose near to the tree line, keeping the colours from coming too close to the masked sun. The colours will mix and mingle on the paper. Repeat these washes in the river, adding a strong mix of quinacridone gold around the sun's masked reflection in the water. Leave to dry completely, keeping the board at the same angle.

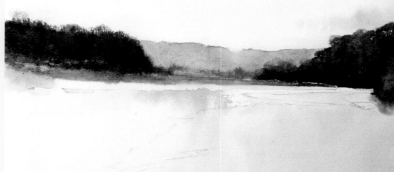

Sky and distant hills.

Step 3: Dampen the sky with clean water. Using a No. 10 brush, add washes of lemon yellow on the left-hand side and permanent rose. To the right, paint the cloud shape with permanent rose and with it still damp drop in some cobalt blue to the central section; it will blend but leave the permanent rose showing at the edges, giving the appearance of the setting sunlight catching the edges of the cloud. Paint the hill in the middle with a mixture of permanent rose and cadmium yellow. With the washes still wet, add a little cobalt blue and permanent rose at the bottom. This will blossom up, adding interest and help to ground the hill within the landscape.

With kitchen towel, lift out a 'notch' of light on the skyline; make certain that it's directly in line with both the sun and its reflection in the river.

Dark hills.

Step 4: Mix dark, strong washes of ultramarine blue with green gold, ultramarine blue with burnt sienna, and pure washes of ultramarine blue and burnt sienna. Use these to paint the wooded hillsides, varying the mixes as you go. Add pure burnt sienna to the sunlit tops of the trees and hills; from these pull out some tree shapes and branches with a fine rigger.

Paint the field on the left with a mixture of ultramarine blue and green gold, dropping in some dark mixes of ultramarine blue and burnt sienna to represent bushes.

Dampen the hill in the middle with clean water and wash in a mix of ultramarine blue and permanent rose. With a fairly strong mix of burnt sienna touch in the trees directly below the sun. Using a No. 8 brush pick out the boats with a blue grey mix (this is more of an indication of their shape rather than the finished colour). Allow to dry.

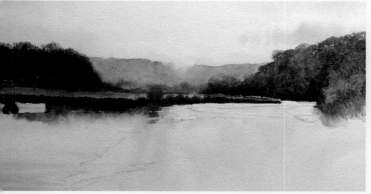

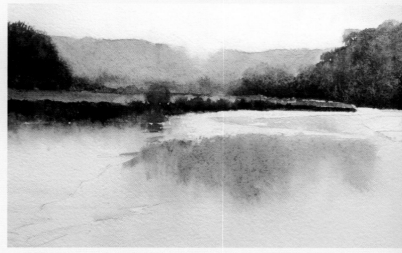

Riverbank and reflections.

Step 5: With the board at a slight angle, dampen both the riverbank and river with clean water. With prepared mixes of ultramarine blue with burnt sienna and pure burnt sienna, using a No. 10 brush paint in the bank and touch in some bush-like shapes on the bank tops. Concentrate the pure burnt sienna closer to the area of sun's refection. Allow the colour to flow into the river area creating the reflection. Do not alter the angle of the board and allow all the washes to dry.

Lay in an under-wash.

Step 6: Dampen the small beach to the right of the sun's reflection and the foreground marsh with clean water and lay in washes of quinacridone gold and burnt sienna with a No. 10 sable brush. Keep the board at a slight angle so that the colours creep down the paper, becoming paler as they drop. Allow the painting to dry at this angle. These under washes will give an underlying warmth to any subsequent washes laid over them.

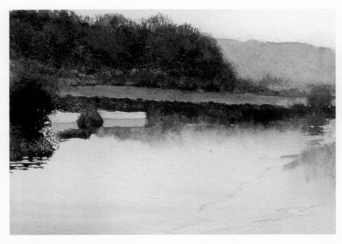

Rippled reflections.

Step 7: Paint the large bush and its reflection to the left of the boats with mixes of ultramarine blue and green gold with some burnt sienna dropped in as it begins to dry. Paint the rippled reflections from the bush using the tip of a No. 4 sable brush. With a pale mix of ultramarine blue, permanent rose and a touch of neutral tint, paint in the foreground ripples on damp paper, increasing the gaps between the ripples as you go up the paper.

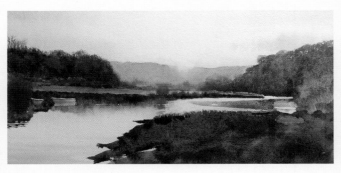

Foreground washes and boats.

Step 8: Remove all the masking fluid. Dampen the river inlet on the right and touch in a mix of burnt sienna with quinacridone gold. Paint in the hull of the upturned dinghy using a No. 4 sable and a mix of ultramarine blue with a little neutral tint. Working on dry paper, using strong mixes of ultramarine blue with green gold and ultramarine blue with burnt sienna, paint in the marsh. Indicate some stalks and rough grasses with vertical brush marks. Allow to dry.

Building up the foreground texture.

Step 9: After carefully protecting the rest of the painting with scrap paper, spatter mixes of ultramarine blue with green gold and ultramarine blue with burnt sienna over the marshy foreground to develop the texture.

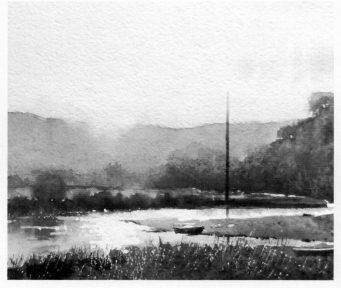

Finishing touches.

Step 10: With strong mixes of burnt sienna and ultramarine blue, using a rigger paint in the tree on the right-hand side of the design.

The telegraph pole is painted in three stages: a dark mix for the lower section, burnt sienna further up, and clean water at the very top, with the burnt sienna allowed to flow into it. This transition from the very dark to the orangey bleached top helps to emphasize the strength of light coming from the setting sun.

Redefine the boats with slightly stronger colours and add a little structural detail to them. With dark mixes add some grasses and their reflections at the water's edge and with a sharp scalpel carefully scratch in some stalks and grasses, concentrating these near to the brightest area of the painting, across the marsh.

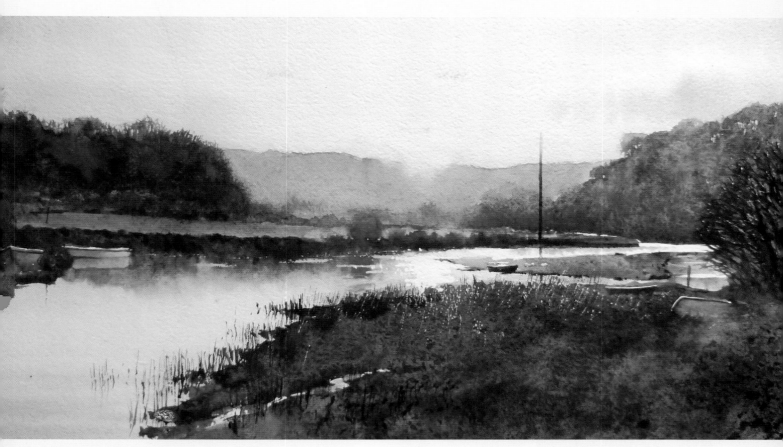

Finished painting: *Sunset at Aveton Gifford*.

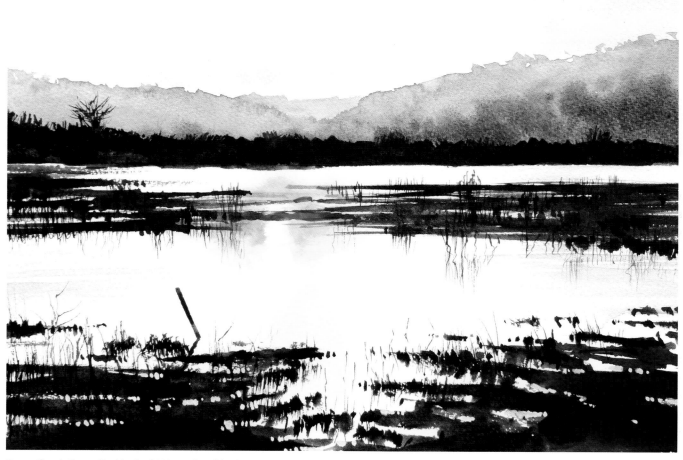

Sunset Sketch. Paper: Bockingford 300gsm (140lb) NOT.
Size: 24 × 33 cm (9½ × 13 inches).

Enjoying the unexpected

Many artists will make sketching trips out to favourite painting grounds to gather information or to work *en plein air*. If the location is known the artist will be aware of the state of the tide, the sun's position in the sky and therefore the direction of light, and even the activity likely to be happening at that time of day. This knowledge is useful in planning the trip; knowing what time of day a particular part of the river will be bathed in glorious sunlight or when it will be cloaked in shadow can make the difference between the trip being a joy or immensely frustrating.

Getting to know a river or area of landscape will always prove valuable and is to be recommended. But no matter how well the landscape is known, an artist's eyes should never be closed to the unusual, unplanned or the unexpected. Simply looking at the river from a different vantage point – drawing from a seated position rather than standing for example – can present a known landscape in a completely unexpected way and can act as a stimulus for new works.

SUNSET SKETCH

I planned an afternoon's work on the banks of the River Avon, one of my favourite painting grounds. It was a rather overcast afternoon in late winter, the light flat and with few shadows to bring contrast and interest to the scene. The incoming tide was beginning to flood the marsh, but it looked dull and lifeless. It had all been rather disappointing and I was beginning to pack my materials away when

the clouds parted and the sun appeared, turning the marsh to gold. The scene was completely transformed. The gap in the clouds wasn't large so I knew that I didn't have time to unpack my gear and make a painting. Hurriedly I made a quick pencil sketch, wrote a few notes, took a couple of photographs on my smart phone and as quickly as the sun had appeared it was gone. The unexpected had provided a moment of magic.

Sunset Sketch is a small watercolour sketch made back in the studio after an afternoon's sketching and is typical of a painting made for a purpose – in this case in preparation for a larger, more considered watercolour. In this smaller watercolour I was able to work out the design and composition, test colours, and to decide on the placement of the underlying horizontal, vertical and angled geometry that makes up the hidden structure of the painting. All of these compositional decisions were made to support the focus of the painting, the reflected sun. In one of those rare serendipitous moments, the angled post actually existed at that position within the design, adding much-needed scale and a vertical to the painting. Place a finger over the post to see how its absence alters the balance and feel of the work. Had it not existed, it would have been necessary to invent it considering the design impact it adds to the piece. It is much better to work these things out in a sketch rather than trying to resolve them mid-way through a larger work.

It was painted quickly, loosely and with energetic brush strokes depicting the marshy foreground and distant hills, with very little reworking or attention to topographical detail, intent as I was to evoke the feeling of the moment rather than a photographic rendering.

A balance of styles

Often students, and indeed some artists, are intimidated by working on what might be described as more considered paintings. These tend to be more finished in style, and are larger and more disciplined; because of the greater investment in time they become accordingly more precious – the paintings have to succeed, which doesn't always lead to the best watercolours. Smaller sketches, or studies, can often by their very nature be less constrained and more open to experimentation than the considered pieces. That's not to imply that sketches aren't as considered as their more finished relations; of course they are. But in a sketch, colours can be tested, designs and compositions arrived at, their success judged on their usefulness

to the artist rather than whether a gallery takes them or they have a red spot stuck to them at an exhibition.

An interesting approach to watercolour exists somewhere between the two – the considered and the sketch – combining both qualities in one painting, whereby some parts of the painting will carry more detail, but others will be looser, sketchier in execution. Arriving at a successful balance between the two can be a challenge, and it doesn't always work, but when it does the paintings seem to have an unlaboured ease about them, a quality well worth striving for.

PASSING SHOWER OVER THE DART

When painting or sketching *en plein air* it's much easier to paint when the weather is dry than wet. But it would be wrong to think that only good weather makes for a good painting. To venture out on just the fine, sunny days means missing out on moody, atmospheric skies, dramatic storms or mist-filled mornings, all of which can be the inspiration for great paintings and are perfect watercolour subjects. For a stream to run it needs water, and that water will have come from somewhere and more than likely the source of the water will be rain. So rather than ignoring it, embrace and welcome it.

The sweep of a storm cloud with rain falling from it across a distant skyline makes for the perfect subject. Dartmoor has its fair share of rain ('liquid sunshine', as I've heard it described on more than one occasion), and on this day the skies were heavy and if it wasn't raining at that moment, it would be very soon.

On the road just beyond Postbridge I noticed a cloud heavy with rain in the far distance. As I looked soft sheets of rain began to fall from it, the detail of the distant moor fading before my eyes. Here, with just a few ingredients, a relatively simple landscape was transformed into something quite beautiful. It was crying out to be painted.

The inspiration for *Passing Shower over the Dart* was twofold: the gently snaking river and the rain falling at the horizon; a deceptively simple landscape painting but one with such a narrow tonal range and so many soft edges it would prove to be challenging. Too much hard-edged detail in the wrong part of the painting and the illusion of rain falling could be destroyed.

The painting needed to be considered as a whole. As with any painting, it would be wrong to consider any part

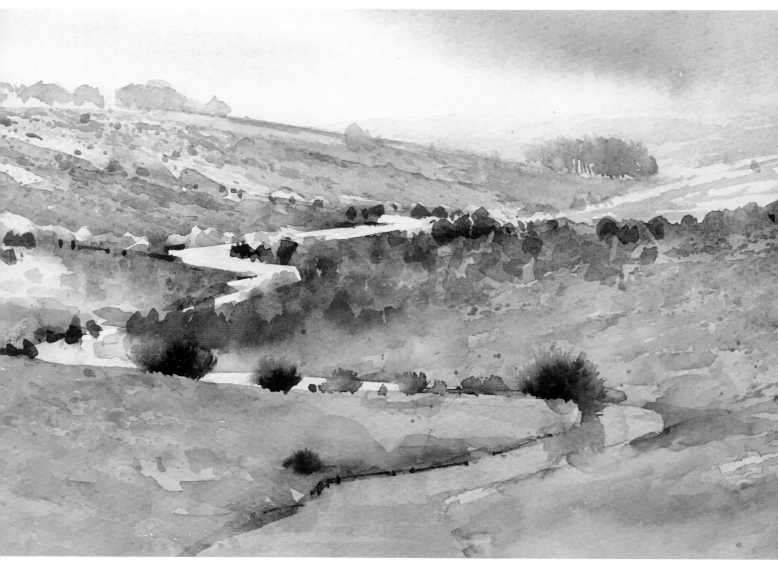

Passing Shower over the Dart. Paper: Bockingford 300gsm (140lb) NOT.
Size: 33 × 22 cm (13 × 8½ inches).

of it in isolation, since any mark, colour, tone or wash in any part of the painting would have an impact on the painting as a whole. At art college I was always encouraged to 'paint all of the painting at the same time'; in practical terms this is an impossibility but the advice has always stood me in good stead in that I always consider the consequence of any of my actions and the impact that they might bring to the painting as a whole.

In this watercolour I had to find a way to balance both the lack of tone and the lack of detail to make a convincing image. Looking across the moor towards the rain I noticed that the river was one of the lightest tones within the scene, in fact it was lighter than much of the sky. That

would prove useful in the design: not only could I use it to draw the eye into the scene but it also presented me with the opportunity to introduce a much-needed light passage amongst the limited tones of the landscape. Growing alongside the riverbank were some dark gorse or thorn bushes. These would also be useful, for on days when tonal lights and darks are in such short supply these dark bushes juxtaposed with the light of river can offer some relief and interest to the limited tones in the rest of the landscape.

The sky's tone needed careful consideration and treatment. It should always be remembered that the sky will invariably provide the light for the landscape below. Make the sky too dark and the landscape loses its source of light.

It is better to under-paint rather than to over-paint the sky; it is always easier to add colour in watercolour than to take it off. A mixture of ultramarine blue and neutral tint was used in the sky. This was painted in two stages: first the sky was painted on damp paper, as were the distant hills in cobalt blue and raw sienna. When this was dried the sky area and distant hills were dampened with clean water, and with the board at a steeper angle the second sky wash was added. The angle of the board allowed the wash to run down over the hills, creating the impression of falling rain.

SPRING ON THE DART

It was a bright spring day when I ventured down to the River Dart near to the small Devon town of Totnes. It was an area that that was relatively new to me as a painting location, although I did know that the English painter J.M.W. Turner (1775–1851) had painted a view upstream to Totnes in 1824 from somewhere close by. The river at this point is tidal, and at the time of my visit the river level was dropping fast, revealing the foreshore that was shining bright in the spring sunshine.

It was a typical spring day, with warm sunshine one moment and a chilly blast the next. The far bank was changing from moment to moment as the clouds cast shadows on the gently sloping hills and fields. The skeletal trees were just beginning to show signs of waking after the winter. The Dart seemed big and full of light as it sparkled and reflected the blue of the spring sky.

Having settled at the end of a footpath I sat and looked at the scene before me for a few minutes, not rushing to sketch or to take photographs, but just getting to know what was there; to take notice of how the reflections altered as the wind ruffled the river's surface, and how the light changed on the water according to the brightness of the sunshine. The colour in the trees on the opposite bank, for example, would change from a grey to a purple as the light altered. Time spent just looking can be extremely useful for the artist, and here it helped to focus my attention. I was struck by the open, fresh feel that the river had about it that morning. Spring was very much in the air and I was excited by the prospect of painting it.

After sketching, making some colour notes and taking some photographs to support my intended painting I returned to the studio to plan it.

STEP BY STEP DEMONSTRATION

Spring on the Dart

Paper
- Two Rivers 300gsm (140lb) NOT
- Size: 35 × 39 cm (13¾ × 15¼ inches)

Materials and equipment
- 2B pencil
- Masking fluid
- Sparkle brush
- Nylon masking brush
- Brush soap
- Dip pen
- Sable brushes, size 14, 10, 8, and 4
- Old bristle brush
- Palette
- Kitchen roll
- Maskaway eraser
- Painting board

Artist quality watercolours
- May green
- Ultramarine blue
- Permanent rose
- Green gold
- Winsor blue (green shade)
- Transparent oxide brown
- Burnt sienna
- Neutral tint
- Raw sienna

I wanted to convey both the openness of the location, with the broad river taking centre stage, and the airiness of the day. These would be my inspiration and focus.

The design of the painting comprised two strong diagonals, one from bottom left foreground moving the viewer's eye towards the centre on the scene and the other moving the viewer downstream and further into the painting, with the dark on the far bank acting like a signpost pointing out which way to go. I was once told that all paintings are made up from triangles. I'm not certain that I completely agree with that. But I do find that by simplifying scenes into triangles, or shapes approximating to triangles, that it helps in building the underlying structure of the painting. To consider it in such fundamental geometric shapes makes it much easier

to move the viewer's eye around the painting. For example, the foreshore on the left creates one triangle, pointing into the painting; the bank and hills are another one, leading the eye back into the watercolour with the group of trees acting as a stopper, preventing the viewer's eye from falling out of the image.

The colour choice was for strong, fresh colours; the May green and Winsor blue in particular would offer this. However, the Winsor blue needs to be used carefully; it is such a strong colour, it can easily overpower others colours both on its own and within a mix. A little of this really does go a long way.

The foreground of the painting was to be very textural in execution and the choice of this randomly textured paper, Two Rivers, would complement the effect I wanted to achieve.

Drawing and masking.

Step 1: On the stretched paper loosely draw out the main features with a sharp 2B pencil. With the sparkle brush apply masking fluid to the sunlit areas of the river; apply it rapidly, concentrating the largest area of the masking fluid in the centre of the patch of sunlight. With the nylon masking brush mask out a few sparkles on the stream to the left, pick out some of the larger stones, and mask out the foreshore by spattering masking fluid; remember to protect the rest of the painting with scrap paper. Flick some masking fluid over the bottom part of the trees on the left and draw in a few masked branches with the dip pen. Allow these areas to dry fully before adding any paint.

Sky washes.

Step 2: Mix puddles of pure Winsor blue and ultramarine blue with permanent rose, and with the board at a slight angle, on dry paper paint in the sky with a No. 10 brush, leaving the unpainted white of the paper to become the clouds. Concentrate the ultramarine blue/permanent rose mix towards the bottom of the sky. Be careful not to lose the shape of the clouds by painting in too much of the Winsor blue. Leave to dry.

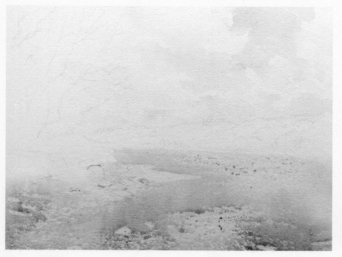

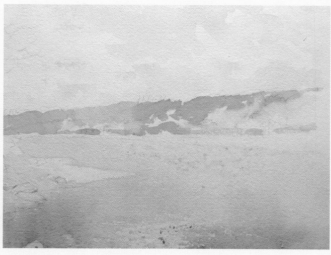

River washes.

Step 3: Having previously prepared puddles of pure Winsor blue and ultramarine blue with permanent rose, slope the board at an angle of about twenty degrees and dampen the river area with plenty of clean water, letting it soak into the paper for a few moments. The exact timing depends on a variety of things, but normally if the shine on the paper changes to a dull matt then the paper has dried too much; look for the moment the shine just begins to go and then work into it. With a well loaded No. 14 brush add the washes of colour, letting them merge and flow down the paper together. While the colours are wet you can go back into the washes, but as soon as the wash begins to dry put the brush down and leave it alone, don't fiddle. So many watercolours have been ruined by artists not putting their brushes down and staying back from the painting when they should have done so.

Initial washes for hillside and far bank.

Step 4: With the previous step completely dry, use a No. 8 brush and mixes of May green with green gold to lay down washes for the far bank and distant hill, varying the strength of the green as you paint to create a more natural effect.

Creating tree textures.

Step 5: Tear some scraps of paper to act as mask when spattering the main tree group to the left. Torn edges produce a far more natural looking edge to the foliage than a sharp, cut edge. If the shape to be masked is very complex, tear the shapes separately and stick the pieces together with masking tape. Mix a wash of burnt sienna and green gold and with an old, round bristle brush spatter it on allowing it to gather towards the bottom of the trees. It is important not to allow the spatter to dry with the mask in place, as this can often act like a wick and draw colour to it which in turn can spread to the watercolour paper, leaving an unwanted blotch. Therefore without dragging the paint, carefully lift the mask, putting it to one side to dry; it can be used again.

Allow this to dry fully before adding the next slightly darker spattered layer. With this layer still damp, pull a fine rigger through some of the marks to create trunks and branches. Allow to dry fully before moving on to the next step.

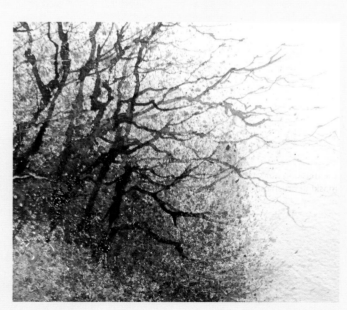

Adding branches.

Step 6: With the board flat and the previous stage completely dry, mix a wash of neutral tint and transparent oxide brown. With a fine pointed No. 4 brush, draw in further branches. Use both a fine rigger and dip pen with the same mix to draw in the thinner branches. Get the dip pen working on some scrap paper before using it on the painting; these pens can often blob annoyingly before flowing freely. It's useful at this stage to have some reference drawings or photographs of trees to work from.

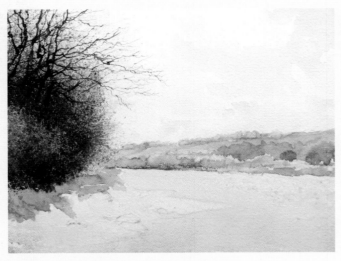

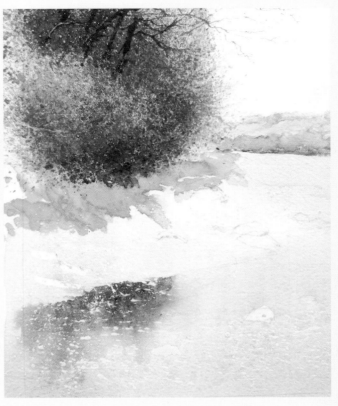

Developing the banks and distant trees.

Step 7: Mix washes of May green with green gold, green gold with ultramarine blue, and permanent rose mixed with ultramarine blue. Vary the strengths of the mixes and paint in the trees on the far bank with a No. 8 brush. Think of shape rather than detail; there is no need to paint in every leaf, or branch or twig, as at this distance they wouldn't be seen. Use dry brush strokes for the nearer stand of trees, the broken effect of the stroke allowing the green of the fields to be seen through them. Paint in the bank with raw sienna, dropping in a little of the permanent rose ultramarine mix as you move along. When this is dry, strengthen the bottom of the bank with a stronger version of the same mix.

On the nearer grassy bank add pure May green and green gold, letting them mix together on the paper. Allow all parts to dry. In the immediate foreground, and with the rest of the painting protected with a scrap paper mask, flick on some permanent rose and ultramarine blue to create foreground texture.

Tree reflection.

Step 8: With a large brush and clean water dampen the paper immediately below the main trees and bushes. Tilt the board slightly and with the colours used in the trees; burnt sienna, green gold and transparent oxide brown, drop in the colours at the top edge of the damp paper. The colours will flow downwards creating the reflection. Keep the board at the same angle when letting the paint dry, as any change of angle might result in a cauliflower.

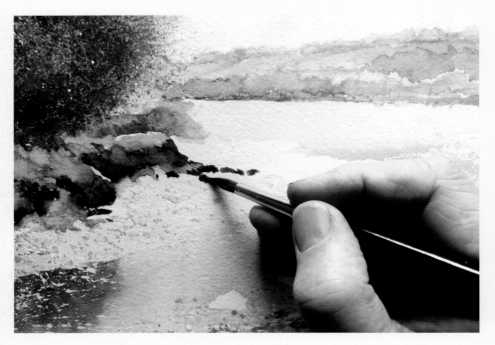

Remove the masking, build the banks and finish the painting.

Step 9: Make certain that the painting is completely dry and the using the Maskaway eraser carefully remove all the masking fluid. With a No. 8 brush and washes of ultramarine blue with neutral tint, begin to paint in some of the details on the near bank, picking out rocks and stones as you move along the bank. There is no need to paint all of them as this will make this part of the painting too busy to the eye and detract from the focal point, the light on the river itself. Add a few leaves to the main tree, using mixes of green gold and burnt sienna. These larger leaves will help to bring a sense of scale to the trees, appearing to bring them further forward towards the viewer; by so doing the hill and trees on the far bank will appear to recede further into the distance, thereby creating a greater sense of openness and space within the painting.

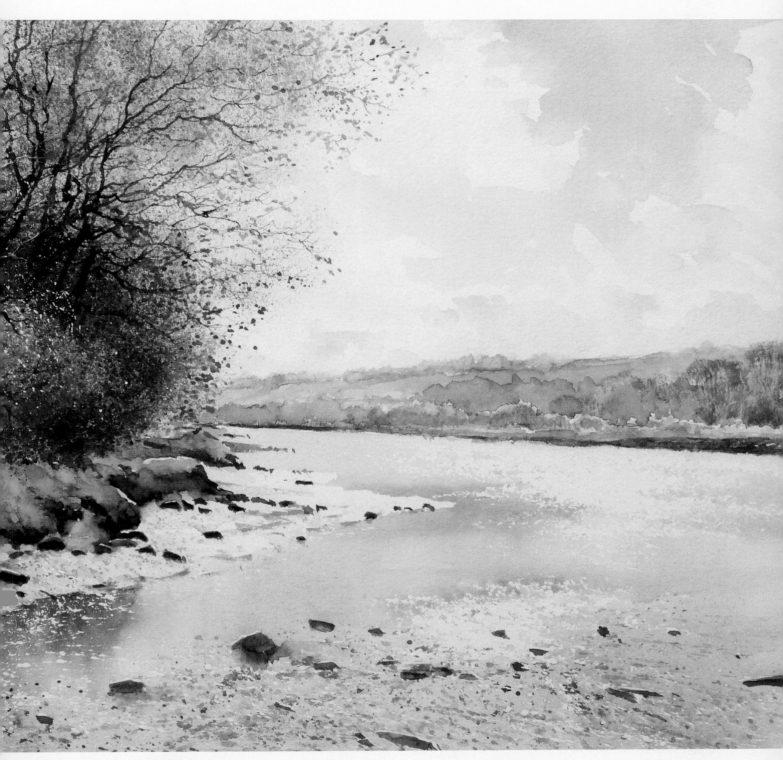

Finished painting: *Spring on the Dart*.

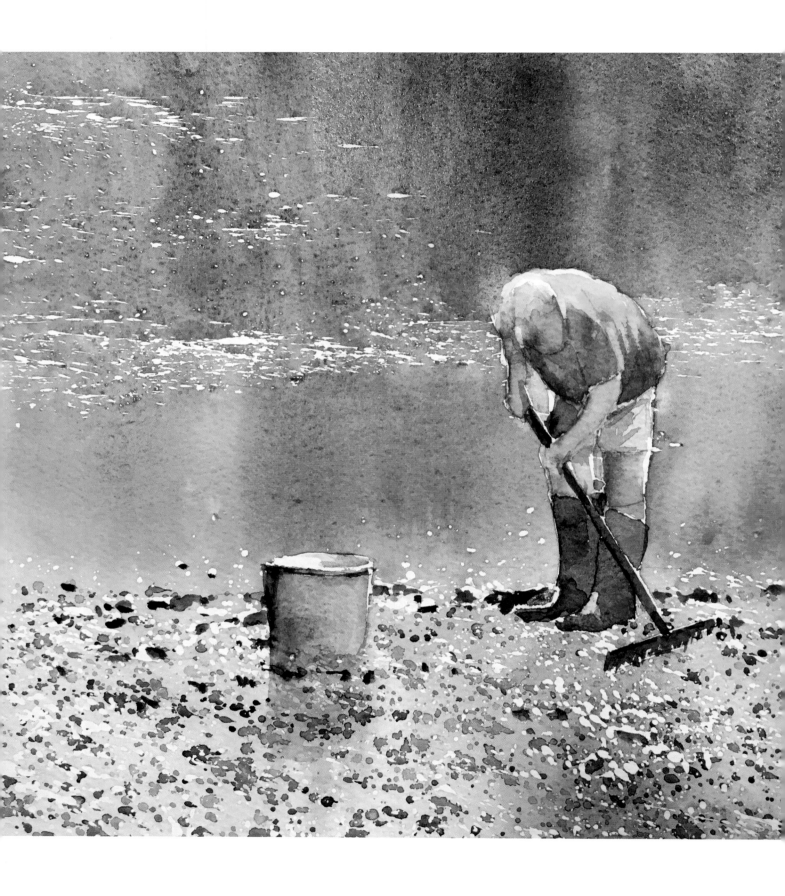

The Working River

There is nothing – absolutely nothing – half so much worth doing as simply messing about in boats.

KENNETH GRAHAME, *THE WIND IN THE WILLOWS*

...unless of course you are painting them.

T he working river can provide the artist with a wealth of painting opportunities. It doesn't have to be a large, busy port or harbour full of hustle and bustle – you are just as likely to find something of interest with just a few moorings, a small slipway or a single boat resting at low tide in a little-known creek. All provide potential painting opportunities to the keen-eyed artist.

It might not be boats themselves that provide the interest – it could be a fisherman digging for bait, a rotting mooring post with drooping ropes, or some rusting chains running up the riverbank to an upturned bucket.

In the work of John Constable it is clear where his interests lay. His paintings are full of the subjects that attracted him to put paint to paper; where other artists might have overlooked them he choose to include them. As he wrote to a friend in 1821, '...the sound of water escaping from mill-dams, &c., willows, old rotten planks, slimy posts, and brickwork, I love such things.... As long as I do paint, I shall never cease to paint such places. They have always been my delight.' He painted what interested and excited him: a good starting point for any painter.

Boats

Boats have long been a source of inspiration for artists and I'm no exception. Whether in full sail, moored at a pontoon or simply left high and dry at low tide, they excite me and attract my attention.

They offer much by way of shape and colour, scale and interest; a carefully placed boat can bring a scene to life. But many students find the painting of boats rather difficult. With so many seemingly awkward curves and odd angles, taut rigging lines, tall masts, short masts, outboards and cuddies, it can all look rather confusing and difficult to interpret in paint.

So where to start? As with so many things, before we start painting we need to start looking, and what better way to look than to draw? The more time you spend observing and analysing boats, the more aware you will become of what makes a boat look like a boat. Try to draw them as often as you can and in as many different situations as possible.

Boats, by their very design, are made to move, to float, to sail or motor away. This can be immensely frustrating when trying to draw them. One solution is to start with boats that are out of the water, or at the very least left high and dry at low tide. Boatyards, sailing clubs and tidal rivers are ideal locations to find these.

It also provides the added bonus of being able to see how much boat is lost from view when in the water; although not quite of iceberg proportion, it is quite significant. As a college lecturer once said to me about the benefit of life drawing, not only was it a good discipline to help improve one's drawing, especially of the nude; it also helped in the drawing of clothed figures as well, in that the

Sketchbook studies of boats and structural details. Pen and ink, 22.5 × 30 cm (8¾ × 11¾ inches).

With some boats out of the water at low tide I was able to take the opportunity to sketch some of the details often lost from view, in this case the propeller and rudder in preparation for a planned painting.

artist was aware of the mechanics of the figure that was lost from view by being clothed. The underlying logic of movement and structure was understood and the figure would not be placed into positions that the mechanics of the human form would find impossible. I think the same things can apply to boats. By having an awareness of the boat's structure, any drawing or painting of them will carry greater authority.

One of the easiest ways to observe the shape of boats is with strong sunlight coming from behind them, in the early morning or late afternoon. Artists refer to this effect as *contre-jour*, from the French meaning 'against daylight'. The strength of the light reduces the boat to an almost silhouetted shape, with much of the fiddly (often distracting) detail lost in the light. This reduced, simplified form makes it much easier to asses and draw the boat's shape.

Like people, boats come in many different shapes and sizes – some long and thin, others shorter and much dumpier. Including different types of boats will make for a more pleasing painting, as it adds interest and variety.

With the right amount of visual context clues, the viewer will complete the painting for you. In the example here, one boat and its reflection has been painted in sufficient detail to be easily recognized.

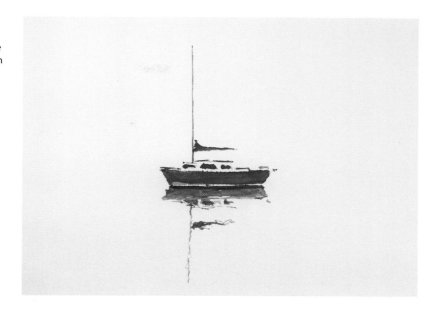

In this next stage, simple boat-like shapes have been added to create the impression of a busy mooring. On closer inspection you note that hardly any boat-like detail is included with these added shapes. However, the thin vertical lines will be read as masts, the horizontal shapes as the hulls of boats or pontoons, as the shapes are read and given meaning to them when seen in context with the more detailed boat. We see 'boats' as all the clues contained within the image point towards the shapes being so.

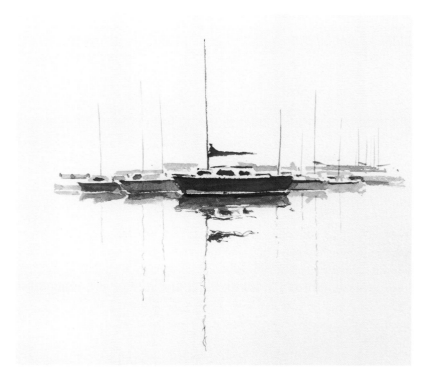

Be selective

One problem that often arises for artists is the level of detail to include in their paintings, particularly when painting the rigging lines or the masts on boats. These are often painted so strongly and so thickly that they appear out of all proportion to the rest of the vessel and detract from the finished work.

It is not necessary to paint in everything that you can see, or at times more damagingly, everything that you know to be there. Often this level of detail can detract from the rest of the painting as the viewer is drawn to this part over all others, like a moth to a flame. An indication will often be all that's needed; a few well placed strokes to suggest a rope and the viewer will complete it for you. Learn to be selective by picking out the most important features. Don't over-complicate; less can be more and will probably give you a better result. Aim not to produce the portrait of a boat but rather the *character* of the boat (what I like to call the 'essence of boatness').

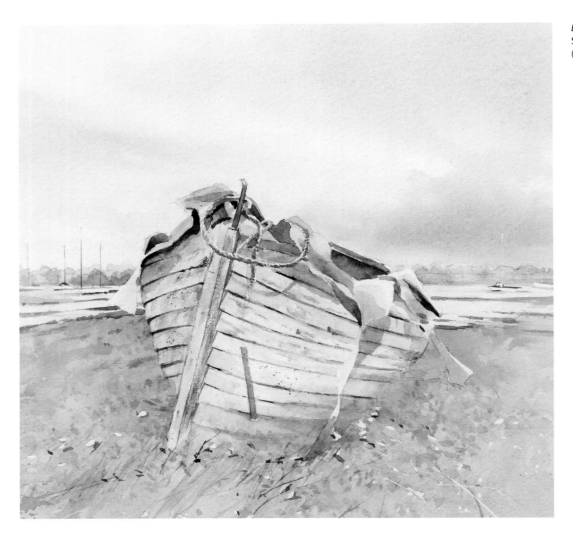

Better Days.
Size: 32 × 31 cm
(12½ × 12 inches).

I don't expect you to become a master boat builder just by drawing and painting them; however, by observing through pencil and paint you will begin to see how a boat is constructed, such as how tall masts are likely to be and where they might be placed, at what angle an outboard motor might hang over a boat's stern, or how boats sit in the water.

Equipped with this greater visual knowledge it will be easier to render realistic-looking yachts and boats full of character that will add life and interest to your paintings.

BETTER DAYS

Abandoned boats, rotting hulks or dinghies awash with water now only used by perching birds provide rich pickings for the painter.

This once-loved wooden dinghy was gradually succumbing to the tides and the weather. The faded paint was peeling and flaking, the tarpaulin, shroud-like and gradually disintegrating, was bleached almost white from countless summers, and the whole thing was beginning to settle into the marshy riverbank. With its interesting textures and shapes it was a painting waiting to happen.

After some time walking around it, viewing it from every angle I decided that a low vantage point would work best. From that viewpoint, looking slightly up to the boat, it acquired a monumentality, like a sculpture on a plinth – a fitting farewell to the now sad little vessel.

The colours were chosen to reflect the mood of the painting, nothing too bright. The muted colours within the scene itself worked well, reinforcing the rather sad and forlorn atmosphere.

A dark looming cloud to the right pushes the boat forward. But it also serves as a reminder to the viewer that a storm is brewing; potentially bringing further damage to the small craft, bringing its eventual demise even closer. It seemed fitting to paint it at low tide, as the boat had long

since proved unseaworthy, its usefulness long gone. It was almost as if the river had laid it reverentially to rest on the marsh and then retreated leaving it to its fate. In the distance other yachts and small pleasure craft looked on, yet – in a strange synergy due to the state of the tide – they were also going nowhere.

For many, this might seem to be rather overdoing the planning, giving so much attention to a small watercolour painting. But this level of consideration leads to a more powerful, satisfying image with all the elements that make up the painting being used to support the overall vision.

All too often when painting or looking for subjects one will come across a view that presents all the elements that would make for an interesting watercolour. Perhaps trees need to be moved, figures added, or boats left out completely. Seldom will a scene be perfect as it is, requiring little or no further action on the artist's part. *Better Days* was one of these rare occasions.

LOOKING UPSTREAM FROM GREENWICH

I rarely get to see truly industrial, busy working rivers, living as I do on the edge of Dartmoor in the southwest of England. So a trip to London was the ideal opportunity to paint one of the country's most iconic of rivers, the Thames. A waterway most unlike what I was used to painting, I hoped it would be worth the trip.

Once in London it didn't take me long to get down to the river and, armed with sketchbook and camera, I went searching out painting locations. The river was full of sightseeing cruisers, police launches and the occasional pleasure craft. The working river was certainly at its most active. Heading downstream on the south bank I passed the Globe Theatre, London Bridge, HMS *Belfast* and Tower Bridge. There was lots to see, and much to paint and draw for many, but for me nothing excited me enough to put pencil to paper. These quintessential scenes of London were perhaps a little too 'chocolate box'-like for my taste.

I walked on, wondering if I was being too fussy in looking for somewhere to draw or paint; perhaps I should just get on with it and it would all work out in the end. But that approach would have been wrong – with all my experience of watercolour painting over the last forty years I would suggest that if the interest or inspiration isn't present from the concept then the resulting painting shows it. It is as if the lack of excitement felt by the artist comes out in the painting and is communicated to the observer; the painting needs a spark. Without this it lacks integrity and authority. Therefore I believe it to be absolutely essential that the artist should be true to themselves and paint what really interests them. That's were the spark burns brightest. This is not to suggest that painting exercises or other genres of painting shouldn't be considered or investigated, particularly when new to watercolour painting, but once a basic understanding of the medium has been attained then the choice of subjects should be carefully considered and the artist should choose the ones they find the most interesting.

It's also very useful to break down and analyse the reason behind these choices. For example, if a landscape is the preferred choice of subject matter, try to work out what it is within the landscape that has captured the attention. It might be the colours, textures, the light or shadows. Whatever it is, once these areas of interest are discovered, then the artist can start to build paintings around these choices.

My interest in landscape painting centres around the effect that light can bring to a scene; shadows, sparkles and light-filled skies all interest me and have become the starting point for many of my paintings. Other things within the landscape might catch my attention and interest me, and I'm always open to other stimuli – an artist cannot afford to be blinkered – but I tend to notice the light first and and the effect it has within the landscape. At this point I invariably begin to consider how I could develop what I see before me and turn it into a painting. Light excites me, it's what I enjoy painting and I return to it as a subject again and again.

It's worth stating that the artist's choice of subject matter is one of the key factors that often begins to define an artist's individual style. Looking skywards I noticed that the clouds were beginning to thin and the weak sun was beginning to peep out and that could only mean one thing: light. So I went in search of light on water.

I eventually arrived at Greenwich Pier and was able to look upstream towards the city. The strong light bouncing off the water had reduced the boats, buildings and tower blocks to little more than abstract shapes; I had found my inspiration.

With a few quick sketches, some colour notes and photographs, I had gathered enough information to make a painting upon my return to the relative comfort of my studio.

The design

I decided quite quickly to employ an almost square format for the painting, with the sky filling approximately the top third and the remaining two thirds the river and buildings. Much of the central part of the painting would be taken up with the light sparkling off the water. A lot of masking fluid would be needed to create this effect and the choice of Two Rivers paper was partly dictated by this, as I knew it would be easy to remove from this type of paper, and partly by the surface texture of the paper, the random nature of which would help in creating interesting granulation patterns.

As the scene would be painted *contre-jour*, the colours would appear to be bleached out and the amount of visible detail reduced. Therefore I decided to simplify both colour and detail, choosing to concentrate on the shapes of boats and buildings instead.

The underlying colours of the watercolour would be blues, purples and warm greys, the mixes being made from granulating colours which would create interest within the washes themselves as they settled on the paper. The simple horizontal design of one third sky and two thirds land, which can look at times a little staid, was enlivened by the strong diagonal of the embankment wall to the left with the railings above. This dynamic movement leads the viewer's eye into the painting, with the tall, thin, triangular shape of the Shard skyscraper to the right acting as a stopper, preventing the viewer's gaze from falling out of the picture. Just as important as leading the eye around the painting is deciding what that design needs to prevent the eye leaving the scene. Trees, masts, buildings, even clouds or patches of colour can be used as stoppers to arrest the viewer's visual movement out of the painting and redirect their attention back into the painting.

In order to bring a little contrast and some warmth to the blues and greys a little orange would be introduced to the sky, and some browns to the top of the wall on the left.

STEP BY STEP DEMONSTRATION

Looking Upstream from Greenwich

Paper
- Two Rivers 300gsm (140lb) NOT, stretched
- Size: 30 × 33 cm (12 × 13 inches)

Materials and equipment
- 2B pencil
- Masking fluid
- Nylon masking brush
- Sparkle brush
- Sable brushes, size 10, 8 and 4
- Scalpel
- Palette
- Ruler or T square
- Kitchen roll
- Maskaway eraser
- Painting board

Artist quality watercolours
- Ultramarine blue
- Cobalt blue
- Winsor blue
- Burnt sienna
- Permanent rose
- Cadmium orange
- Neutral tint
- May green
- White gouache

Drawing and masking.

Step 1: After working out the format and design of the watercolour use a 2B pencil to draw in the outline of the subject. Be careful not too add too much detail even at this stage: think shape, not detail. With a fine nylon brush, apply the masking fluid to the main boat and pick out one or two details on the distant bank. Allow this to dry completely.

To create the bright sunlight on the water, use the sparkle brush to roll masking fluid onto the paper. Make certain that the central section is well covered as this area will represent the strongest concentration of light. Vary the angle of application slightly in order to portray the movement of the water caused by tide, wind or wake.

Sky washes.

Step 2: Checking that the masking fluid is completely dry, dampen the sky with clean water and allow it to soak into the paper slightly. With a pale wash of cadmium orange paint in some cloud shapes across the full width of the sky at the horizon. Let the colour flow over the distant buildings using a No. 10 brush. With the paper still damp add some pale Winsor blue below the cadmium orange and cobalt blue above. A little cobalt is also added to the orange on the skyline and with kitchen roll some small clouds are lifted out. The colours will mix and merge on the paper creating soft-edged blends and these will act as a contrast to the hard edges of the silhouetted buildings. Allow this to dry.

Creating waves.

Step 4: With the previous stage completely dry, using a damp brush lift off a little of the colour in the foreground to indicate small waves. Don't take these marks too far up into the river as the sense of scale will be lost and what would look like a gentle swell close to the viewer could appear to be tidal wave in the distance.

River washes.

Step 3: Mix pure puddles of ultramarine blue, permanent rose and neutral tint. Working on dry paper with a No. 10 brush, paint the river, varying the colours as you paint. The paints will mix together on the paper producing a variety of colours that will bring interest and texture to the river. As these begin to dry, but with the paper still damp, drop in some neutral tint near to the embankment wall on the left.

Distant buildings.

Step 5: With stronger mixes of the washes used for the river and a No. 8 brush, paint in the buildings. Vary the strength of the washes and allow the colours to flow from building to building. Allow these to dry and add further washes to define structure but not detail to the skyline. When building up the washes, leave a few gaps to represent windows, but be careful not to overdo these or they will become too intrusive within the overall design and create unwanted attention.

Embankment wall.

Step 6: In order for the light on the water to stand out, some strong tonal contrasts need to be introduced. The embankment wall is one such opportunity. Mix a good puddle of burnt sienna and ultramarine blue and paint the very dark wall with the mix. Add the same mix to the bottom of the buildings seen through the fence. If a hard edge begins to form at the top, soften it with clean water. When this dries, using some burnt sienna paint in the top of the wall and buttresses.

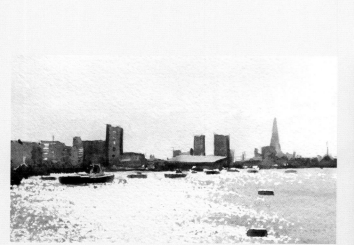

Adding structure.

Step 7: Checking with kitchen roll that all the paint is dry, carefully remove all the masking fluid. With the mixes used for the buildings, paint in the boats and buoys. Treat the painting of the boats and buoys in the same way as the buildings, concentrating on shape over detail. With the small No. 4 brush take some May green and a little burnt sienna and touch in the leaves on top of the embankment wall. Let the painting dry completely.

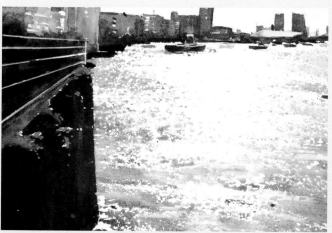

Final touches.

Step 8: Use a T square or ruler check that the buildings are standing upright and vertical, and adjust if necessary. With white gouache or acrylic ink, paint in the fencing, running the ferrule of the No. 4 brush along the ruler's edge to keep the lines straight. When this is dry add the fence posts, making sure they stand vertical, using a dark mix and finish each one off with a spot of white at the top. In order to define the embankment's buttresses use a scalpel or sharp knife to scratch carefully up the sunlit edge of each one.

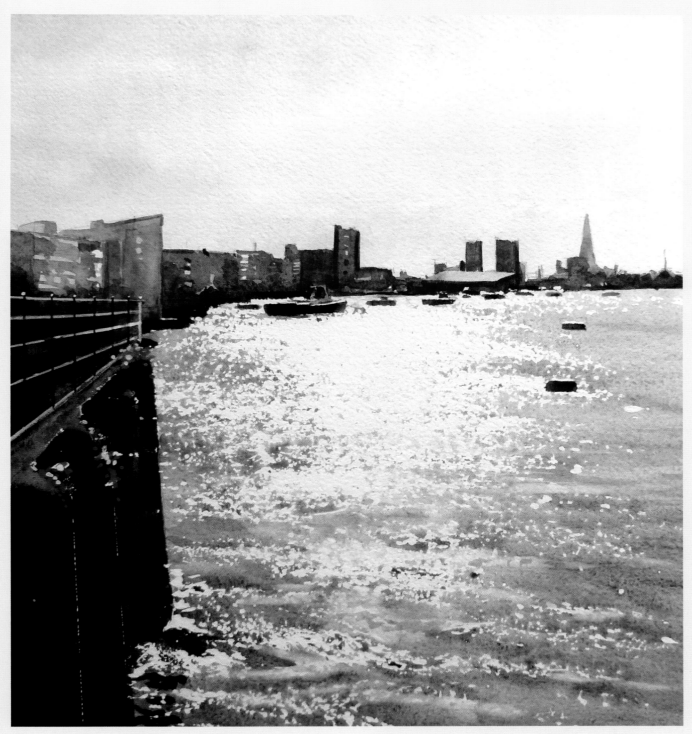

Finished painting: *Looking Upstream from Greenwich*.

Figures

The inclusion of people can bring a painting to life, transforming a scene with human interest, especially if they are doing something. But the would-be painter will often shy away from their inclusion or, worse still, populate the painting with figures that resemble little more than shop mannequins, standing around without really doing anything or adding anything to the design, sometimes even distracting the viewer by their careless placement and execution. A well-placed figure or group of figures can help to bring distance, a sense of scale and variety to the painting.

Imagine a busy marina with a number of figures all standing perfectly still, arms by their sides all looking in the same direction. Not only is it highly unlikely but it would also look very false. Now imagine the same scene with the figures engaged in some sort of activity: some coiling ropes, others chatting, a few pulling on ropes or climbing aboard. How different it would it look and feel; alive, and full of interest for the viewer.

To create images like these the artist needs reference, to have gathered information, a library of figures ready to be called on when making the painting. Photographs, as we have seen already, have a part to play when gathering information, but when it comes to collecting figure references then drawing is best. Obviously a snapshot can record a person in a fraction of a second, but a drawing that has taken time to create can often reveal more about the figure than a snapshot ever can.

The artist, when drawing, will be noticing many things about the figure; the way light might pick out a shoulder, the angle the figure stands at, the colour of a shirt or the tilt of their head. All this information is fed into the drawing. To do this in a few minutes takes a great deal of practice, but the effort is worth it. Keep a sketchbook in your pocket or bag and whenever the opportunity arises, use it. In all my years of drawing only once have I been asked what I was doing, and even then asked very politely. If possible join a life drawing group or go out with others if you are nervous about working alone.

On a practical level, start with figures that are likely to keep the same position for a few minutes, or if not the same position then at least one that has a repeated action; when reading a paper for example, the pose is held for a short time, then the page is turned and the pose held again. People drinking coffee, having a picnic, or waiting for a train all make good subjects; the more you do the better you will get, and the more useful their portrayal will be in paintings.

THE BAIT DIGGER

The Bait Digger is a watercolour study that I painted back in the studio after sketching this would-be fisherman raking up bait on the river's foreshore one summer afternoon.

He was ideal to sketch, as he stayed within a very small area of the shore and repeated his raking action at regular intervals, making it relatively easy to capture him in pencil. I made some written notes about the colour of his shirt and how the light was catching his boots and almost at the same time as I had finished gathering information he had finished gathering his bait and was gone.

It is worth pointing out that at no stage did I try to draw his face; for the painting I had planned it wasn't needed and this detail might well have distracted the viewer from the rest of the painting. I also simplified the hands into workable shapes – no fingers and thumbs to get in the way. Detailed facial features, fingers, thumbs and feet are seldom needed to convey convincing-looking figures in watercolour riverscapes.

Back in the studio I drew the figure out a couple of times until I was happy with it and then transferred the design onto watercolour paper using tracing paper.

The figure was the painting, meaning that both the foreground and the background elements needed to be simply painted in order not to divert attention away from the figure. Dividing the horizontal elements of the design into approximately two thirds river and one third foreshore, using masking fluid I masked out a few flicks on the river and spattered the foreshore to indicate sunlit stones or shinning pebbles. The figure was completely masked, as was his bucket, to allow me to add washes freely without having to worry about painting carefully around the figure and bait bucket.

The masking fluid prevents the wash coming into contact with the paper's surface, but paint will still land on the masking fluid layer and can stay wet for much longer than the paint that is on the watercolour paper. This can present a problem for the unwary artist. On many occasions I've seen students about to remove the masking fluid after only checking that the wash is dry on the paper paying no attention to whether there is any wet paint on the masked area. To have carefully protected an area of the painting only to have wet paint smeared across it when removing the masking fluid can be immensely frustrating and can easily be prevented.

Before removing masking fluid, particularly over large areas of the painting, lay a piece of kitchen towel over it.

With selected areas masked I was able to add plenty of colour-rich washes freely and without being inhibited by having to painting carefully around intricate shapes.

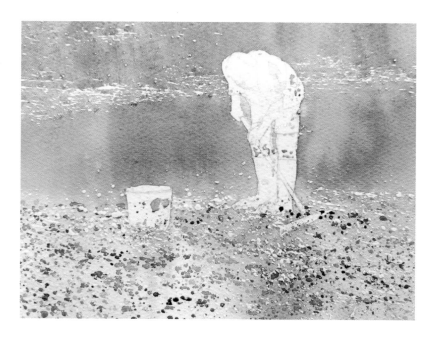

The Bait Digger.

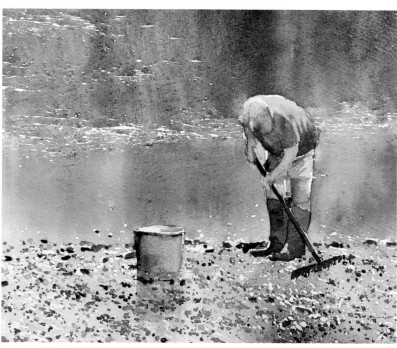

If it picks up some paint don't try to remove the masking fluid; wait for a few more minutes and try again. Patience, it is said, is a virtue – in watercolour it is a necessity.

After the masking fluid was removed from the figure I painted him simply and directly, allowing the colours in his face and hair to run into one another. Only when the figure was fully dry did I add some further washes to emphasize both shape and form.

The phrase, 'it's about as exciting as watching paint dry', used when something is so unexciting that it verges on boredom, is well known. But in respect of watercolour watching paint dry is always exciting, as is watching a clean water wash drying on watercolour paper. Getting to watch washes drying and understanding how the stages of drying can influence the behaviour of additional washes is an essential requirement of the watercolour painter's art. A thorough understanding of when to add paint, and conversely when not to add it, was behind the success of *The Bait Digger*.

Add colours too soon to a very wet wash and the paint can have little effect; too late when the wash is almost dry and the colours will have no chance to mix and merge. Time spent adding paint to wet, damp or almost dry paper will reveal the different effects that can be achieved, and suggest how they might be used in paintings.

WOODBRIDGE WORKINGS

Woodbridge is a busy Suffolk market town on the banks of the River Deben. It is loved by many artists and I am no exception; when in the area I always make my way down to the river with sketchbooks, paints and camera at the ready and a buzz of excitement about me.

Whenever I visit Woodbridge it always seems busy – boats on the water, dinghy races, building work going on, and the famous tide mill acting as the backdrop to all the hustle and bustle – and this trip was no exception.

Everywhere I looked there was something happening. Visually it was a very complicated scene, and therein can lie the problem. If the artist concentrates on putting every busy detail they see before them into the painting, the consequence will be that the viewer won't know where to look. It's the artist's responsibility to make certain that this doesn't happen.

It is absolutely essential to give careful consideration to what the painting is about. This clear visual objective will help when deciding on the design of the painting, particularly when deciding what to put in and what to leave out. This is an area of painting that often terrifies the inexperienced and the experienced artist alike. It would be wrong to state that anything can be left out of a painting: a view of the Houses of Parliament without Big Ben would be rather disappointing, but the same scene with one less pedestrian in the painting would make very little difference. Here on the Deben, is the overall success of the painting going to be compromised if one rope is omitted, or a mooring post left out? No, it won't be. The artist will look at the view in front of them and consider it the starting point for a painting, not the finished article. They will,

if you like, be prepared to take all the pieces they see and rearrange them into a design that expresses the response they as artists have had towards the scene; changing colours, altering tone, increasing height – all and any of these will be considered in order to make the painting work.

I regularly leave out trees, boats, buildings, even people if I believe that their inclusion might create confusion, or unbalance my painting. Conversely, I will invent and include trees, boats, buildings or people if my design needs it.

Many will have heard of the legendary 'artist's licence', which gives the holder permission to alter or distort the truth; I carry mine with me every time I paint and use it frequently.

The complementary pairing of orange and blue was what caught my attention first when out sketching at Woodbridge. The little boat lying at a slight angle at low tide on the Deben, with its juxtaposition of bright orange-red fenders and blue hull clamouring for attention, would be my focus for the painting. The challenge would be to balance boat and fenders with the extremely complicated background so that the focus remained where I wanted it, not becoming lost in the elaborate distance.

In order to concentrate the viewer's attention I chose a square format; a more traditional landscape format would have left too much space to the side of the boat. I decided to minimize any reflection as this would have detracted from the main area of focus. I also simplified the background, blocking in shapes to hint at objects rather than accurately define them. The background was painted within a very narrow tonal range and with similar colours. This approach would help to push the background into the distance, and the use of stronger colours and a wider tone range would bring the more detailed foreground forward.

I wasn't certain if the painting needed the inclusion of some figures to bring scale and interest to the scene, so I sketched out a few alternative designs. On reviewing them, I felt that their inclusion took too much attention away from the focal point and I therefore chose not to include them.

Woodbridge Workings

Paper
- Two Rivers handmade 300gsm (140lb) NOT
- Size: 32 × 32 cm (12½ × 12½ inches)

Materials and equipment
- 2B pencil
- Masking fluid
- Nylon masking brush
- Sable brushes, size 10 and 8
- Palette
- Ruler
- Kitchen roll
- Masking tape
- Maskaway eraser
- Painting board

Artist quality watercolours
- Ultramarine blue
- Cobalt blue
- Winsor blue
- Raw sienna
- Burnt sienna
- Quinacridone gold
- Cobalt violet
- Neutral tint
- Lemon yellow
- Cadmium red
- Permanent rose

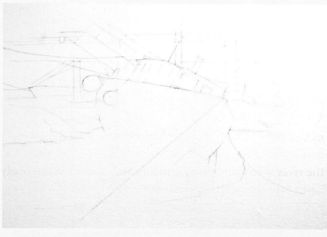

Masking and drawing.

Step 1: With the design resolved, sketch it out onto the stretched watercolour paper using a 2B pencil. The mooring line to the left, the gangway and the walkway are strengthened and straightened with the use of a ruler. Apply masking fluid to some of the lines, the large mooring post, boat stack and some patches on the foreshore and leave to dry.

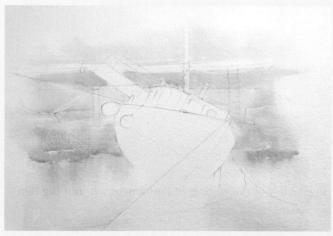

First washes.

Step 2: Dampen the paper with a wash of clean water but keep the boat area dry. With mixes of raw and burnt sienna, and pure quinacridone gold, paint in the muddy riverbank allowing the colour to flow freely down the paper into the river. Keep the board at a slight angle. Mix ultramarine blue and burnt sienna and paint the background in with loose brush strokes.

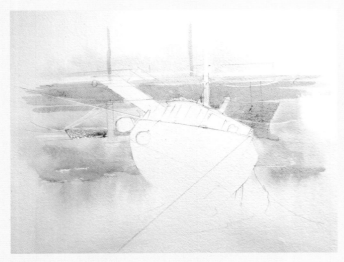

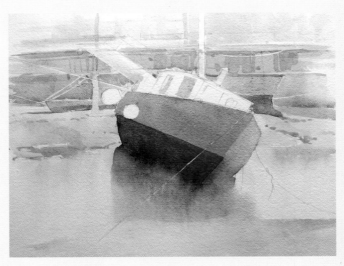

Build up the background structure.

Step 3: Checking that the previous step is completely dry, begin to build up structure in the background with a series of overlaying washes. Use mixes of burnt sienna, ultramarine blue, and cobalt violet. Don't try to paint in too much detail; think in broader, more structural terms. With the right amount of structural information the viewer will turn the shapes into planks, ladders and boats without the artist having to paint all of them individually, piece by piece. With burnt sienna build up some of the structure of the far bank.

Boat and reflections.

Step 4: Having prepared puddles of cobalt blue and Winsor blue, with a No. 10 brush paint in the hull of the boat, both sides, down to the water. Be careful not to paint over the boat's fenders. Allow this to dry. With the same wash paint in the left-hand side of the hull. This over-wash will create the stronger toned shadow side to the vessel.

Checking that the previous layer is completely dry, prepare a wash of ultramarine blue and neutral tint, dampen the river directly below the boat and paint in the bottom of the hull, allowing the wash to run into it. In the damp river area drop in some burnt sienna and Winsor blue and let the colours merge to create the simplified reflection.

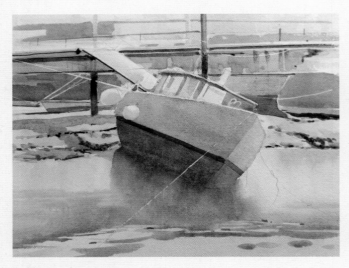

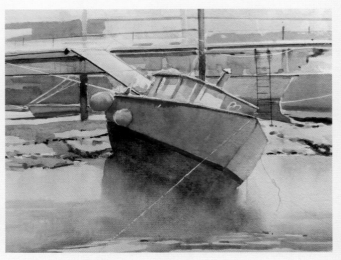

Building up the structure.

Step 5: Build up and strengthen some of the structural details using the same washes as previously used in the background and on the foreground bank. Dampen the bottom of the boat and touch in some patches of burnt sienna, portraying rust. Under-wash the two buoys with lemon yellow and let them dry completely. This yellow under-wash when overlaid with cadmium red will shine through, increasing the brilliance of the resultant orange.

Definition and adding interest.

Step 6: Using a No. 8 well pointed sable, add a wash of cadmium red over the fenders, keep the wash stronger towards the bottom. With the bottom of the fenders still damp, touch in some thick cadmium red to further darken the tone and help to define their shape and form. Paint in with various blues and browns the windows and the boat's wheelhouse. As these dry, add shadows on both the boat and riverbanks with washes of ultramarine blue and permanent rose. Try to add these washes and marks quickly and with energy when executing them; confident marks will make for confident-looking paintings.

Remove masking fluid.

Step 7: Prior to removing the masking fluid dampen the river nearest the near bank directly below the right-hand fender and drop in a mix of burnt sienna for its reflection. Let the painting dry thoroughly. Remove all the masking fluid with the Maskaway eraser. With a No. 4 brush, paint in the dark blue tops to the fenders. Strengthen the detail on the boats, gangway, wheelhouse and posts. Run the ferrule of the brush against the ruler when painting straight lines. Finally add the ropes and lines with mixes of ultramarine blue and neutral tint. Note the detail on the nearest rope.

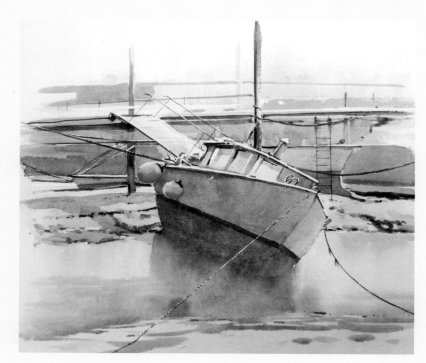

Finished painting: *Woodbridge Workings*.

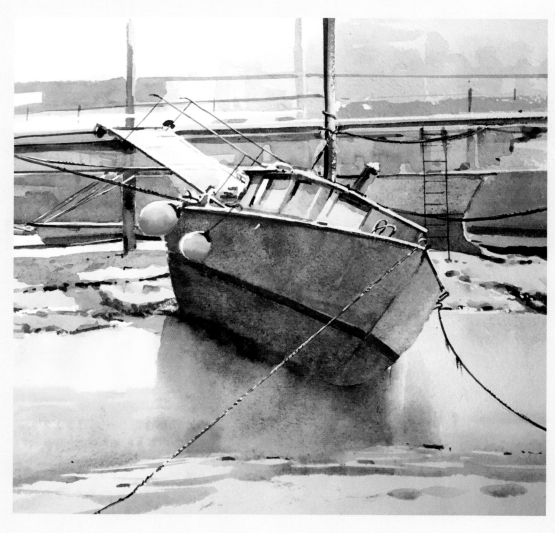

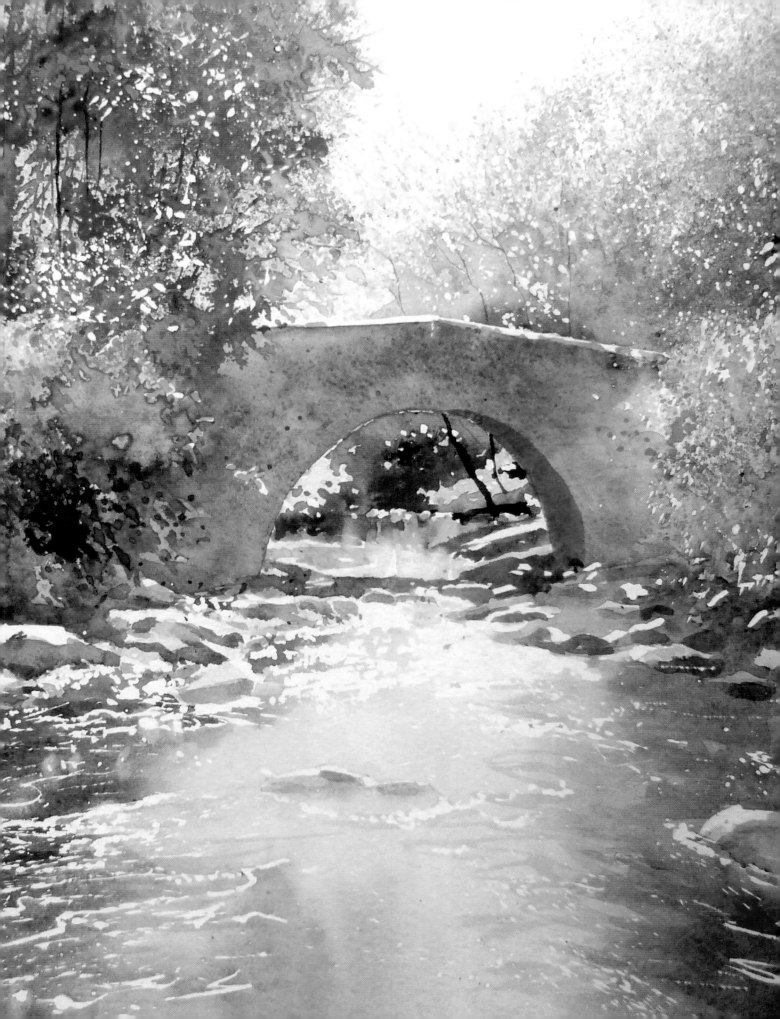

Bridges

As the stream widens on its journey towards the sea and broadens into a river, so bridges will begin to appear along its course. Where the river is still narrow a simple wooden footbridge might be all that's needed but as the river broadens so the design will by necessity become ever more complex. Bridges are constructed in a variety of shapes, sizes and materials and often provide scale and a focal point to watercolour riverscapes. Whether a simple rustic footbridge or the vast elegance of a sweeping suspension bridge spanning a wide estuary, all provide interesting subject matter for the inquisitive artist.

Living as I do on the edge of Dartmoor, I probably have more than my fair share of bridges; with so many lanes and roads weaving across the moor and with so many streams, leats and rivers to cross I am fortunate to have a wide range of styles to choose from when deciding what to draw and paint.

Beloved by visitors are the picturesque stone bridges with their interesting patterns and textures, variations in colour and tone, and the elegant symmetry of their arched construction. Some were built hundreds of years ago at crossing points that might themselves go back even further in time. Being built from the local stone, which has weathered and softened over time, they seem to have grown from the landscape of the moor itself.

Long before man began to span rivers with arched bridges they crossed them in simpler, more direct ways, by building what we now know as a 'clapper' bridge.

These, the oldest bridges on Dartmoor, can consist of a single slab of granite laid across a stream from bank to bank, or a number of slabs placed on stone piers straddling the river if it is wider. How our ancestors managed to manoeuvre such heavy slabs without modern mechanical means still amazes me and is something I give thought to every time I visit to draw or paint. Whatever the weather, whatever the time of day or season, these clapper bridges make for interesting subjects. My favourite time is when the sun picks out the flat stones in a blaze of dazzling light after a shower.

As we have seen previously in the book, there are many factors that contribute to the creation of mood and atmosphere, both in the landscape itself and within a painting. However, there are few more atmospheric places to paint than a clapper bridge on Dartmoor when a mist or fog descends and all traces of modern day life are lost from view.

HARFORD BRIDGE

The overwhelming sense I experienced when sketching beside the beautiful River Erme in early summer was that of the light. Not just the strength of it – although it was certainly bright – but its quality. It was awash with greens and yellows; the air itself seemed to be coloured, bouncing back from the water and into the trees. The reason to make the painting was there all around me; the inspiration was the light.

Harford Bridge

Paper
- Two Rivers 300gsm (140lb) NOT
- Size: 32 × 37 cm (12½ × 14½ inches)

Materials and equipment
- 2B pencil
- Masking fluid
- Nylon masking brush
- Brush soap
- Sable brushes, size 10, 8, and 4
- Old bristle brush
- Palette
- Kitchen roll
- Maskaway eraser
- Painting board

Artist quality watercolours
- Lemon yellow
- May green
- Ultramarine blue
- Cobalt blue
- Permanent rose
- Green gold
- Winsor blue (green shade)
- Transparent oxide brown
- Burnt sienna
- Neutral tint

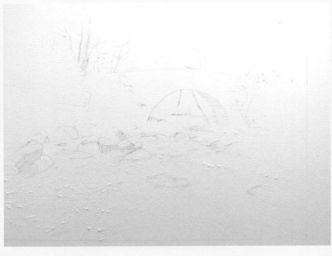

Drawing and masking.

Step 1: On a stretched piece of watercolour paper, sketch the design loosely using a 2B pencil, paying particular attention to the bridge and its arch. Draw this as accurately as possible. If it proves particularly difficult, trace the design from a photograph or drawing and then transfer it to the watercolour paper. Mask out the highlights on the river, rocks, and the top of the bridge, and spatter some masking fluid on with a nylon masking brush. Allow to dry.

The design of the painting is relatively simple: the diagonal shape of the river leads the eye to the single arch which in turn frames the focal point, the river seen beyond the bridge. The juxtaposition of the bright darks with the bright lights creates interest for the viewer – a visual reward for the journey.

The strong shadows and bright highlights help to emphasize the brightness of the day. This breadth of tonal range is useful to the artist as the contrast between the tones can give the painting a real lift. A narrow range of tones often leads to a weak or insipid watercolour.

The colours underpinning the whole design are the greens and yellows of the trees and their reflections within the river. The square format complements the bridge; the

traditional landscape format would have left too much space either side of the bridge and this would in turn detract from the focal point. Photographers talk about cropping and cropping again when framing up a shot; that way they concentrate on the salient points within the photograph and are not distracted by unnecessary elements which can lessen the impact of the final image. The artist would benefit from adopting a similar practice.

The trees to both the left and the right act as 'stoppers'; these stoppers prevent the viewer's attention or interest falling out of the painting and they direct the attention back towards the focal point. The shape of the sky area (a 'V') is used in a similar way to the trees in that it points and directs attention towards the bridge with the focal point through the arch.

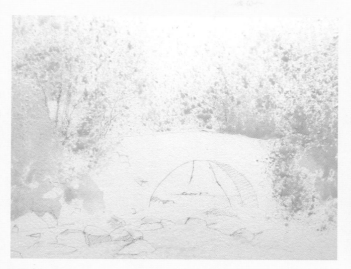

Initial washes.

Step 2: Protect the bridge and the river with scrap paper and spatter on lemon yellow using a No. 10 brush. Draw the spatters together on the lower parts of the trees and bushes. Be careful not to have the board at too steep an angle as all the colours will run together. Leave the paint to dry.

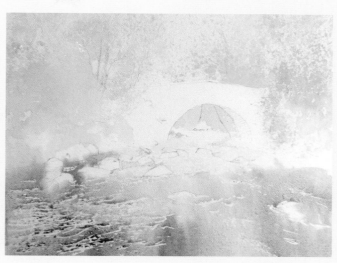

River washes.

Step 3: With the No. 10 brush add washes of Winsor blue, ultramarine blue and lemon yellow for the river. Concentrate the blue in the centre of the river, a reflection of the sky, and the blue yellow mix towards the riverbanks. Allow the colours to mix and merge on the paper. It's important at this stage to let the colours dry out. Don't be tempted to go back into the wash before this is the case, as it would be likely to cause unwanted back runs, 'cauliflowers'.

Some dark reflections.

Step 4: Dampen the river with clean water and allow it to soak into the paper before adding some darks; mixtures of ultramarine blue and green gold. Brush the colours vertically into the damp areas with the No. 10 sable. With some green gold and transparent oxide brown, use a well-pointed brush to paint in some ripples. Paint in a wash of lemon yellow at the focal point and drop in some green gold and transparent oxide brown for the river under the arch. Allow the colours to dry completely.

First bridge washes.

Step 5: With a mix of cobalt blue and burnt sienna paint in the bridge shape with the No. 10 brush. Go over the shadow area of the arch; a darker wash will be added later to describe the shape. Add some clean water to either side of the bridge. This will allow the mix to soften into the damp paper, preventing unnaturally hard edges, which can often prove difficult to hide with subsequent washes.

Build up the tree textures.

Step 6: With mixes of May green and ultramarine blue, and with areas of the painting protected with scrap paper, spatter on the mix, building up the texture on the trees and bushes. Allow to dry fully before adding a further spattered layer, this time with a slightly darker mix. Draw the mix together on both riverbanks and drop in some burnt sienna. As the area begins to dry, using a fairly strong mix of neutral tint and ultramarine blue paint in the trunks, branches and darker clumps of foliage.

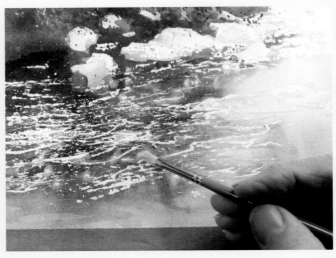

Lift out some colour.

Step 7: Once the previous stage is completely dry, use an old oil painting brush with some clean water to dampen and soften any of the masked areas that require lifting. Carefully soften the paint with clean water and lift it off with kitchen towel.

Remove the masking fluid.

Step 8: Using a piece of kitchen towel to check that the painting is bone dry, carefully remove the masking fluid. This process should not be rushed; rubbing too hard or pulling at the masking fluid as it begins to come away is likely to result in the paper tearing and although not always disastrous it can be difficult to paint subsequent washes over damaged paper.

Adding detail to the rocks.

Step 9: With mixes of burnt sienna, green gold, and ultramarine blue with permanent rose, begin to add details to the stones, rocks and bridge work. Use the smaller No. 4 sable for this. Be careful not to lose all the lights at this stage, as this is easily done.

Arch shadow.

Final adjustments.

Step 10: With the ultramarine blue and permanent rose mix paint in the underside of the bridge's arch, using the size 4 sable. Be careful not to make it too dark as this will act as a barrier to the viewer's eye and detract from the focal point. Take the shadow below the bridge from one side to the other. While this is still damp, drop in a little green gold.

Step 11: After checking that the previous stage is dry, continue to add details and work up the rocks and stones nearer to the bridge. Add some tree trunks to the focal point with a mix of ultramarine blue and neutral tint, adding some thinner branches above the bridge. With some acrylic inks spatter on some bright greens to add further texture, making certain that the rest of the painting is protected with scrap paper. Adding the opaque acrylic ink or even opaque gouache can be used to reclaim some of the lost lights, but should always be used sparingly.

Finished painting:
Harford Bridge.

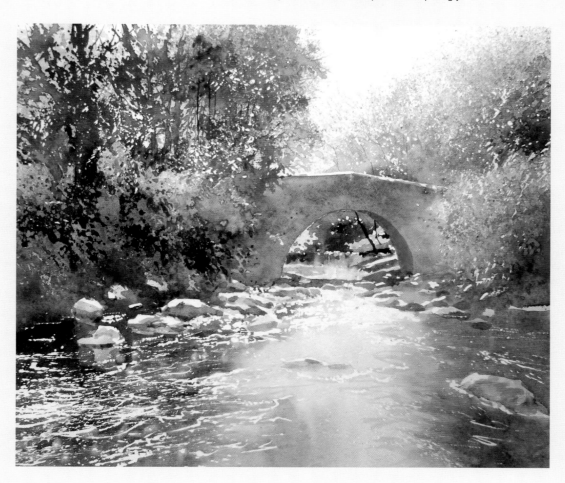

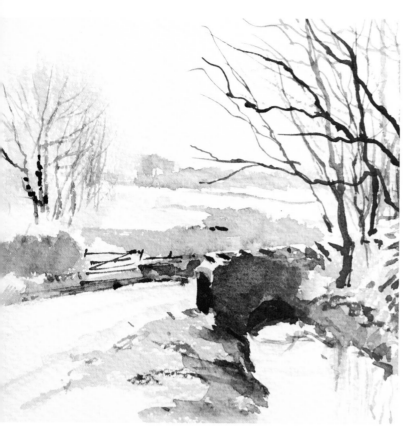

Inspiration can come from the most unlikely sources, as was the case with this roadside stream.

In praise of the prosaic

Do not overlook the more mundane to provide worthwhile subject matter. On a recent sketching trip I came around a bend in a narrow country lane and was dazzled by the bright sunlight bouncing off a fast-flowing stream running by the roadside, a scene that I'm sure is repeated up and down the country day in and day out. Getting out from the car with sketchbook and camera to hand, I looked back along the stream towards the bend.

Here it was flowing from under the road through a broad culvert. A culvert is nothing more than a manmade structure that allows the stream to pass under the road, quite often nothing more complicated than a simple pipe, as was the case here.

Many would think that a pipe passing under a road would offer little to interest the serious watercolour painter, but think again. Here in the most unlikely of places was everything I enjoy and look for when painting water: light, textures, shadows, movement and colour all centred around nothing more romantic than a drain! I reached for my camera to capture the quickly changing light, scribbled down a few drawings and painted a quick tonal sketch before moving on.

A broad river or wide estuary might be the choice of many when setting out to paint or sketch and nothing should be taken away from the painterly opportunities that they offer. But equally a small ditch in the corner of a field or a gulley running alongside a road also offers a beauty all of its own and should not be dismissed because of size or location. The artist can take inspiration from all around them, and should be open to the possibilities that each location offers. A puddle can be as inspiring as a lake to the artist's eye.

SNOWY BRIDGE

It doesn't snow often in the part of Devon that I'm fortunate to live and work in, so on the rare occasions when it does, I drop everything and head out with camera, paints and sketchpads to gather information before it goes.

Walking by the delightful river Avon I came across the scene portrayed in this little watercolour. The contrast of colours first caught my attention; the warm browns of the stone bridge stood out starkly in contrast with the white of the snow and the blue purple within the shadows. The contrast of colours was my inspiration and would become my focus for the painting. Wanting to focus the viewer's attention on these points I decided to simplify the background by reducing the number of trees and buildings, and instead made more of the distant hills. The bridge, the focal point, would stretch almost from one side of the painting to the other; the trees at either end acted as 'stoppers', keeping the viewer's attention within the painting. I decided to push the tonal range within the design, strengthening the darks in order to give greater contrast with the whites. By doing this the the overall painting would gain more tonal impact. I made these decisions on site and with sketches and notes made my way back to the studio to paint.

Snowy Bridge

Paper

- Two Rivers 630gsm (300lb) NOT, unstretched
 Note: the paper was heavy enough in this case not to need stretching, although it was stuck down to the painting board with masking tape when painting.)
- Size: 31 × 23 cm (12 × 9 inches)

Materials and equipment

- 2B pencil
- Masking fluid
- Nylon masking brush
- Sable brushes, size 10, 8, and 4
- Rigger
- Palette
- Kitchen roll
- Maskaway eraser
- Painting board
- Scalpel
- White pencil crayon
- Masking tape

Artist quality watercolours

- Ultramarine blue
- Permanent rose
- Winsor blue (green shade)
- Burnt sienna
- Raw sienna
- Quinacridone gold
- Neutral tint
- Green gold

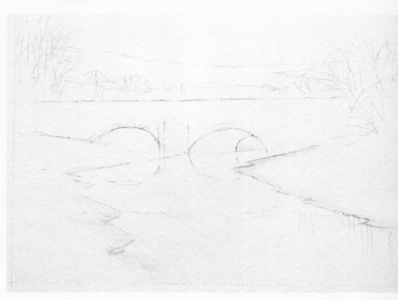

Drawing and masking.

Step 1: With a 2B pencil loosely sketch in the main shapes, paying particular attention to the bridge and the curve of the arches. With the nylon masking bush mask along the top of the bridge wall and the edge of the riverbank where it meets the water. Leave to dry.

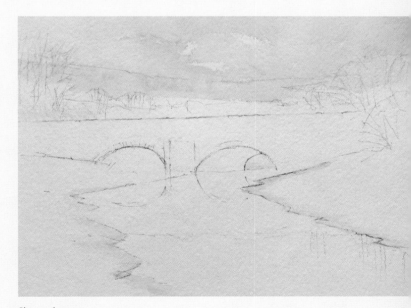

Sky washes.

Step 2: With a wash of clean water dampen the sky area bringing it down over the distant hills the with a No. 10 brush. Mix puddles of raw sienna, Winsor blue and ultramarine blue with a touch of permanent rose and drop these colours into the damp sky. Let the colours mix and merge on the paper, allowing some to spread into the hills, and allow to dry.

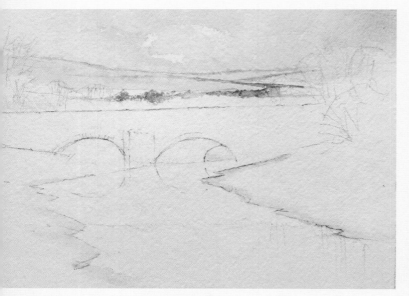

Distant trees and hedgerows.

Step 3: With a mix of ultramarine blue, permanent rose and a touch of green gold, use a No. 4 sable to paint in the distant field boundaries and trees, varying the strength of colour as you paint. Be careful not to make the tones too strong. Leave to dry.

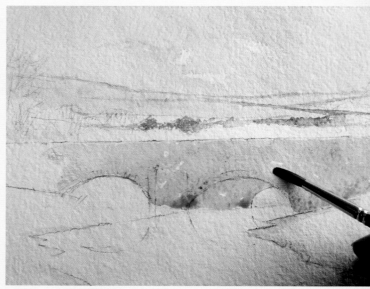

Initial bridge washes.

Step 4: Make a mix of burnt sienna with quinacridone gold and wash in the bridge. Vary the mix as you paint, but don't add any texture or detail at this stage.

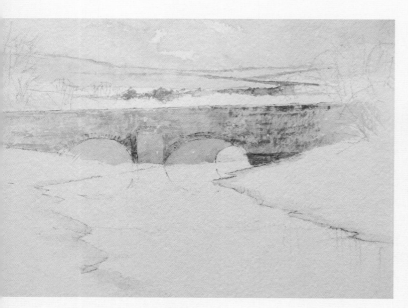

Adding texture to the bridge.

Step 5: After checking that the previous stage is dry, add texture and detail to the bridge with dry brush strokes, picking out some stones with a very well pointed No. 4 sable. Use slightly stronger mixes of the colours as used previously for the bridge. Leave to dry.

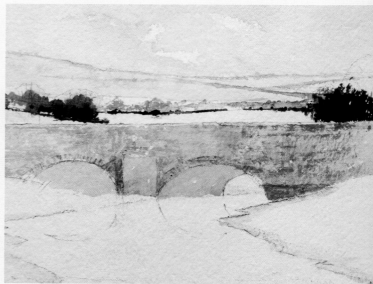

Developing the trees.

Step 6: With a fairly strong mix of ultramarine blue with permanent rose paint in the nearer bushes and trees. With them still damp drop in some green gold and burnt sienna. Allow to dry.

Larger trees and initial river washes.

Step 7: With a strong, thick mix of ultramarine blue and neutral tint, paint in the trees at either end of the bridge, using both the No. 4 for the ivy covered trunks and the rigger for the thinner branches. With clean water brush in the shape of the tree and drop in some ultramarine blue with a touch of Winsor blue and let them run into the dampened area. Paint the shadowed areas in the snow with a mix of ultramarine blue and permanent rose using the No. 8 sable. Carefully wash over the river with clean water and with the board at a slight angle working from the bottom upwards brush in a mix of Winsor blue and ultramarine blue, darker towards the bottom of the painting. With the board at the same angle leave everything to dry thoroughly.

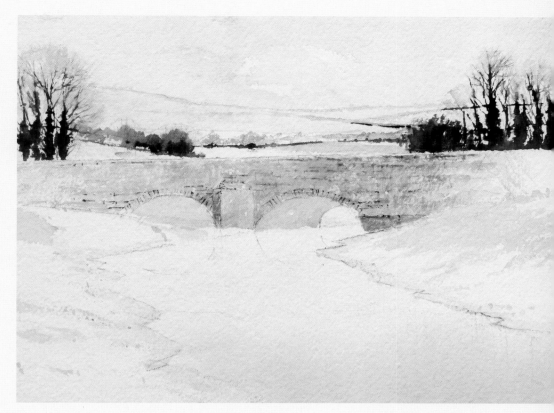

Bridge reflections.

Step 8: With the board at a slight angle use clean water to brush over the reflection area of the bridge. Drop in the same mixes used to paint the bridge allowing them to flow downwards. When the wash begins to dry leave it alone, avoid the temptation to fiddle or to add other washes, to so do will likely result in 'cauliflowers' and in this instance would be unwelcome.

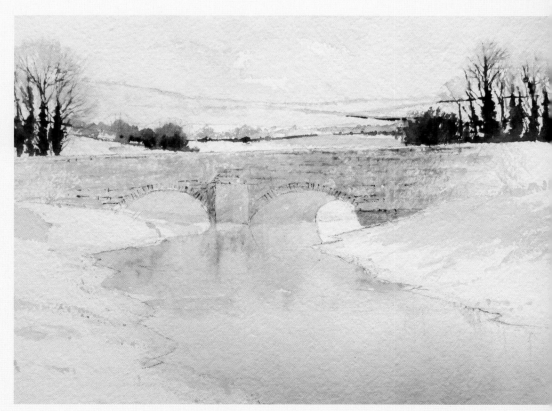

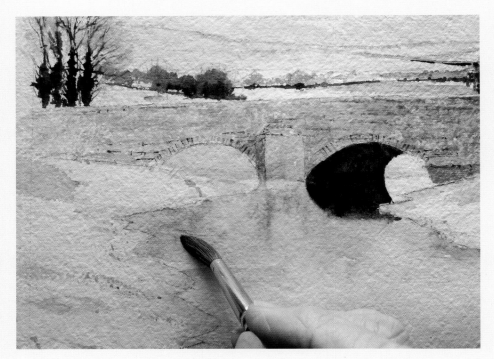

Arch reflections.

Step 9: Take ultramarine blue, neutral tint and a little burnt sienna and mix a fairly strong dark and paint in the reflection of the bridge's arches. To avoid too precise a reflection, dampen the paper up to the edge of the reflection with clean water and paint the reflection to it; as the dark touches the damp paper it will soften the edge slightly, presenting a more natural-looking reflection.

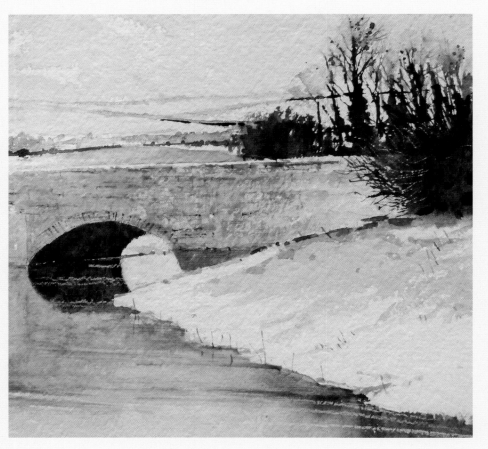

Final touches.

Step 10: Checking that the previous stage is completely dry, carefully remove all the masking fluid using the Maskaway eraser. Paint in the tree at the right of the bridge with mixes of burnt sienna and ultramarine blue using a No. 8 and a rigger. When this is completely dry use a scalpel or sharp craft knife to scratch in some branches. With the No. 4 brush touch in a few shadow details on the bridge using burnt sienna. Dampen the river directly below the trees at both ends of the bridge, and drop in a mix of burnt sienna with ultramarine blue, pulling some of the colour down with the brush for the reflections. Strengthen some of the bridge reflections with drawn horizontal marks using burnt sienna and a well pointed brush, paying particular attention to the vertical reflections of the buttress.

Being careful to protect the rest of the painting with some scrap paper, spatter a few darks on the trees. With the rigger, paint in a few dark grasses poking up through the snow and any corresponding reflections on the banks. Allow to dry.

Finally with a white pencil crayon draw some streaks on the river depicting ripples or wind marks.

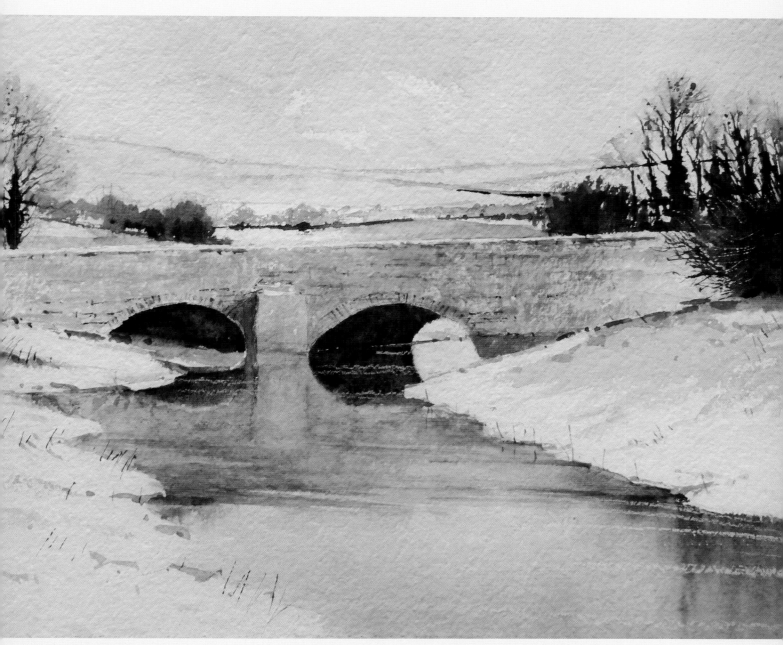

Finished painting: *Snowy Bridge*.

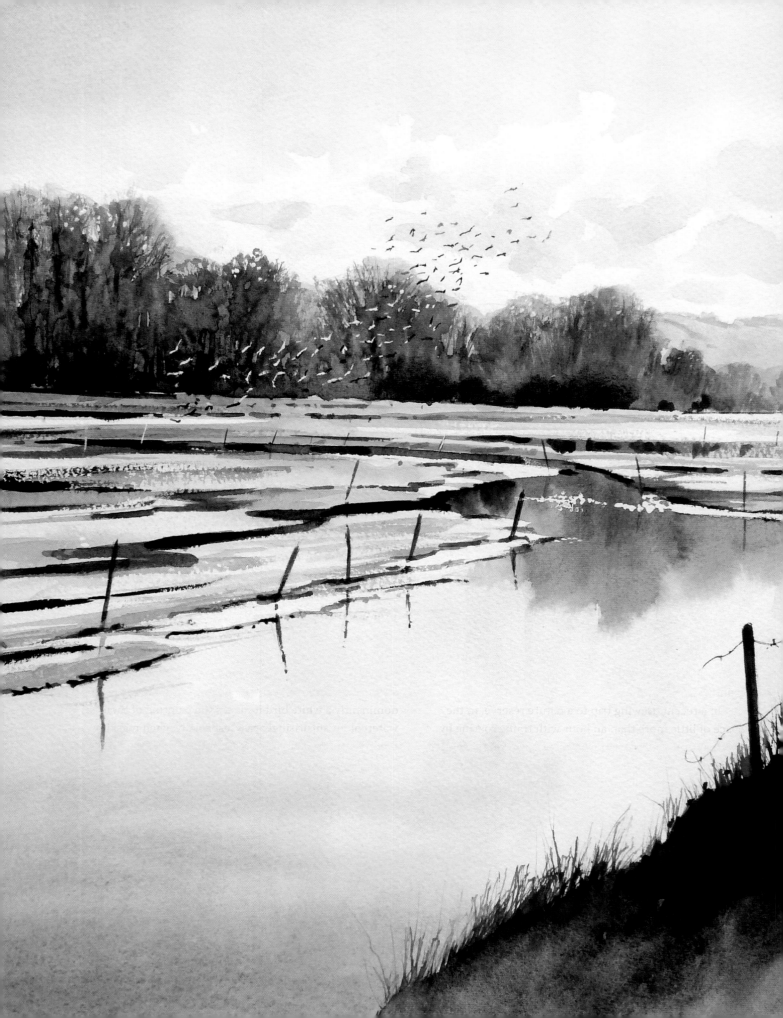

Wildlife

It's not uncommon when working out in the landscape to spend several hours in one spot, quietly observing the scene before you, gathering information, painting *en plein air* or simply sitting and looking. During these periods of focused observation it's likely that you will see, or better still be visited by, birds or wild animals that in normal circumstances would be difficult to spot. Not only can it be a thrill to witness animals in the wild going about their daily business totally oblivious to the artist's presence, but as an artist one should treat this as another opportunity to gather information which may be useful in later works. Take for example the inclusion of birds in flight within a painting. They can bring both life and movement to the work. The time spent sketching and recording such cannot be underestimated. Gone will be the days of painting 'Ws' or 'Ms' in the sky and thinking that they look like birds in flight: they don't. Better observation will lead to better, more convincing paintings.

On a recent drawing trip to a nature reserve, in the space of little more than an hour with traffic roaring by less than 100 metres from where I was working, I spotted a pair of kingfishers, a little egret, a heron, a peregrine falcon, and scores of ducks and other waders. Although I was only able to sketch a few before they flew off, the others were photographed; these images will make useful reference material. The highlight of the trip occurred just as I was packing my sketchpads and paints away, when a barn owl, silent and ghost-like, passed within a few metres of me looking for its next meal, seemingly completely oblivious to my presence. There was no time to draw, but I managed to grab the camera and record a few images.

Seeing the owl made me think differently about the watercolour that I had been planning for much of the day. Now, instead of the river being the primary focus of the painting it would be the supporting act, with the barn owl itself now being the main area of attention. Its presence would help to bring a distinctive atmosphere of twilight to the painting.

STUDY OF A MUTE SWAN

As you might imagine, I spend quite a lot of my time by water; and if I'm drawing by a slow-moving river or shallow lake it doesn't seem to be long before I have a visitor in the shape of a regal-looking swan, or two. Gliding effortlessly as they go, they look as if they own the water. Sometimes I feel I should be asking their permission to be there! I find that the inclusion of a swan often brings an air of serenity and calm to a painting and being predominantly a white bird it makes the painting of them in watercolour surprisingly easy, especially when masking fluid is employed.

Although one might think that since this painting is a simple study of a single swan little if any thought would have gone into the design, but that would be wrong. The painting's format, the placement of the swan within the picture, tone, colour – all the considerations that an artist would give to a more finished work apply equally to smaller-scale paintings.

The study is not merely about the swan, it's also about the reflection and the movement within the water. Therefore I chose a rather narrow portrait format that

would amplify the swan, particularly its neck and its reflection, but it would also allow room to include the wake. The shape of the wake is useful in this study in that it gives a strong directional movement to the design, which in turn adds a dynamic element to the watercolour. The swan really appears to be moving towards the viewer. The underlying colour palette is essentially a series of blues, complemented by the orange of the swan's beak. When out sketching take a few moments to search out complementaries: berries and leaves, boats and buoys, flowers and foliage are all useful combinations to consider when planning a painting.

In order to make certain that I got the size of both the swan and its reflection correct I chose to trace them from one of my photographs. I'm sure that some readers will cry out in horror and disgust to learn that I dared to trace from a photograph, seeing it as being some form of cheating, but I see it as a useful tool to be used as and when required. Although in the case of the swan study I worked from a photograph, more often than not I will make a tracing from a drawing and transfer that to the watercolour paper. Not only is this method easier and more accurate than trying to draw the design again, but if the subsequent drawing gets lost under watercolour washes it can be quickly re-established from the tracing. Or if the unthinkable happens and the watercolour for whatever reason needs to be abandoned, once again the tracing will prove useful and can save an awful lot of time.

TRACING FROM A TABLET

I have recently discovered that it's possible to trace an image from a tablet, in this case an iPad. Obviously one needs to be careful not to press too hard in case the screen is damaged, and I wouldn't advise using a piece of tracing paper that has lots of graphite on it. However, it is quite easy to trace key elements from a reference photograph – a group of figures or the curve of a bridge's arch, for example. I had expected the image on screen to move as I drew on it, but the tracing paper acts as a layer between screen and pencil preventing direct contact, thereby tricking the screen into responding as if nothing is touching it.

STEP BY STEP DEMONSTRATION
Study of a Mute Swan

Paper
- Bockingford 300gsm (140lb) NOT
- Size: 17 × 28 cm (6¾ × 11 inches)

Materials and equipment
- 2B pencil
- Masking fluid
- Nylon masking brush
- Sable brushes, size 10, 8, 4 and 2
- Tracing paper
- Palette
- Kitchen roll
- Maskaway eraser
- Painting board

Artist quality watercolours
- Ultramarine blue
- Winsor blue (green shade)
- Raw sienna
- Permanent rose
- Cadmium red
- Cadmium orange
- Neutral tint

Drawing and masking.

Step 1: After transferring the drawing from the tracing to the stretched watercolour paper, mask both the swan and its reflection with masking fluid using the nylon masking brush. Let it dry naturally. Avoid using a hair dryer to speed up the drying time, because with so much masking fluid on the paper the blast of air from the hair dryer might end up blowing the masking fluid where it is not wanted. It's worth noting that if masking fluid ends up in the wrong place within the painting, avoid rubbing at it straight away with finger or kitchen roll, as this can damage the paper's surface, making it almost impossible to paint on afterwards. Instead, let it dry and then carefully remove it in the normal manner, by gently rubbing with a clean finger or the Maskaway eraser.

Initial river washes.

Step 2: After checking that the masking fluid is completely dry prepare two wells of pure colour, ultramarine blue and Winsor blue. With the board at a slight angle, using the large No. 10 sable lay a wash of Winsor blue over the top three-quarters of the paper. Paint the remaining quarter with the ultramarine blue, working from the bottom up and allowing the colours to mix where they meet. Keep the board at the same angle and let the colours dry.

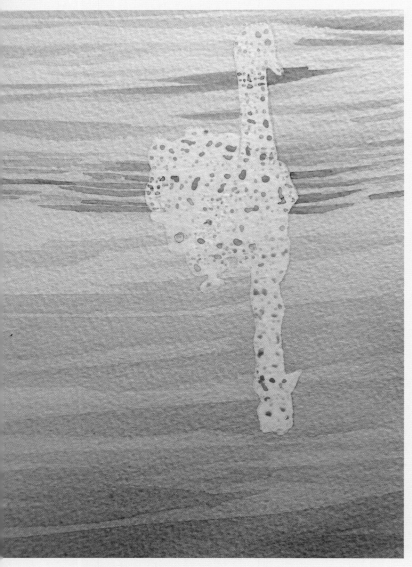

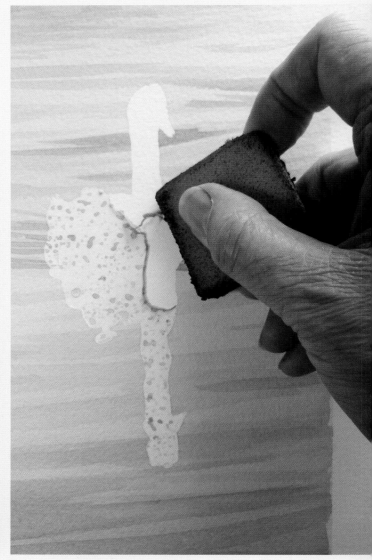

Defining ripples and movement.

Step 3: With some washes of Winsor blue mixed with ultramarine blue and Winsor blue with neutral tint, paint in the ripples varying the colours as you paint. A well-pointed No. 8 sable is ideal for this. Not only can it produce both fine and broad lines but it has the capacity to carry a lot of wash within the brush, making this type of mark easier to produce and reducing the number of times you have to revisit the palette. Note that the ripples caused by the swan's wake are narrower and closer together than the broader ripples in the foreground. The difference between the two helps to emphasize the swan's forward motion. Leave to dry.

Removing the masking fluid.

Step 4: After checking that none of the paint is still wet, carefully remove the masking fluid. This is quite a large area to remove; be careful not to pull at the dry masking fluid when removing it or you are likely to tear the paper. It's likely that the removal of the masking fluid will have removed some of the pencil details from the swan. These should be restated, either by using the master drawing from the tracing or freehand, using a 2B pencil.

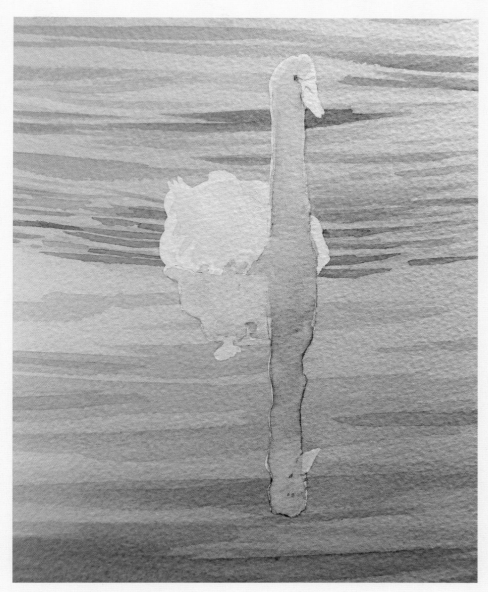

Adding structure and detail to the swan.

Step 5: Prepare washes of permanent rose with ultramarine blue, raw sienna and neutral tint and with a No. 4 brush begin to add detail to the swan. Note that the reflection is slightly darker in tone than the swan itself. As a rule of thumb, lighter colours have a tendency to reflect darker in water, and darker colours lighter. Although this is a useful guide when painting reflections nothing beats first-hand observation, so take the time to assess carefully the tonal values of both object and reflection.

Working from the reference photograph, continue to build up the detail with overlaid washes. Care should be exercised at this stage of the painting, however: the swan's characteristic white plumage could easily be lost by an over-zealous use of washes. Paint with confidence but also with control and consideration.

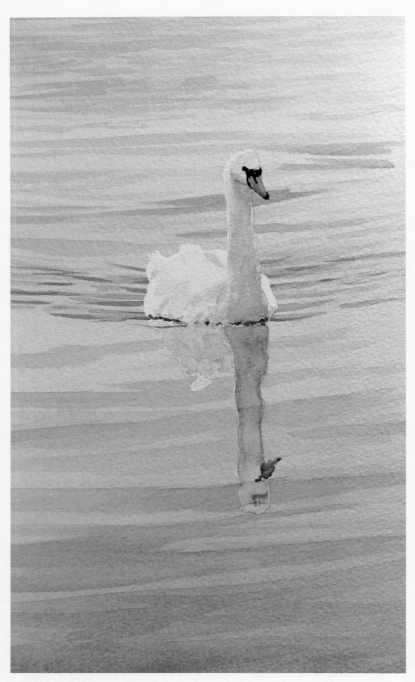

Finished painting: *Study of a Mute Swan*.

Step 6: The red of the beak makes quite a dramatic statement in this little study. With a well-pointed No. 2 brush paint the beak with a mix of cadmium red and cadmium orange, the bottom of the beak being slightly stronger in colour than the top. Let this dry. If the darker details are added before the beak is bone dry the colours will run together, ruining the sharp divisions between the colours. For the eyes and dark parts of the beak use a strong mix of neutral tint, the strong mix achieved by adding as little water to the pigment as possible, just enough to make the paint flow. Add a few shadow details at the water line and pick out a few ripples with neutral tint.

When painting the reflections of the beak and eyes, use the same mixes as previously used in the painting, but with the addition of slightly more water in the wash as the reflective colours are a little paler than in the swan itself.

FLATFORD MEADOWS

It is not wildlife alone that is worthy of consideration and inclusion within the watercolourist's art. When a river runs through farmland, don't overlook the more obvious opportunities to include other animals: cows, sheep or even horses. A herd of Friesian cattle made for a very interesting design element within the painting *Flatford Meadows*. The contrast between the black and the white of the cows draws attention and acts as a welcome relief to the painting, which is made up predominantly of series of 'greens'.

Including cattle in a painting is a useful device in indicating both scale and distance and they often feature in my work. I'm particularly keen to include red or brown coloured cows when the opportunity presents itself. The reason might seem rather curious, but it's partly down to J.M.W. Turner and a certain splash of red.

The story goes that the great English landscape painters John Constable and Turner were such rivals that when their paintings were due to be hung side by side at the Royal Academy Exhibition of 1832 Turner took some dramatic action. After watching Constable put the finishing touches to his painting within the gallery, Turner decided that his own work was lacking in colour so in order to address this issue, and to steal the show, he painted a single daub of red paint right in in the middle of his canvas; the daub being a buoy. It grabbed the attention of all who saw it and upstaged Constable's work. I like to think of the reddish brown cattle playing the same role of Turner's dab of red, creating attention within the piece and attracting the viewer's interest.

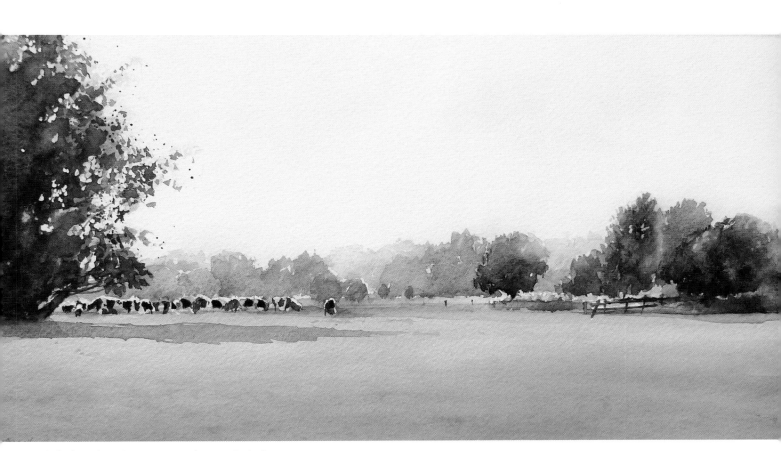

Flatford Meadows. Size: 35 × 16 cm (13¾ × 7 inches).

SUMMER ON THE YARTY

This is one of my favourite summer scenes to search out and to paint in watercolour. All the ingredients are there: bright sunshine, deep dark shadows, a slow-moving river and distant cows – perfect!

I was due to give a painting demonstration to a group in east Devon. Knowing how close the River Yarty was to my destination I left a couple of hours earlier in order to spend a little time drawing and information gathering. The sun was high but not quite overhead, and the distant hills were slightly hazy with little definition of trees or the hedgerows. Coming round a bend in the river the large tree stood out, dark and full of interesting shadows. The reflection on the day was more broken than I have painted it, the river faster flowing and fragmenting its appearance. I have chosen to work with a simpler, wet into wet reflection as this helps to portray the languid, unhurried feel that the landscape in summer seemed to have on this particular day.

In the sketch that I made on location, there is a small stand of trees in the mid-ground. For design reasons I chose to leave these out as they acted as a barrier to the sense of flow to the distance and space that I wanted to create across the water meadows towards the hills. For some it might be considered wrong to leave out such a distinct feature within that landscape, but after careful consideration I felt that to include it would create a very different picture and not the one I wanted to paint. I was trying to portray an open feel to the landscape, inviting the viewer to move along the river through the fields and on to the hills; to include the trees would have blocked the flow. Essentially I was more concerned to paint the character and atmosphere of the location rather than be constrained by topographical accuracy.

In order for the viewer not to dwell too long in the foreground and to move more easily into the painting I simplified much of the riverbank. The river, curving to the left, leads the eye into the mid-ground, towards the cows with the tree on the left of the painting acting as a stopper, preventing the viewer's interest drifting out of the image. The large dark tree gives scale and tonal contrast within the watercolour, and because it leans inwards it directs the viewer's movement back into the mid-ground. This movement is also emphasized by the fence, which, although it did exist, was also altered to direct attention back into the painting.

The paper, a stretched piece of Two Rivers handmade paper 300gsm (140lb) NOT, was specifically chosen for two key reasons: firstly I would be able to lift colours more easily from it than from other papers; secondly the rough, random nature of the surface texture would complement the granulating colours that I knew I wanted to work with, especially within the reflection of the large tree, creating interesting effects.

STEP BY STEP DEMONSTRATION
Summer on the Yarty

Paper
- Two Rivers 300gsm (140lb) NOT
- Size: 37 × 25 cm (14½ × 9¾ inches)

Materials and equipment
- 2B pencil
- Masking fluid
- Nylon masking brush
- Sable brushes, size 14, 6, and 4
- Palette
- Kitchen roll
- Maskaway eraser
- Painting board

Artist quality watercolours
- Ultramarine blue
- Winsor blue
- Raw sienna
- Cobalt blue
- Burnt sienna
- Green gold
- Cobalt violet
- May green

Drawing up and masking.

Step 1: The design is loosely sketched out on the watercolour paper using a 2B pencil. Mask out the cows in the mid-ground, some sparkles on the river and the fence using masking fluid applied with a fine nylon brush.

Spatter the large tree with some masking fluid; this will eventually create some sky holes. With a tree as large and dark as this fine old specimen, there is a danger of it becoming just a large, overpowering, lifeless area within the painting. By masking out some patches representing the sky seen through the leaves and branches this possibility is significantly reduced.

Be careful not to overdo the detail in the drawing; instead aim for a looser result that indicates the main areas of the design, concentrating on size and scale. Too much detail can often lead to the artist filling in the spaces with paint rather than using the drawing as a guide.

First washes.

Step 2: Prepare pure puddles of raw sienna, Winsor blue, May green, ultramarine blue and green gold in separate wells. With the masking fluid dry and the board at a slight angle of about 20 degrees, paint a wash of clean water over the painting area and allow it to soak into the paper slightly. With the ready prepared puddles of colour, wash in the sky, distant hills, trees, field and main tree onto the damp paper, letting the colours mix and fuse together. To avoid even at this stage over-attention to detail I used a large No. 14 pointed sable. It's important not to go back in to the washes; let them merge and dry naturally.

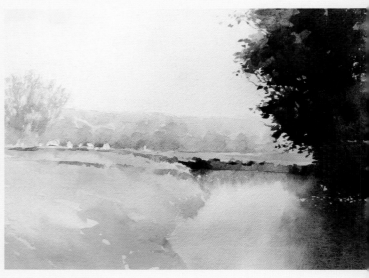

Early structure.

Step 3: Strengthen the distant trees and hills with stronger versions of the first wash colours. Begin to add structural marks to the meadow and foreground bank to describe their form with May green and a little burnt sienna to the bank side. Develop the darks of the riverbank to the right with stronger mixes of ultramarine blue and burnt sienna. Allow to completely dry.

Main tree and reflection.

Step 4: Dampen the area of tree and river with clean water. Working quickly paint the tree with a series of strong, dark washes of the ultramarine blue and green gold mix, the balance within the mix being towards the blue. Vary the strength of the mix as you paint. Use the same mixes to drop in the tree's reflection, adding a touch of burnt sienna towards the bottom. The colour from the tree should flow into the reflection washes seamlessly.

The mid-ground riverbank is treated in much the same way as the tree's reflection but this time use the same colours for the reflection as those that are used in the bank.

With the river still damp, add a little Winsor blue to the left of the reflection. It is important to keep the board at the same angle when drying in step 4. If the angle is altered, a damp wash might flow back into one that is drying, causing 'cauliflowers', something to be avoided within the reflection.

With the tree dry begin to paint in branches with a No. 4 sable and indications of foliage at the tree's edge. It might seem like quite a jump from the previous to step to this one, but with the under washes in place and stronger ones freely applied suddenly the painting will appear to be almost near completion.

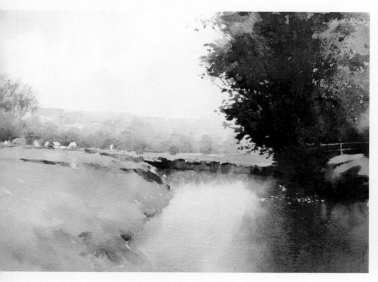

Continue building the structure.

Step 5: Using stronger mixes begin to add more structure to trees, the meadow and riverbank. Think of these marks and washes not as an opportunity to add detail, but as a way of adding structure to the painting. A simple mark with a brush might on its own suggest very little, but in context it can describe the shadow from an overhanging bank perfectly; no need to add the shadow for every single blade of grass when one mark will do the job – structure over detail. The distant hills, mid-ground trees and bushes had a wash of cobalt violet added to add texture and interest.

Remove the masking fluid.

Step 6: It is important to check that all the paint is dry before you remove the masking fluid, as any wet or damp paint can easily destroy what the artist has been so careful in protecting. It is advisable to lay a piece of paper towel over the masked area to check for any damp paint, these areas will show on the paper towel indicating that the paint needs a little longer to dry. Remove all the masking fluid.

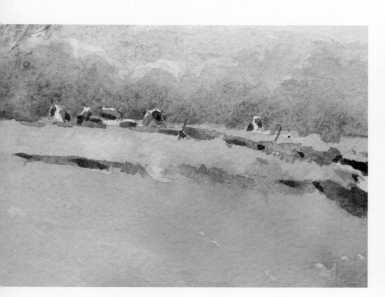

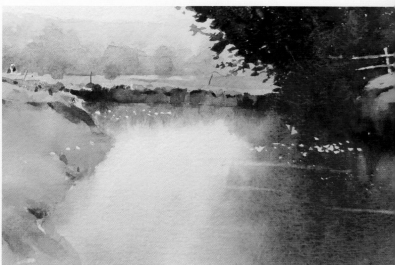

Cows, fence and lifting out.

Step 7: The cows add some scale and interest to the painting, but should be treated cautiously: too much detail and they will create too much attention. With a No. 6 sable and a mix of ultramarine blue with burnt sienna and pure burnt sienna paint in the cows, leaving some of the white of the paper showing to indicate highlights.

With a damp brush lift out three streaks across the tree's reflection. These indications of movement or wind lines help to establish the plane that the water sits on. I also lifted a few marks out of the large tree to indicate lighter parts and branches. Indicate a few fence posts; these should never be vertical, as a slight angle makes them more interesting.

Assess and adjust.

Step 8: Time to stand back and assess the whole. Two things stood out: the white fence looked a little too stark against the dark of the tree so I added a little colour to knock it back; also the meadow lacked a little texture, looking rather bland and uninteresting. Cautiously, and with the rest of the painting protected with scrap paper, I flicked on a mix of green gold and May green, taking great care not to overdo the spattering as too much would create an unbalancing amount of interest in the painting's design. I picked out a few branches in the mid-ground trees and with a damp brush I lifted out some marks from the river indicating the effects of a light breeze.

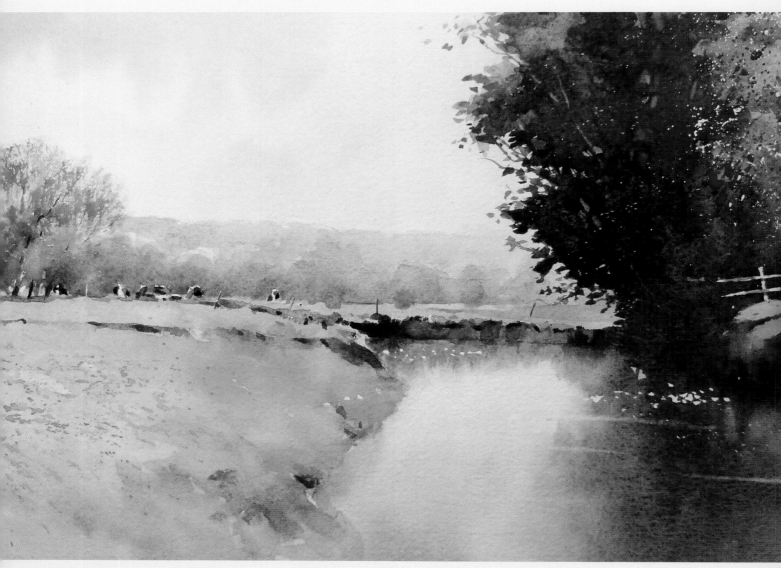

Finished painting: *Summer on the Yarty*.

FLATFORD GEESE

The River Stour near to Flatford Mill provided the setting for this quick sketch of Canada geese late one summer afternoon. A great skein of them had passed overhead as I was sketching some willows and landed just upstream from me. Although I hadn't planned to be drawing geese that day it was an opportunity not to let slip. Drawing or painting wildlife often means working very fast – not knowing when the birds would take flight certainly made for a quick study! I worked as fast as I could, recording in 2B pencil an indication of the birds' markings and their characteristic stances. If the bird moved or wandered off as I was drawing it, I looked for another one to sketch. The aim was to get enough visual references down, sketches, colour notes and photographs that might prove a useful addition to a painting at some stage in the future.

'HOW LONG DID THAT TAKE...?'

This seems to be one of the most popular questions that I'm asked when running a workshop or giving a demonstration. I'm not always certain if it's helpful to give an answer, since some paintings can take longer than others and there are so many variables: the size of the painting, how complex the execution is, even the drying conditions within the studio – all can vary tremendously and have a direct result on the time required.

With *Summer on the Yarty* for example, from first pencil marks on the watercolour paper to calling it finished took a total of five hours and twenty minutes. This included waiting for masking fluid and washes to dry and the thinking time between stages. It was a damp day when painted and the studio window was open for about half of that time. The painting took about the length of time that I expected it to.

If I work on a watercolour of a similar size for longer than two days I find that it often loses its freshness and vibrancy, almost as if it's going a little stale on me. About ten hours spread over two days would be the maximum time that I would give to this size and style of painting; smaller paintings would take much less.

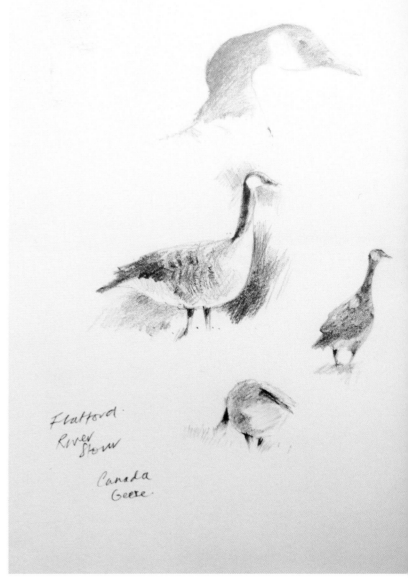

Flatford Geese.

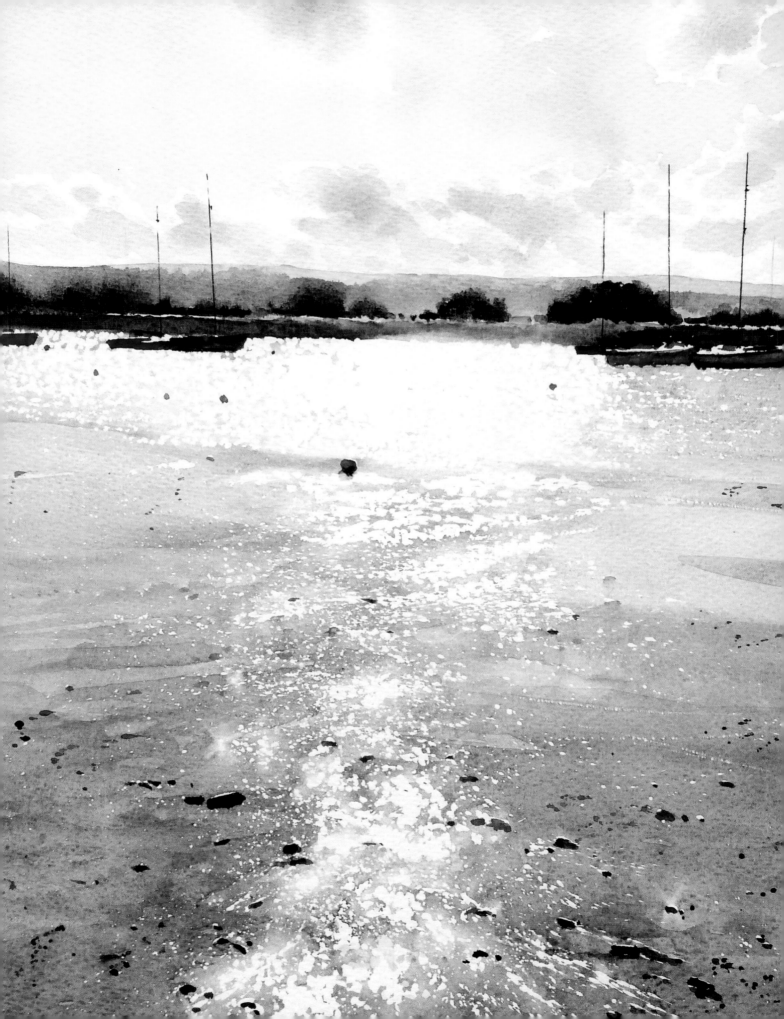

The Estuary

If I were to be asked what type of location excites me the most and makes me want to reach for my paints more than anywhere else then it has to be where the river meets the sea, the estuary. It is so full of interest, light, movement and colour, and if the wind is blowing from the right direction with a salty tang in the air you know that the sea is not too far away. It is a constant source of inspiration, providing wonderful subjects that have filled countless sketchpads over many years.

I'm fortunate in living where I do as I have several wonderful estuaries within easy reach. I know them well and paint them regularly in all weathers, at all times of the day and in all four seasons. They each have their own individual charm and identity. Some are broad and expansive, full of working boats and dominated by the tides; others are more intimate and have an air of secrecy about them. They all make ideal subjects for the watercolour painter.

I'm sure that most people would choose to visit round about the time of high tide when the estuaries are full of water, ripples and currents, action and interest, with lots going on to interest the painter. They would be right to do so. I've done it myself on numerous occasions, but for me, the charm of a estuary lies not at *high* tide but at *low*, when the estuary takes on a completely different feel. With the tide out the whole location seems transformed, the wet mud reflecting the light from the sky, clouds drifting both overhead and seemingly on the ground below one's feet. The expanse of the estuary seems to be stretched wider, full of space, creating a landscape, briefly existing between land and water, of tantalizing beauty; watercolour seems the most appropriate medium in which to capture the spirit of the estuary at its most transient state.

Light effects on mud

Capturing the light effects on mud might not seem to be the most captivating of subjects, but I find it one of the most alluring that a watercolourist might attempt. The mud that can be dull and lifeless, with little to appeal to the painter, when hit by light is suddenly transformed into the most exciting of painterly possibilities. Trying to recreate that effect on paper simply with paint and water is, for me, one of the most interesting of subjects to attempt in watercolour.

Although I would consider myself as a representational or figurative painter, attempting to paint watercolours that depict something or someone that would be easily recognized by most people, it would be wrong to say that my depiction of mud is anything other than an attempt at a painterly representation of it. When painting the wonderful stuff I allow the watercolour to describe it for me without too much intervention on my part. For the most part the effect is largely as a result of managing the combination of masking, water, pigment, the angle the board is inclined when washes are applied, and standing back, resisting the urge to fiddle.

Masking allows the artist to create the light effects that the mud and its surroundings are subject to. These can range from bright sunlit pebbles, sparkles shining as brilliantly as cut diamonds, or thin trickles of water flowing along narrow runnels towards the main river channel.

The pigment comes from the watercolour paint applied in the wash. If the artist paints with granulating colours like sediment dropped by the river so the pigment particles of colour will settle onto the paper's surface, creating texture and interest.

Water combined with the pigment creates the wash; the more water within the wash, the more it will flow.

The angle that the board is painted at has a huge and often surprising effect on the behaviour of the wash and its result. The steeper the angle and the wetter the wash the faster it will flow, so less pigment will settle out. Lessen the angle and the same wash will flow more slowly. The slowing down of the wash's movement will allow for more pigment to settle onto the paper; gravity is a surprisingly good painter! When painting estuaries the angle of the board will often change during the course of the painting dependent on the amount of granulation required for the effect that I want to create.

By understanding and combining all these factors, and with practice, it's possible to get the watercolour to do most of the work for you. Resist the urge to keep going back in and adding washes, or dropping in more colour; instead, wait and watch what the paint does. See how it runs between masked areas, how the colours mingle on the paper, note which of the colours granulate out, let the watercolour do its own thing. If further washes need to be added, which is likely to be the case, let these initial washes dry first before adding subsequent ones.

STONY FORESHORE

In this study of a muddy foreshore based on sketches and photographs made on a trip to the river Dart, I have concentrated on the four principles of masking, water, pigment and angle to achieve the desired effect.

The underlying design principle is very simple, with the river towards the top of the painting and increasingly larger stones moving down the painting with the largest of these in the foreground. This change of scale helps to bring a sense of recession to the work. The bright, shining pin pricks of light bouncing off the wet mud are created with large amounts of masking fluid flicked on with the nylon brush. Paints were chosen primarily for their granulating qualities, particularly the ultramarine blue and the cobalt violet.

STEP BY STEP DEMONSTRATION

Stony Foreshore

Paper
- Two Rivers handmade 630gsm (300lb) NOT
- Size: 26 × 19 cm (10 × 7½ inches)

Materials and equipment
- 2B pencil
- Masking fluid
- Nylon masking brush
- Sable brushes, size 14, 10 and 4
- Palette
- Kitchen roll
- Masking tape
- Maskaway eraser
- Painting board

Artist quality watercolours
- Ultramarine blue
- Burnt sienna
- Transparent oxide brown
- Cobalt violet
- Neutral tint
- Permanent rose
- Green gold

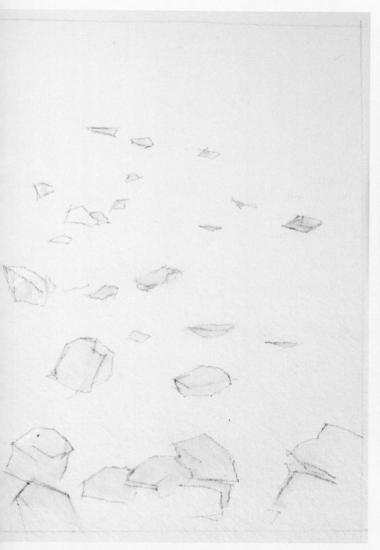

Drawing and masking.

Step 1: Although the paper was not stretched for this exercise it was still stuck securely down to a painting board with masking tape. With a 2B pencil, loosely draw in the main rocks and stones and mask them out. Flick spatters of masking fluid from the nylon brush all over the muddy area of the painting, concentrating the bulk of the masking fluid where the light is at its strongest and brightest. Allow to dry fully.

Initial washes.

Step 2: With the board at quite a steep angle, about 45 degrees, take a large brush and wash over the whole of the painting with plenty of water. This is likely to require a number of passes with the brush as the dry masking fluid will repel much of the water and it's essential that the paper is completely covered. In separate wells mix washes of ultramarine blue with neutral tint and burnt sienna with transparent oxide brown. Apply the washes and allow them to drain downwards. Keep the board at the same angle and let it dry naturally (don't use a hair dryer). This will take some time due to the amount of masking fluid on the paper's surface.

Secondary washes.

Step 3: Brush the whole of the painting with clean water. Add more colour, burnt sienna and transparent oxide brown, to both sides of the central sunlit section and let the colours drain downwards.

Pebbles and the river.

Step 4: To create the smaller stones and pebbles spatter some clean water from a No. 8 brush over the foreshore, concentrating most of the spatters towards the top of the painting but avoiding the river itself. With strong dark mixes spatter either side of the sunlit centre, varying both colour and tone as you work, with the larger, darker spatters towards the foreground. With a mix of pure cobalt violet wash in the river allowing the colour to settle and granulate out.

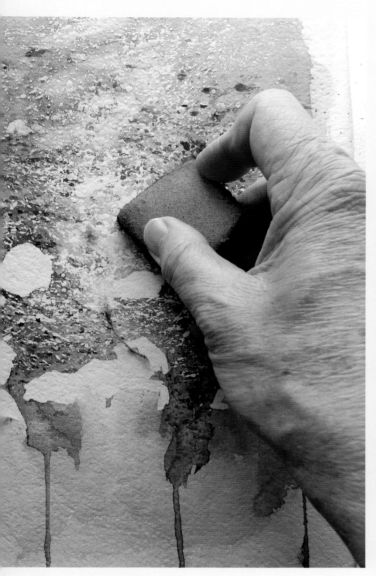

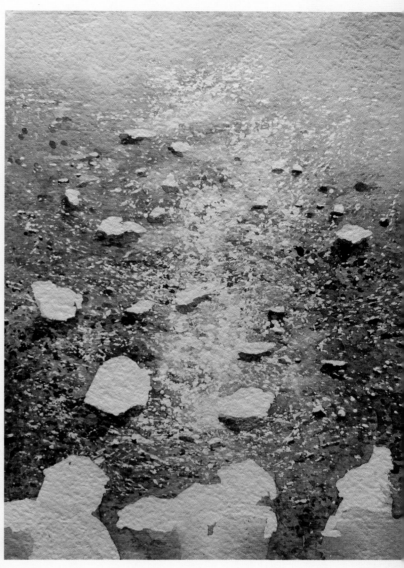

Remove masking fluid.

Step 5: Making certain that the painting is completely dry remove the masking fluid using the Maskaway eraser or clean fingers. Rub gently and don't be tempted to pull at it, as this may result in the paper tearing.

Shadows.

Step 6: Use a mix of ultramarine blue with permanent rose and paint in the shadows cast from the larger stones and some of the pebbles using a well pointed No. 4 brush. Make certain that all the shadows share the same light source and fall in the same direction.

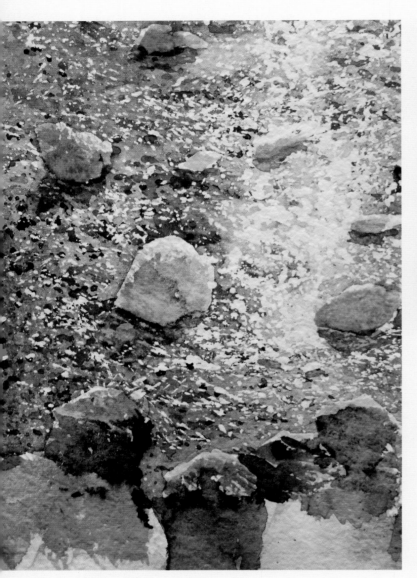

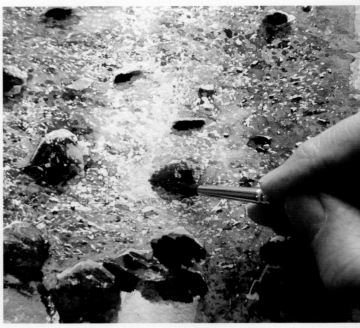

Adding details to the stones.

Step 8: Using a No. 4 brush add more detail to the main stones, with a strong mix of transparent oxide brown and neutral tint. Use a variety of brush strokes including dry brush work to indicate shadows and texture. Don't over-paint the previous washes completely, but allow parts of them to show through. With the tip of a well pointed No. 4 brush and a wash of cobalt violet and ultramarine blue, indicate a few ripples in the river.

Developing the larger stones.

Step 7: Take a No. 8 brush and lay in a wash of green gold to the larger stones, leaving some of the white of the paper showing to depict the sunlit tops. With the wash still damp, drop in mixes of ultramarine blue and burnt sienna allowing them to mix on the paper, concentrating the colours towards the bottom and shadow side of the stones. This will give the stones shape and form.

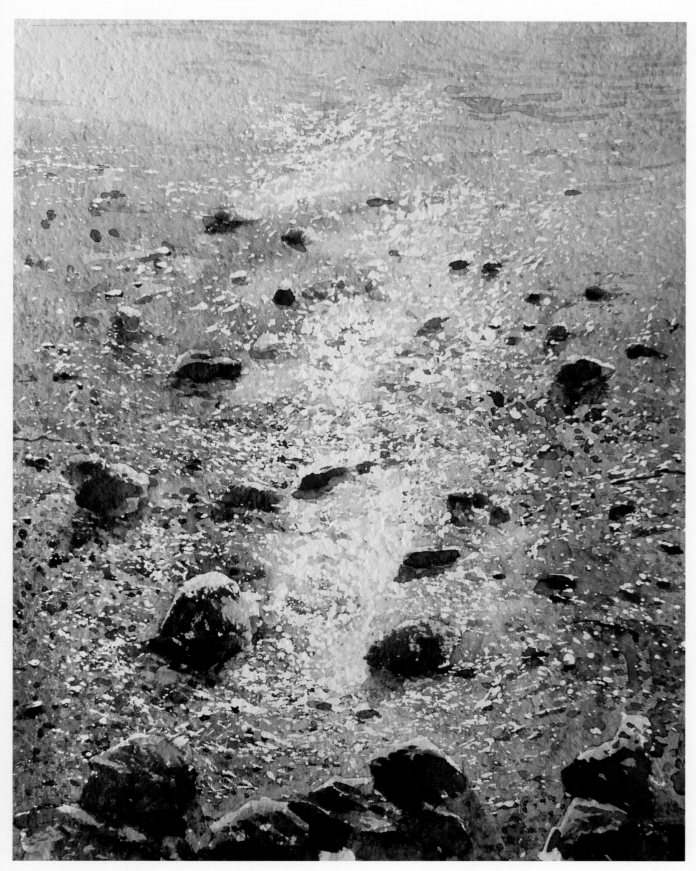

Finished painting: *Stony Foreshore*.

HEAD OF THE ESTUARY

The inspiration and focus behind *Head of the Estuary* was immediately apparent upon my arrival on the banks of the River Avon, it was the space. The expanse of the broad estuary seemed vast, somehow seeming so much wider than at high tide. I wanted to emphasize this in the watercolour.

I chose a design that had a number of strong underlying diagonal elements within the composition in both the sky, through the shape of the clouds, and within the estuary itself in the shape and direction of both riverbanks. These are useful in leading the eye into the painting and with the lack of detail and interest within the estuary the strong design geometry helps to establish the breadth and expanse of the scene. To balance the strongly diagonal composition I planned to place a few horizontal marks within the foreground, representing a line of stones or runnels and to use the masts to add some important and very useful verticals. In river scenes I will often use masts, not just as a way of bringing verticals into the design but almost as a way of visually linking the land and the sky.

The colour palette would emphasize the warm browns found in the mud along the Avon, which I would also introduce into the trees and hills. The pigments chosen for their granulating qualities added interesting textures to the painting, particularly in the muddy foreground. In order to gain the maximum effect from the paints' characteristics I chose to work on a sheet of Two Rivers paper; its random surface would encourage the creation of some interesting textures. Being such a hard paper I knew that it would also readily accept the use of quite a concentrated area of masking fluid and its subsequent removal.

The river in the middle distance was shining brightly in the morning sunshine; so strongly was it shining it appeared to be a brilliant white, with no trace of colour. To depict this effect I proposed to mask out this particular passage of the painting with masking fluid to prevent any washes compromising the whiteness of the paper. Any unwanted washes would reduce the tonal impact and thereby lessen the effect that I wanted to create.

The contrast between the brightness of the river with the darks of the hills and trees would give a good tonal punch to the painting, further emphasized by the placement of some larger darker stones in the foreground. The change of size, with the predominantly larger stones in the foreground diminishing in size as they recede into the painting, is used to bring a sense of distance and space to the watercolour.

Head of the Estuary

Paper
- Two Rivers 300gsm (140lb) NOT
- Size: 36 × 25 cm (14 × 10 inches)

Materials and equipment
- 2B pencil
- Masking fluid
- Nylon masking brush
- Brush soap
- Sable brushes, size 14, 10, 8 and 4
- Rigger
- Dip pen
- Palette
- Kitchen roll
- Maskaway eraser
- Painting board

Artist quality watercolours
- Ultramarine blue
- Winsor blue (green shade)
- May green
- Permanent rose
- Cobalt blue
- Burnt sienna
- Transparent oxide brown
- Cadmium orange
- Cobalt violet
- Green gold

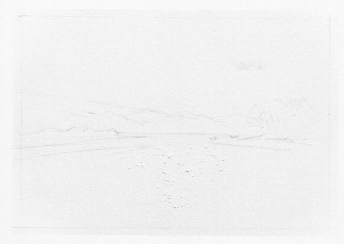

Drawing and masking.

Step 1: Working on the stretched paper, draw out the key shapes of the design with a 2B pencil. There is no need to draw in every tree, rock or boat; concentrate on the main shapes, paying particular attention to scale and proportion. With the nylon masking brush mask out the broad sunlit part of the river and some simple boat shapes on the riverbank to the right. Flick a few sparkles onto the estuary mud and with larger marks mask out the more pronounced light reflections in the foreground. Allow to dry fully.

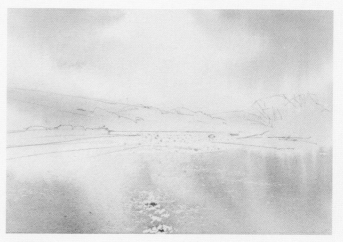

Initial washes.

Step 2: Prepare some washes in separate wells of pure Winsor blue, ultramarine blue, May green, cobalt violet and burnt sienna and a mix of ultramarine blue with permanent rose. Dampen the paper with clean water, make certain that it's completely covered, and with the board at an angle of about twenty degrees apply the washes with a No. 14 brush. Repeat the washes used in the sky in the estuary below concentrating the burnt sienna towards the bottom of the paper. Introduce the May green for the hills and trees. The colours will mix together as they drain down the paper producing new colours with soft edges and setting the scene. Allow to dry with the board at the same angle (altering the angle of the board at this point might cause some unsightly and unwanted 'cauliflowers').

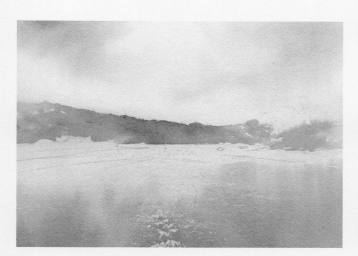

Developing the hills, sky and estuary.

Step 3: Dampen parts of the sky and with some of the previously prepared washes strengthen the clouds as required. With prepared washes of May green, burnt sienna and ultramarine blue, with the size No. 14 sable apply the washes on dry paper to develop and strengthen the hills and shapes of the trees, the movement of the brush following the fall of the land. With the sky and hillside drying, tip the board to an angle of about thirty degrees. With the largest brush, apply water to the estuary area and from the washes used in step 2 strengthen the colours, letting the colours drain downwards.

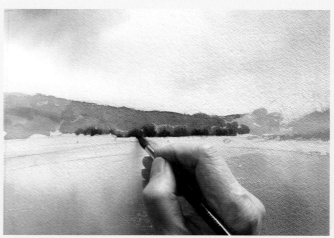

Strengthening the trees.

Step 4: After checking that the previous stage is completely dry, mix washes of May green with transparent oxide brown and a wash of pure ultramarine blue. With clean water and a No. 10 brush dampen the hillside and trees. Leave some dry paper between the hill and the tree tops: this will eventually depict the light hitting the tops of the trees. Paint the trees and hillside varying the mix and strength of colour as you work. With the trees still damp, use a strong mix of ultramarine blue and transparent oxide brown. Don't have too much water in the mix, and touch towards the bottom of the damp trees; the colour will bloom upwards, adding both shape and shadow to the tree forms. Leave to dry.

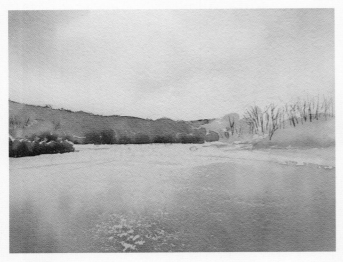

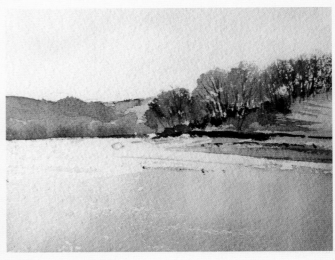

Trunks and branches.

Step 5: With the fine rigger, paint in the main trunks and branches for the small stand of trees to the right. Use a mix of transparent oxide brown and ultramarine blue, paint the trunks and branches by pulling the rigger from the bottom upwards towards the top of the tree. Although much of these will be lost under subsequent washes many of the branches will still be visible to give some structure and scale to the trees. With the same mix add some darks to towards the bottom of the hill. Leave it to fully dry.

Adding foliage and detail.

Step 6: Using a No. 4 brush, wash in a mix of green gold and ultramarine blue for the shadows cast by the trees to the right and allow to dry. With a No. 8 brush and a mix of transparent oxide brown with ultramarine blue, dry brush the larger tree shapes on both sides of the estuary. Vary the strength of the mix in order to add variety to the tones and colours within the trees.

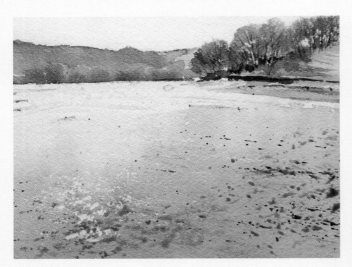

Texture in the foreground.

Step 7: Making certain that everything is completely dry and with the board flat, use some scrap paper to protect the painting apart from the area of the estuary. Spatter some drops of clean water from a No. 8 brush and let these soak slightly into the watercolour paper. With mixes of transparent oxide brown and burnt sienna, spatter these over the same area, the larger spatter marks nearer to the bottom of the painting. Some of the droplets of paint will land on dry paper producing more defined, sharper marks; others will land on the damp areas, resulting in softer-edged ones. Allow to dry naturally – don't use a hair dryer.

Foreground stones.

Step 8: Paint in the stones with a small brush, No. 4, with a strong mix of ultramarine blue with burnt sienna. As the paint is beginning to dry take a damp brush and pull some of the colour directly below a few of them downwards to indicate reflections. These are likely to be further out into the estuary, where the mud is damper and more reflective than in the immediate foreground. These reflections should be subtle rather than striking. The closer the stones appear to be to the viewer, the larger and darker they will appear to be. With some green gold touch in a few dabs of paint in and around some of the stones. Leave to dry.

Boats and reflections.

Step 9: The boats are painted very simply, with the absolute minimum of detail; just enough to indicate that the shapes are boats. The masts are painted in white gouache, running the ferrule of the brush against a ruler to produce a straight line. Note how the line of the mast changes from light against the background of the trees to dark against the lighter sky.

With cadmium orange touch in the small dinghy pulled up on the riverbank. Use Winsor blue for the other boats. Use the same approach when painting these as for the other boats: simple shapes with little detail. With a small brush add a few small dabs of white gouache to the trees indicating sky holes and light catching the leaves. Dampen the area of river below the trees and with the board at a slight angle drop in some of the trees' colours allowing them to drain downwards creating the trees' reflection. Allow to dry.

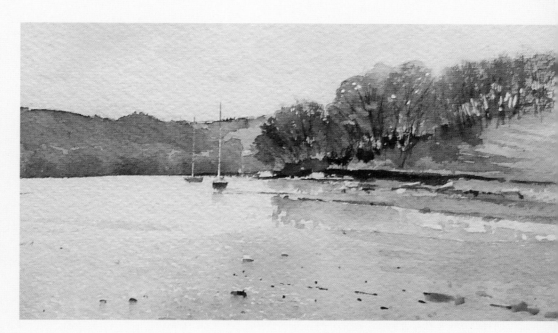

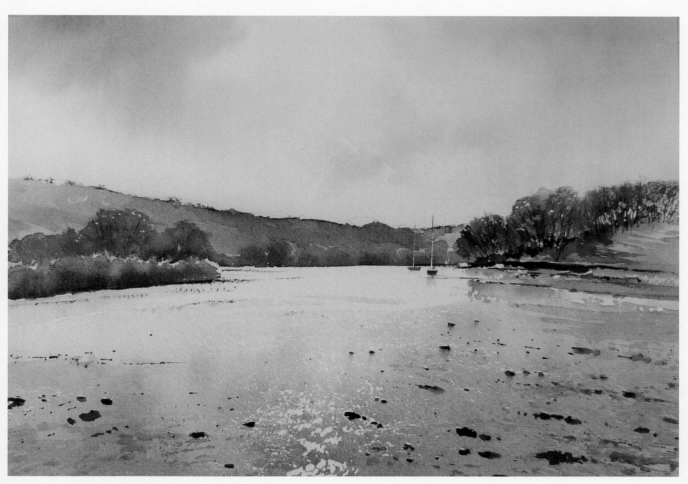

Finished painting: *Head of the Estuary*.

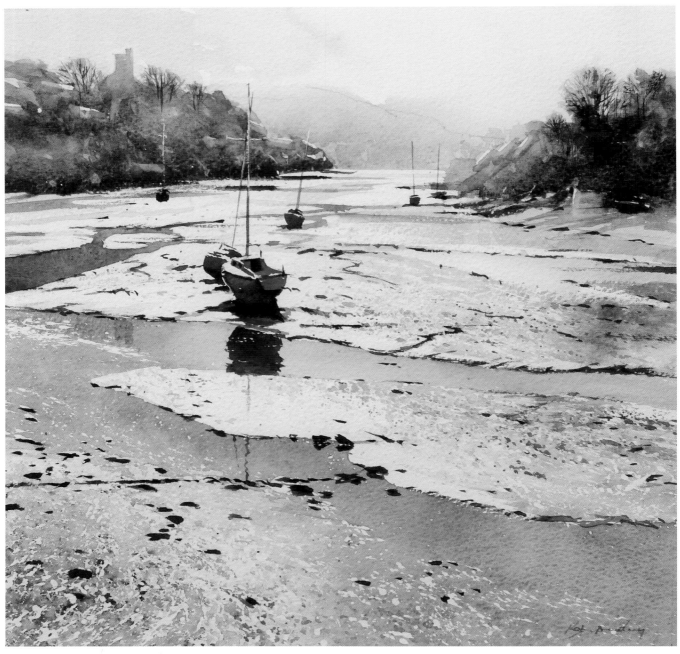

November at Newton and Noss.

NOVEMBER AT NEWTON AND NOSS

This painting was based on a photograph given to me by a very good friend. She knew that the snapshot contained so many of the elements that I look for when making a painting: wonderful light, shining mud at low tide, boats and tree-lined hillsides. Everything was there, and with her permission I was keen to use it as the basis for a painting. For me this is quite unusual: I would not normally work from a photograph that someone else had taken. Putting aside the possible infringement of copyright, I would want to have had the experience of taking the photograph myself rather than working from someone else's. If I had taken the photograph then I would have been able to choose on what to focus and zoom in on, how to frame the image, to make the decision about what was important within the scene to me – I could make all these choices before pushing the button and recording the image. But

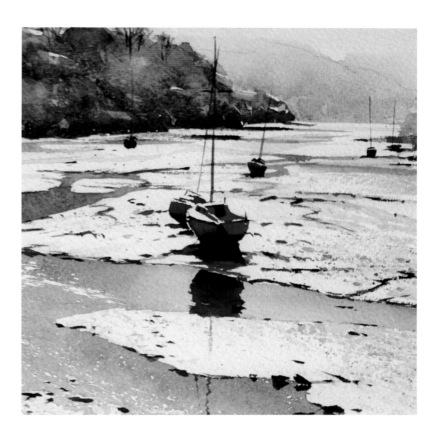

Detail of *November at Newton and Noss,* the boats looking rather flat and a little lifeless.

it's not just about the photograph; it's about the experience of being there at that location at that time. I would have been able to respond to the experience of being in that landscape and committing the experience of such to my memory. Which would allow me to call on these memories when making the painting.

The reason that I decided to work from the loaned photograph was that I already knew the place extremely well having visited and drawn at the same location over many years. Indeed I had made numerous drawings from the very same spot. That knowledge made it possible for me to interpret and work from the photograph as if it was one of my own reference images.

Being on location to make your own sketches, working from your own photographs might at first seem rather daunting but the experience of doing so will give a greater depth of visual knowledge to call on when painting your own watercolours, which in turn will lead to more authoritative paintings.

This painting is not particularly large (it measures only 23 × 23 cm); therefore the design is of utmost importance. Every design decision – be it colour, tone, wash or mark – must have value and contribute to the overall success of the painting.

The movement into the painting is directed by the diagonal river channels, from the right-hand foreground directing the viewer's eye towards the left edge of the painting and then from that point leading the viewer back into the painting and into the distance. The perspectival narrowing of the channels adds to the sense of distance and space.

The day was slightly misty so any detail in the background has been understated. Cobalt blue was chosen to be in the background mix because of its slightly chalky, semi-opaque quality, which would contribute to the effect. There was a lot of light shining off the mud, and in order to achieve this effect I spattered a lot of masking fluid onto it, flicking it from a nylon masking brush and trying to give direction to the spatters, in order to guide the viewer's eye within the watercolour to where I wanted them to look. The distant river was masked out, as were the boats in the foreground and distance.

Tonally I wanted to give impact to the main focal point, the two boats in the mid-ground, and therefore I chose to make them the darkest part of the design, juxtaposed with and in contrast to some of the lightest parts. This light–dark contrast is a useful way to direct and attract attention to specific parts of the painting. Not only can it be a useful

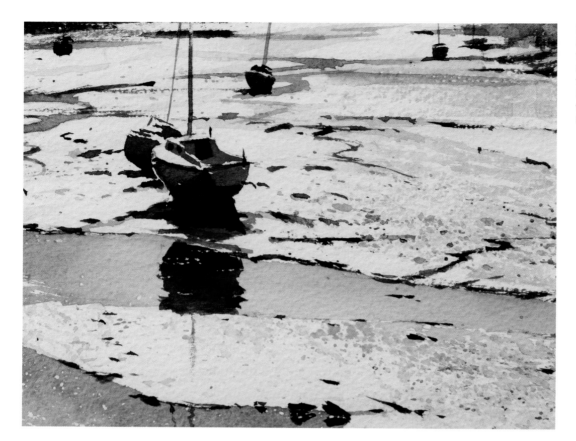

Detail of *November at Newton and Noss* after the splash of permanent rose had been added to the hull. Note how much livelier and energetic the whole painting seems to be with its addition.

device in moving the viewer's eye around the composition, but it can also indicate the strength of sunlight; the greater the tonal contrast the brighter the day. Consider how dull the day appears to be in *Passing Shower over the Dart* in Chapter 5 where the tonal range is much narrower compared to the broader range depicted in the image above.

The photograph was taken in the late autumn or early winter and the palette chosen for the painting complements this through the controlled use of greys, blues and browns within the design. Complementary pairs – yellow in the sky with purple in the water, and orange brown in the mud and blue within the river channels – were chosen deliberately to add interest to the painting.

The painting was quickly executed once the design had been arrived at, taking little more than three hours. However, when completed I felt that it lacked something. The tones worked well, the design was doing what I intended, but it lacked a real 'kick'. It needed something to turn it on, it needed a splash of red.

Not painted as a step-by-step, I did however take a photograph of what I thought was the final painting to send to one of the galleries that I exhibit at. The focal point of the two main boats was where the problem lay; it was rather

COUNTERCHANGE

Counterchange is the term used by artists to describe dark shapes drawn against light shapes or light shapes against dark. It's a useful device to provide interest and clarity to passages within the painting. Within the watercolour *November at Newton and Noss*, counterchange has been used to depict some of the the masts on the boats. The masts are painted in a darker tone when set against the lighter mud of the estuary, and lighter in tone when crossing the darker toned trees of the hills. This effect is not confined to the world of painting: once you are aware of the principles of counterchange you will be aware of just how often it appears in the natural world.

lifeless, as the image below shows. The tonal contrast worked well, but it needed something.

Look what a spot of permanent rose brings to the scene. It energizes it: not just the focal point but to the painting as a whole. That little splash of red makes all the difference.

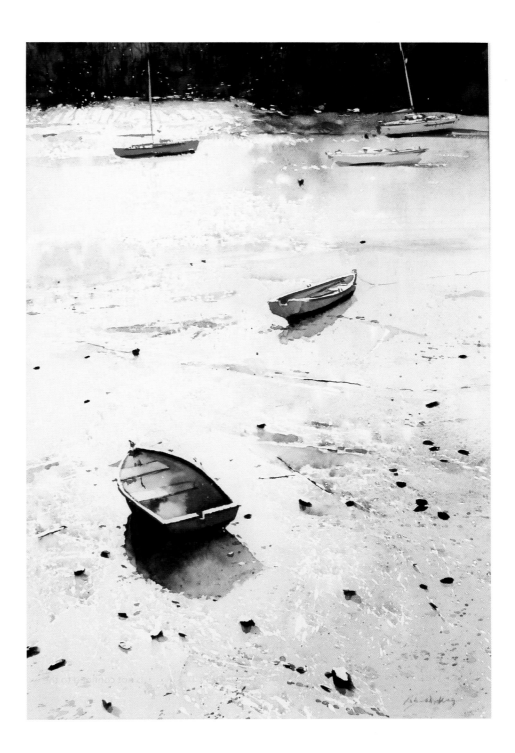

Low Tide at Topsham.

LOW TIDE AT TOPSHAM

The River Exe at Topsham has always proved a rich sketching ground, particularly at low tide. I always enjoy visiting and it never fails to throw up some interesting painting opportunities for me.

On this particular visit the tide was out, the sun was shining, the river sparkling and the mud was full of colour. The scene was made for a watercolour and after gathering information through sketching and photographs I returned to the studio eager to start work. The inspiration and focus was quickly and easily decided upon: it had to be the light and the colours in the mud.

The design was simple. The bottom two-thirds would be the muddy foreshore with all its colours and shining light and the top third would be the sparkling Exe and the dark far bank. The boats offered scale and were placed as a way to direct the viewer's movement through the painting; I thought of them as stepping stones moving the viewer from the near bank to the far one.

Tonally the watercolour needed some rich darks and some contrasting lights to bring a punch to the painting, the near boat with the bright top-lit gunwale juxtaposed with the dark shadowed hull being a good example.

With the foreground boats masked, a fine sparkle brush being used to mask out the light on the Exe and some flicks and spatters on the foreground mud, I was ready to paint.

The watercolour used a lot of colour, but an even larger quantity of water – it was quite literally dripping off the paper. I dropped in lots of strong colours onto the wet surface of the paper, blue for the Exe and blues, purples and browns for the mud, moving them around the paper by tipping and turning the board until the mixes were where I wanted them. I then left it well alone to dry completely.

The two dinghies were painted next with a combination of wet into wet and wet on dry washes. When these were dry all the masking fluid was removed and some of the foreground stones and their reflections were touched in. Finally the three larger boats moored in the river were painted in using gouache rather than watercolour, the opaque quality of the gouache allowing me to cover the watercolour with the minimum of fuss.

And so to the sea...

Our river has ended its journey, it has reached the sea and can go no further. I'm always a little saddened when a river's journey comes to an end, having enjoyed so many aspects of its course. Paintings are to be found every step of the way from its source to the sea, from the chattering stream spanned in a single stride, summer meadows where cows venture down to the river's edge to sip at the cool water, sparkling shallows that shine like diamonds... but I'm not sad for long, for the river will always be there and my brushes will always be busy.

I hope that by explaining my ideas, approach and methods when painting I will have encouraged readers to 'have a go'. An old painting friend of mine once told me many years ago, when explaining how he worked, that he wasn't telling me he was right, he was just telling me what he did. I have taken the same approach within the pages of this book. This is what I do, it works for me and I hope that it will work for you.

If you put one hundred artists together in one room, it's likely that you will get one hundred opinions, some more similar than others and others not similar at all! However, I enjoy meeting fellow artists to share ideas, learning about their techniques and ways of handling paints, discovering what inspires them and why. All this feeds and nourishes my own work, for as artists we should never stop learning.

I believe that painting should be enjoyable. It might not always seem so at the time when you are struggling with a particular passage, or a tricky bit of drawing, but stick with it: it will get better, perhaps not immediately, and with practice you will improve. Anything of worth takes effort. Don't be despondent when you make mistakes: learn from them. If a colour has run where it wasn't wanted, or a distant tone is too dark, instead of ripping up the painting in disgust, analyse why it hasn't worked, write a note on the painting to remind you the next time. Keep the mistakes, as they are probably more useful to you than a painting that has worked and yet you don't know why.

I have always tried to paint what interests me. I have never tried to follow fashion or second guess what will sell, as I believe that through honesty lies integrity. If you paint what you love it will come through in the works themselves and others will notice.

But above all, the key to becoming a better artist is to keep painting.

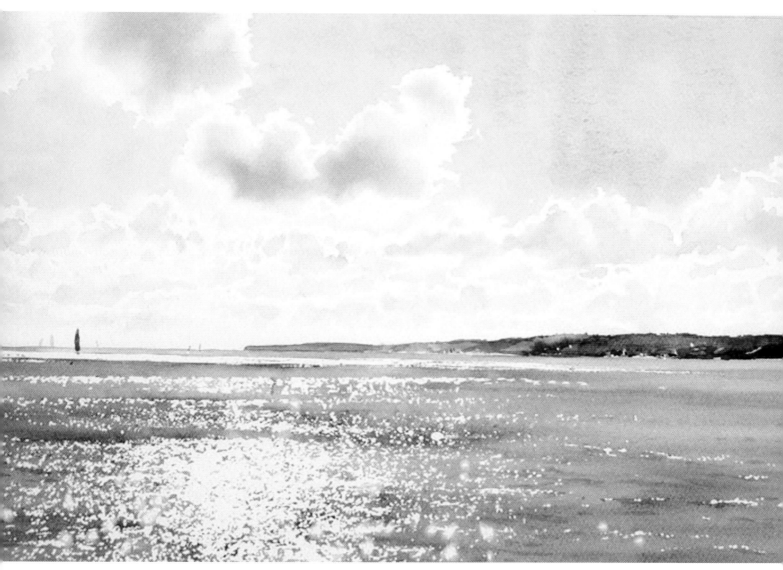

The end of the journey.

Suppliers

Easels

Frank Herring & Sons
27 High West Street
Dorchester
Dorset
DT1 1UP
Tel: 01305 264449 / 267917
Email: info@frankherringandsons.com

Brushes

St Petersburg Watercolours
Euroart
PO Box 361
Wareham
Dorset
BH20 7DA
Tel: 01929 554412
Email: enquiries@stpetersburgwatercolours.com

Paper

Bockingford Watercolour Paper
St Cuthberts Mill Limited
Wells
Somerset
BA5 1AG
Tel: 01749 672015
Email: sales@stcuthbertsmill.com

Two Rivers Paper Company
Pitt Mill
Mineral Line
Roadwater
Watchet
Somerset
TA23 0QS
Tel: 01984 641028
Email: tworiverspaper@gmail.com

General art supplies

Jacksons Art Supplies
1 Farleigh Place
London
N16 7SX
Tel: 020 7254 0077
Email: customerservices@jacksonsart.co.uk

Paint

Royal Talens UK
30 Portland Place
London
W1B 1LZ
Email: sales.office@royaltalens.com

Daler-Rowney Head Office
Peacock Lane
Bracknell
Berkshire
RG12 8SS
Tel: 01344 461000
Email: webmaster@daler-rowney.com

Lighting

Daylight Company Ltd
89–91 Scrubs Lane
London
NW10 6QU
Tel: 020 8964 1200
Email: info.uk@daylightcompany.com

Index

RELATED TITLES FROM CROWOOD

978 1 78500 240 3

978 1 78500 324 0

978 1 78500 108 6

978 1 84797 119 7

978 1 84797 314 6

978 1 84797 085 5

978 1 84797 621 5

978 1 78500 268 7

978 1 84797 715 1